EXPERIMENTAL

DIGITAL

PHOTOGRAPHY

RICK DOBLE

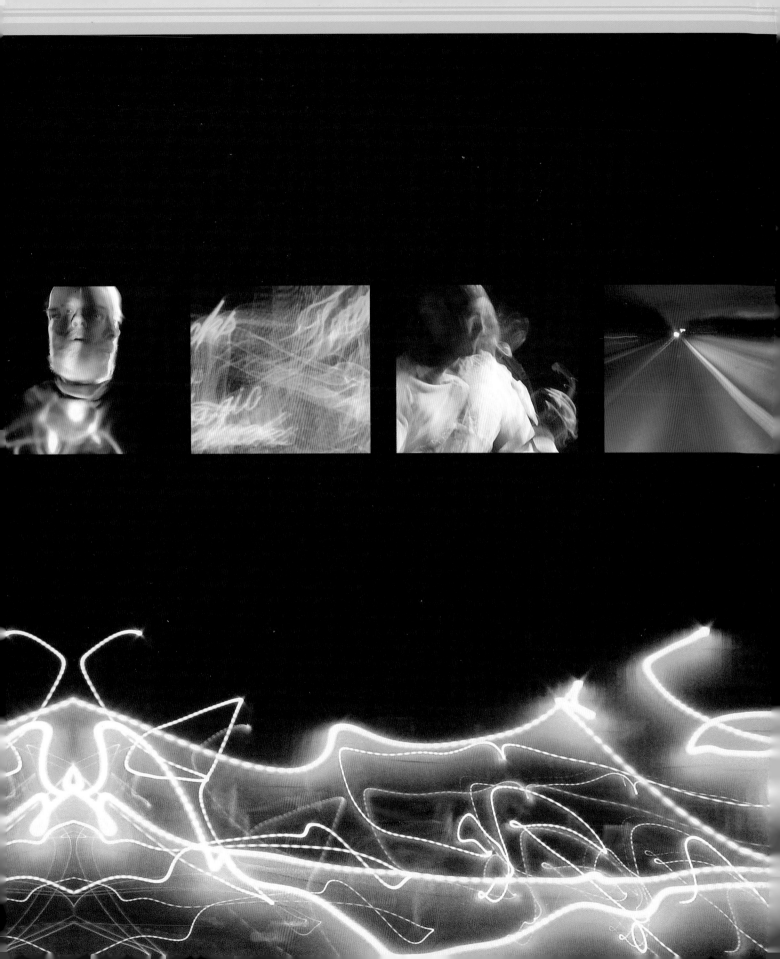

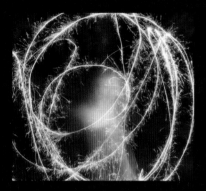

EXPERIMENTAL DIGITAL PHOTOGRAPHY

RICK DOBLE

LARK
PHOTOGRAPHY
BOOKS

A Division of Sterling Publishing Co., Inc.
New York / London

Editor: Kara Arndt
Book Design: Sandy Knight
Cover Design: Thom Gaines, Electron Graphics
Illustrations: Sandy Knight

Library of Congress Cataloging-in-Publication Data

Doble, Rick.
 Experimental digital photography / Rick Doble. -- 1st ed.
 p. cm.
 Includes index.
 ISBN 978-1-60059-517-2 (pbk. : alk. paper)
 1. Photography, Artistic. 2. Photography--Digital techniques. 3. Arts--Experimental methods. I. Title.

 TR642.D62 2009
 775--dc22
 2009029281

10 9 8 7 6 5 4 3 2 1

First Edition

Published by Lark Books, A Division of
Sterling Publishing Co., Inc.
387 Park Avenue South, New York, N.Y. 10016

Distributed in Canada by Sterling Publishing,
c/o Canadian Manda Group, 165 Dufferin Street
Toronto, Ontario, Canada M6K 3H6

Distributed in the United Kingdom by GMC Distribution Services,
Castle Place, 166 High Street, Lewes, East Sussex, England BN7 1XU

Distributed in Australia by Capricorn Link (Australia) Pty Ltd.,
P.O. Box 704, Windsor, NSW 2756 Australia

If you have questions or comments about this book, please contact:
 Lark Books
 67 Broadway
 Asheville, NC 28801
 (828) 253-0467

Manufactured in China

ISBN 13: 978-1-60059-517-2

For information about custom editions, special sales, premium and corporate purchases, please contact
Sterling Special Sales Department at 800-805-5489 or specialsales@sterlingpub.com.

For information about desk and examination copies available to college and university professors, requests
must be submitted to academic@larkbooks.com. Our complete policy can be found at www.larkbooks.com.

A POEM TO DIGITAL IMAGERY

REAL TIME

ON THE EDGE OF DARKNESS
I HAVE SEEN THE TWILIGHT SKY
DO ITS DIGITAL DANCE
IN REAL TIME -
PIXELS PULSING FROM
CERULEAN BLUE TO BLACK
ON MY LCD SCREEN -
VAN GOGH'S DEEPEST COLORS
OUTSIDE HIS CAFE IN THE EVENING
OR HIS STARRY STARRY NIGHT

—RICK DOBLE 1999

DEDICATION: To Donald Buka, friend and film noir actor: When I was young, he taught me the beauty of shadows and of the night.

CONTENTS

EXPERIMENTAL DIGITAL PHOTOGRAPHY

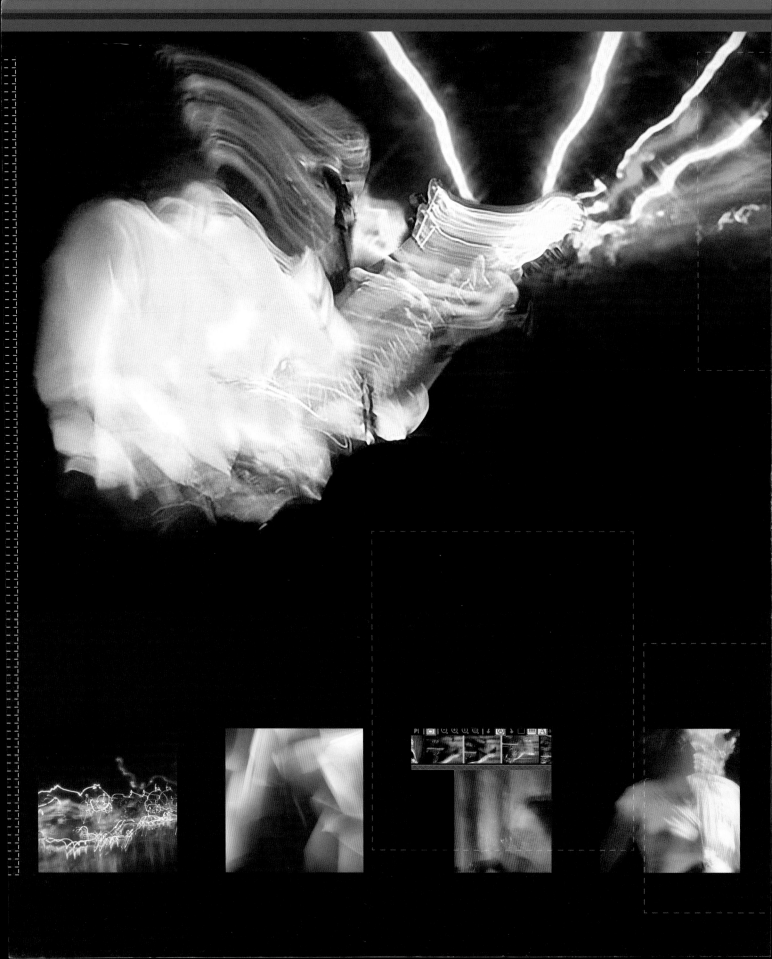

Introduction

TAKE THE PLUNGE INTO
EXPERIMENTAL PHOTOGRAPHY

D o you like to express yourself? Do you like to explore? Do you think outside the box? Would you like to create new photographs that are different from anything done before? Then experimenting with digital photography is for you.

"There are times when it's worth implementing Plan B: Let the chaos of the moment take over."

JEFF WIGNALL,
PHOTOGRAPHER

N O T E

The emphasis of this book is to explore photographic effects created with the camera rather than effects created with computer software.

A new world of photographic imagery has opened up with today's digital tools. Digital photography has been around for several decades, but we are just beginning to harness its capabilities. You don't need the most recent or expensive equipment to accomplish stunning imagery—the Ferris wheel photos on these pages were shot with a basic point-and-shoot camera almost ten years ago. Rather than rushing out to buy the latest technology, learn to use what you already have to take your own experimental photos.

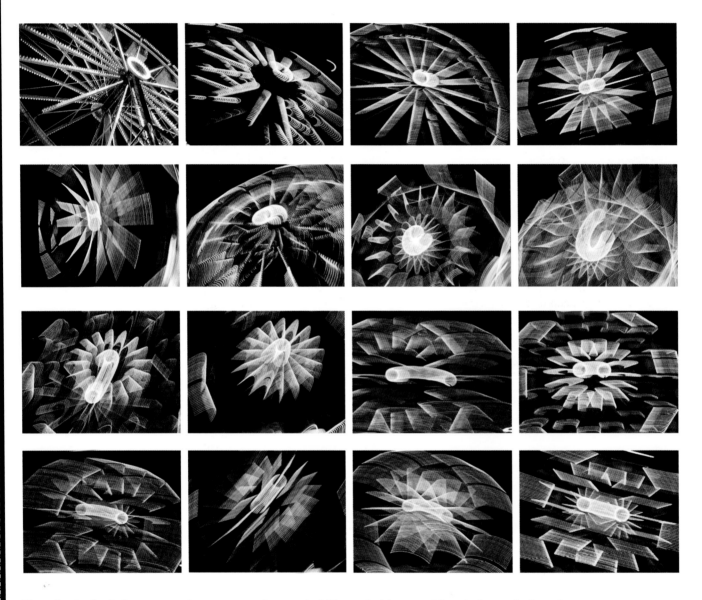

These Ferris wheel photos were taken over a one-hour period. I learned a bit more with each shot and adjusted my technique to get still more unusual effects. Before I could start, I had to find an angle that would eliminate the distracting background of the lights from other fair rides. I found a position directly under the Ferris wheel where I could place the lights against the night sky without the other attractions getting in the way. Then I was able to "paint" these Ferris wheel lights against the dark sky. Several elements helped me achieve these effects: 1) the Ferris wheel was turning, 2) the lights on the Ferris wheel were blinking on and off and cycling through a series of different patterns, and 3) I added a good deal of camera movement as I was making the capture. (Camera Settings: ⅛ second, f/8, ISO 50)

Digital cameras allow photographers to tap into their creative impulses in ways that were impossible with traditional film, and the results can be an expressive and personal art form.

The LCD Advantage

The digital advantage is due in large part to the immediate feedback from the LCD monitor. The very nature of experimenting means that the resulting images can be hard to predict, but with the LCD monitor you can instantly review your shots and make adjustments on the spot. If you use a slow shutter speed to shoot a dancer, is the image going to be a blurry mess or a dynamic sense of the dancer's rhythm? You really won't know until you have taken a number of test shots; the first photos will only be starting points to give you an idea of what to do next, allowing you to focus on the best possible effects.

The instant feedback of the LCD screen also allows new photographers to learn standard photographic techniques quite rapidly. You can learn to handhold a camera at very slow shutter speeds because you will be able to judge quickly what works the best to steady your grip. Soon you may be able to handhold the camera for ½ second and more—in this book I will show you how to do just that.

The Excitement of Creation

Experimenting with digital photography means that at the time of the shoot, almost in real time, you will be learning, adjusting, and taking advantage of elements such as the colors of a dancer's dress. Experimenting with digital— especially in candid situations—is quite creative. Experimental digital photography can reflect momentary imagery in ways never possible before. You may find yourself in a unique situation where the resulting images evolve in a matter of minutes.

Forget About Cost

Cost is no longer an important factor. If you take 100 photos that don't work, you can erase them and they've cost you nothing. With traditional film, those same 100 photos would have cost you money to develop and print, regardless of whether they worked as photos or not.

About Color Photography

COLOR FILM for general photographic use has been around since the 1930s, but it did not become widely available until the early 1970s; even then it was expensive to process, difficult to develop in a home darkroom, and the prints faded quickly. During this time the photographic community did not generally accept color prints as a valid art form and therefore artistic photographers expended very little effort working with color film.

About Color

A very important component of the digital photography revolution is the fast, easy, and low cost access to color imagery. Color is crucial to experimental photography and to expression; it adds another creative element not offered by black-and-white photography and allows for increased subtleties in shading, layering, and depth.

"The "mistakes" of yesterday...are today explored as interesting values in themselves, with great potential for evocative and expressive power."

PETER POLLOCK,
AUTHOR OF
"THE PICTURE HISTORY
OF PHOTOGRAPHY"

What This Book Can Do For You

EXPERIMENTING WITH DIGITAL PHOTOGRAPHY is fun and creative, but you still need a guide to show you how to get started.

IN THIS BOOK YOU WILL LEARN:

• Effects you can create in the camera during a shoot

• Types of experimental imagery that are good starting points

• Step-by-step how-to information that will get you warmed up with a variety of experimental techniques

• How to edit and process your photos in your digital darkroom

• Where to get quality free software that will help you in your efforts

• How to find inexpensive equipment for certain kinds of experimental photographs

• How to grow and evolve as an experimental photographer

• How to branch out from ideas in this book to create your own personal vision

DO YOUR OWN THING

There is no such thing as a "bad" experiment. You might try techniques that have been viewed in the past as mistakes such as using blur, flare, unnatural lighting, or camera movement, but the nature of experimentation means there is no wrong photo. Even photos that don't do what you want can be interesting and point the way to photos that do work.

As you will discover in this book, there are many ways to experiment—subject movement with a slow shutter speed, odd lighting, handholding and panning a camera at an 8 second shutter speed, or mixing a fast flash with blurred motion—there is no end to the possibilities.

Develop A Style

There are no rules for experimenting, however the elements of your photo need to work together in pictorial harmony. The power of any photograph is directly related to its composition. In simple terms, composition refers to how the different parts of a photo work within the frame. Composition can be quite varied, and there are many ways to approach it. One way to learn composition is to look at creative visual work that you admire, such as paintings. When you see an image that strikes you, study it carefully so that you understand why it works.

Eventually you will begin to create original imagery. When you discover a technique that works, learn to control it, refine it, and then make it part of your creative repertoire.

NOTE

How Many Shots?

It is important to take a lot of photos when you are experimenting; the more photos you take, the better. If you really like one photograph out of 20, or even one out of 50, consider it a success. You will want a full range of images to chose from and work with in your digital darkroom, and you may surprise yourself by liking a photo later that you dismissed at the time. This is the nature of experimenting—trial and error, exploring, discovering, and developing your own artistic criteria about what is an acceptable photograph.

Is It Really Photography?

From the beginning, photographic technology has evolved; each advance has expanded the imagery that can be rendered with a camera. Digital photography also makes new and different imagery possible. Some photographers have trouble accepting a different kind of image, but pushing the limits of generally accepted standards has always been an important part of photography.

No matter what the response is to your experimental work, you can be sure of one thing: Experimental digital photography is not a gimmick or a flashy technique. It expands the vocabulary of photography.

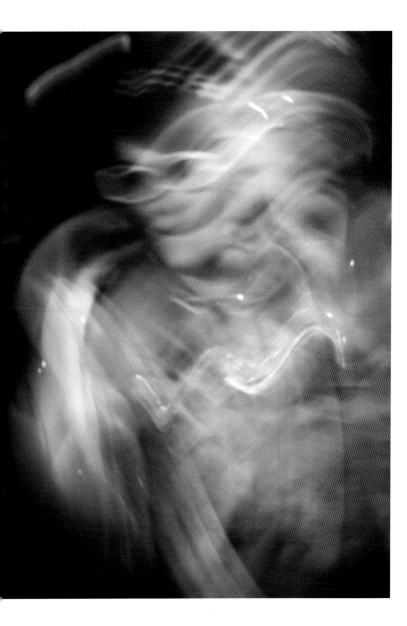

The Top Ten Digital Photography Advantages

DIGITAL PHOTOGRAPHY is beneficial for the experimental photographer because:

1. The LCD monitor allows quick corrections and adjustments almost in real time.

2. The LCD monitor also makes it faster and easier to master difficult photographic techniques.

3. Low expense means that hundreds of experiments can be attempted at virtually no cost.

4. The stabilizer control on many cameras allows shooting at very slow shutter speeds.

5. The color balance can be adjusted depending on the light source or the photographer's artistic taste.

6. The EXIF data recorded with each shot holds valuable information about how the photo was shot.

7. Adjusting a photo once shot can be done quickly and cheaply using software.

8. Cataloging, archiving, and retrieving photos can now be accomplished easily via software.

9. Protecting irreplaceable photographs is now relatively easy and cheap with backup hard drives.

10. Photographers can upload digital imagery to the Internet and reach a worldwide like-minded audience that appreciates their efforts.

LEFT
This ½-second shot of a fast-moving rock musician at night recorded ghostly ribbons of color created by her movement.

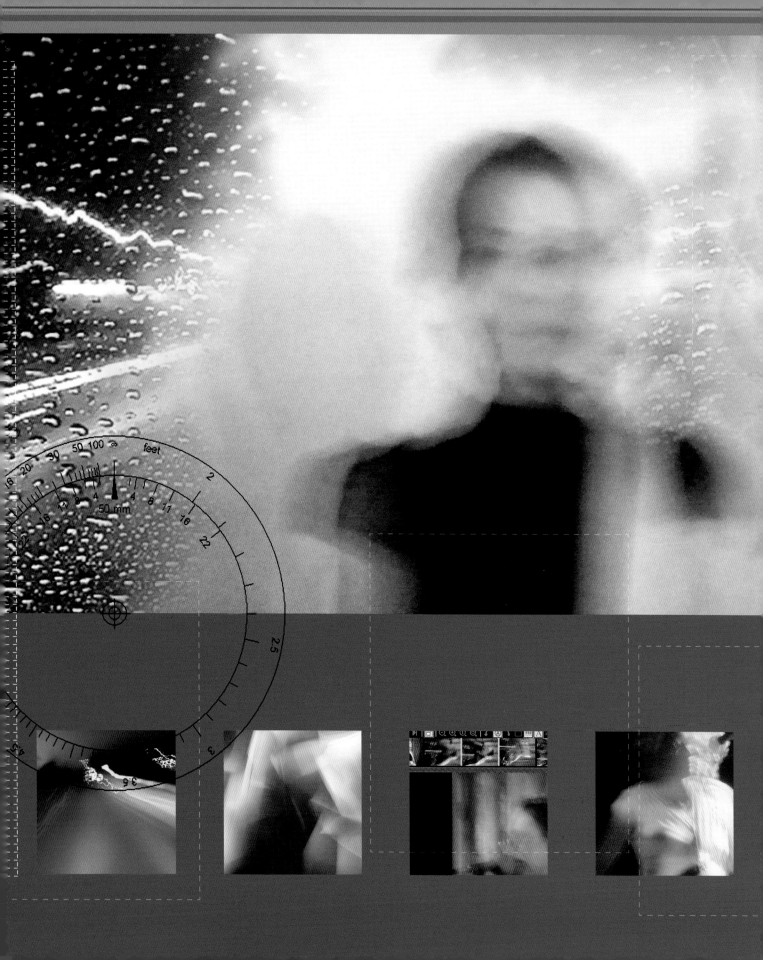

Getting Started

THE TECHNICAL SIDE OF EXPERIMENTAL PHOTOGRAPHY

Even though the photography in this book is experimental, technical aspects still apply—perhaps even more so than with traditional photography. Understanding shutter speed, depth of field, and focal length, for example, are crucial to capturing the best possible experimental image. In addition, using the new capabilities of digital cameras such as the LCD monitor and the display of EXIF data can help you progress quickly and easily.

"Technique is just a means of arriving at a statement."

JACKSON POLLOCK, PAINTER

This 5-second shot, in which I moved the camera to create a pattern from the wall paneling in my home, required a number of test shots that I reviewed on the LCD monitor. Without the monitor feedback, the shot would have been impossible.

USING THE LCD MONITOR

The instant feedback of the LCD screen on the back of your camera provides a powerful capability when shooting experimental photographs. This feature is not perfect, however, and in your quest for excellent photographs, it is important to learn its strengths and weaknesses.

Shoot, Review, Adjust & Shoot

Using the LCD monitor becomes second nature with practice. Ideally, you should review each photo after each shot. Many cameras make this simple by displaying the last photo taken immediately after the shot or displaying the image if you continue to hold down the shutter button. Other cameras require that you press a review or playback button. Get into the habit of looking at what you just shot and make adjustments before taking the next picture. As you become more accomplished, you will do this quickly and learn to make a variety of adjustments such as camera angle, composition, exposure, and white balance. This process—shoot, review, adjust, and shoot again—is the best way to proceed, and is the key to learning and growing as an experimental photographer.

Overall Review

At the end of a shooting session, it is also useful to review all the photos that you just shot. This gives you an overview of the session and shows you how you progressed from shot to shot. This review may also highlight opportunities that you missed but might take advantage of in another session. It is not unusual for photographers to spend more time going over their photos after a shoot than the actual time spent in the session itself.

Judging Sharpness

While the LCD screen is a major advance for the photographic medium and a principal tool for reviewing and judging picture quality, it can be deceptive. Often, a picture that looks sharp on the LCD monitor may not be sharp when viewed at its full size.

As seasoned photographers know, a very small image—such as the thumbnail on the LCD monitor—will look fairly crisp, but when it is enlarged it may reveal blur and other flaws that were not apparent at the small size. LCD screens are getting bigger as manufacturers develop new models, and many cameras help

you accurately judge image sharpness and other qualities by magnifying the image on the LCD screen. Enlarging it (usually with a zoom button or review option in a playback menu) will show you just how sharply the smallest detail is rendered. The only drawback is that you can only see a small section of your photo at a time on the LCD monitor. This section can usually be blown up quite large, so scroll around the image to view different portions. This is the only reliable method for judging a photo's sharpness with the camera's LCD monitor.

ABOVE
I took this photo using a mirror with an early digital camera. Framing the shot and getting the angle just right would have been very difficult without the instant display of the LCD monitor.

LEFT
This woman stood against a wall while people moved around her and registered only as ghostly impressions. Shots like this would be impossible without the review feature of the LCD monitor as it allowed me to adjust the shutter speed to the right setting for the situation—a 2-second exposure.

This 12-second exposure of light coming around the edge of a door was created using a staccato type camera movement. I had to take many test shots to gradually zero in on the right motion for the effect I was after. This would have been impossible without the continuous feedback of the LCD monitor that allowed me to shoot, review, and then adjust my settings for the next shot.

LCD Screen Limitations

The LCD monitor is only an approximation of what your image will look like when it is viewed at full size on your computer screen or when it is printed. Color, contrast, and detail may look very different at the larger size.

Many LCD monitors display images much lighter or darker than they actually are. You can remedy this by adjusting the LCD's brightness setting. View your photos on your computer monitor to get a sense of what they actually look like, and then display them on your camera's LCD monitor again. If you see a marked difference, adjust the lightness or darkness of the camera's monitor with a setting in one of your camera's menus. This is a very simple way to align the brightness of the LCD monitor and that of your computer.

Another limitation is that many camera LCDs display a cropped image. The LCD display often cuts off the edges—a factor which you may only be able to judge when you view the image on your computer. Again, the best way to see the discrepancy is to compare the same photo on your computer and on your camera.

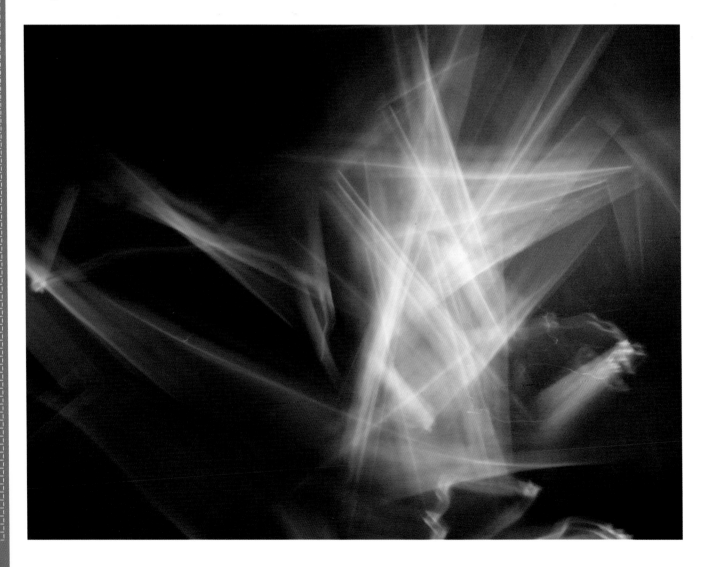

ISO AND EXPOSURE

The term "ISO" comes from the traditional film days, and is a way of rating a film's sensitivity to light. Low ISO film, such as ISO 100, is less sensitive to light and therefore needs more light to capture detail in an image; high ISO film, such as ISO 800, is more sensitive to light and needs less to capture detail. Low ISO film creates higher-quality images, and high ISO film creates lower-quality images with more visible grain. Digital cameras have an ISO setting that mimics these effects by turning down or amplifying the sensor's electronic signal for low and high ISO settings, respectively. A major advantage with digital photography is the ability to adjust the ISO setting for every capture. Some cameras allow you to go from a low of ISO 50 to a high of ISO 6400.

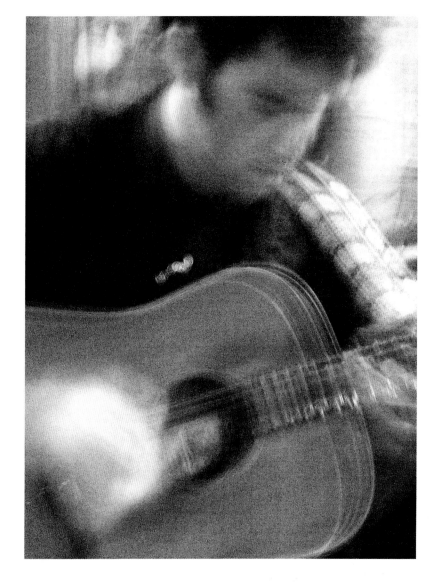

RIGHT
This "grainy" shot was taken using an ISO 1600 with a 6-second handheld exposure under available light in a poorly lit bar. The grainy or noisy effect was intentional, because I was pretty sure that's what I would get under those conditions.

NOTE

Like traditional film, the higher the ISO, the grainier—or noisier—the picture tends to be. In low light, a high ISO—say, 800 or above—may produce noise. If you see a lot of noise in your pictures (random red and blue pixels), you have a few options: You can use the camera's built-in noise reduction feature, lower the ISO number, or use noise reduction software in your "digital darkroom." (Refer to page 176 for more information on noise reduction software.)

The Automatic Disadvantage

The ubiquitous automatic controls are one of the distinct disadvantages to digital photography, and to experimental digital photography specifically. Experimental photography requires more control from the photographer, not the camera, to create a dynamic image. Many people new to photography might never learn about stops or reciprocity if they only use the automatic settings. Whether you know it or not, the camera is making these calculations when it's set to an auto mode, and they are crucial to creating the final picture.

Aperture and Shutter Speed

If you come from a film background, then you already know that shutter speed and aperture (f/stop) work together to create a balanced exposure. Changing one requires a corresponding change in the other. However, a large amount of artistic control is exercised within these settings, and this is especially so for experimental photography.

In general terms, the shutter speed controls how quickly the shutter opens and closes to expose the sensor to a scene's light; increasing the shutter speed setting means the shutter is moving faster and light has less time in which to hit the sensor. Aperture determines how much light is allowed through the lens during that time; increasing the aperture means a larger amount of light hits the sensor at any given time. If you speed up the shutter—limiting the amount of time light hits the sensor—it is usually necessary to increase the aperture or ISO to maintain a well-exposed image. A large aperture is expressed by a lower f/number, such as f/2.8; a smaller aperture is expressed by a higher f/number, such as f/22.

Reciprocity

Shutter speeds, f/stops, and ISO numbers all work together to create an exposure. These settings move up and down in increments called "steps" or "stops," and each setting combination determines the intensity at which light hits the sensor (aperture) and for how long (shutter speed). Changing one setting means you must change the other to compensate and maintain a well-exposed image; hence the term reciprocity. Increasing the aperture by one stop and allowing double the light to hit the sensor means you must also increase the shutter by a stop, which cuts the time the light hits the sensor in half.

The following chart shows how these elements all work together; at a given ISOs, these combinations of aperture and shutter speeds would produce identical exposures.

ISO, f/stop, and Shutter Speed Reciprocity Chart

f/stop	ISO 100	ISO 200	ISO 400	ISO 800
f/2.8	1/8	1/15	1/30	1/60
f/4	1/4	1/8	1/15	1/30
f/5.6	1/2	1/4	1/8	1/15
f/8	1 second	1/2	1/4	1/8

Exposure Calculating Software

MANY WEBSITES HAVE EXPOSURE CALCULATORS to walk you through a number of standard lighting situations. Tweaking one or more of the settings shows you the corresponding change in the other settings.

The photographer's exposure calculator allows you to calculate and change f/stops, shutter speeds, ISOs, and even exposure compensation for virtually any lighting situation, from a landscape lit only by starlight to scenes so bright they are not normally encountered in the natural world. These programs can teach you virtually anything you need to know about these basic camera settings in a variety of lighting situations. If you are unfamiliar with reciprocity in photography, play with the program listed here.

If you're really technologically savvy, the author of this program allows you to copy this calculator and use it on your computer or mobile device.

http://klep.name/programming/expocalc/calculator/

Also go to the following website for another very useful and well thought out calculator:

http://www.robert-barrett.com/photo/exposure_calculator.html

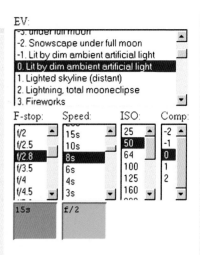

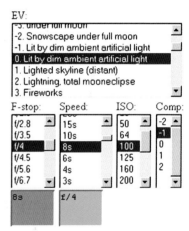

OVERRIDING AUTOMATIC EXPOSURE CONTROLS

Once you have mastered reviewing your photos on the LCD monitor and have gained an understanding of photographic exposure, the next step is to override the automatic controls on your camera.

Shutter Priority Setting

There are a number of shooting modes that allow the camera to set exposures automatically, but that also give you a margin of control over your settings, such as Shutter Priority. This setting allows you to choose a specific shutter speed, and with the reading from the camera's internal light meter, the camera automatically selects the aperture that will create a well-exposed image with that shutter speed.

If you choose a slow shutter speed and max out the aperture (usually the aperture value will blink, indicating that it has reached its limit, and this maximum is not big enough to create a good exposure), you may need to adjust the ISO so you do not have a blown-out image. When shooting motion photography, the Shutter Priority setting is a good place to start.

On some cameras, Shutter Priority may not allow you to set the full range of low shutter speeds available. In this case, Manual exposure mode may be the only mode that gives you access to the longest possible shutter speeds.

ABOVE

With the exposure calculator shown, you first choose a typical lighting situation. Next, select the exposure compensation and the ISO. Finally, you can pick an f/stop and/or a shutter speed. The necessary corresponding shutter speed and f/stop are then displayed below in the blue and green sections.

Aperture Priority Setting

The Aperture Priority setting is similar to Shutter Priority, except you choose the aperture and the camera automatically selects the shutter speed according to the camera's meter reading to properly expose the image. This setting is ideal if you need to capture the maximum amount of light by setting the largest possible f/stop. The camera then chooses the corresponding shutter speed. This is a useful setting in extremely low-light conditions.

Manual Exposure Setting

Once you feel comfortable working with less automated shooting modes and exposure compensation, go one step farther. As an experimenter you gain full control only when you take command of all the settings yourself. Be bold: Put the camera on Manual exposure mode, and set both the shutter speed and the aperture (as well as the ISO). All digital cameras have an internal light meter to indicate if you are overexposing or underexposing the capture, so use that tool to adjust the controls until the exposure is within an acceptable range. Taking test photos will tell you whether your Manual settings are okay.

While it may take some time to completely master, it is the ability to change settings manually that allows you to fully explore the world of experimental photography. Using the Manual controls may seem intimidating at first, but the LCD monitor will help you learn to make the corrections quite rapidly. (You gotta love the immediate feedback of the LCD monitor!)

Exposure Compensation

EXPOSURE COMPENSATION allows you to add to or subtract from the camera's automatic exposure calculations while in various shooting modes, giving you another degree of control. Most cameras will allow you to adjust the overall exposure +/- 2 – 3 stops. When you do this, the photo is consistently darker or lighter than it would have been if the camera had been allowed to make the exposure completely automatically. This is especially useful for experimenting since the automatic exposure often exposes the image "straight."

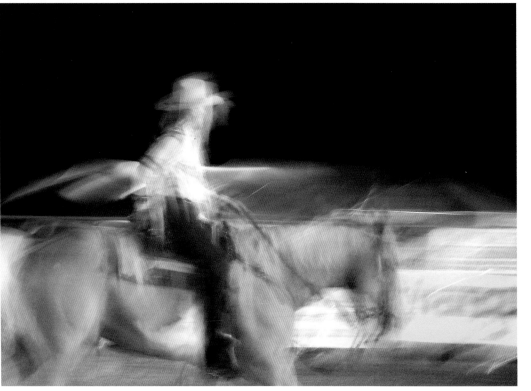

LEFT
Shot under the available light of a rodeo using Shutter Priority, I used the Exposure Compensation feature to lighten the scene, as the camera's normal metering rendered the shot too dark (exposure time: ½ second).

Bulb Setting

As you will find out in this book, you may want to shoot long shutter speeds—maybe 2 seconds, 10 seconds, or even 30 seconds. Manual exposure control is often the best way to do this. You may also try the Bulb setting; this allows you to keep the shutter open for minutes or hours until you decide to close it.

The Bulb setting is only available on D-SLR cameras and some advanced compact cameras. This setting allows you to open the shutter for a time period within your direct control. With this setting, the shutter stays open as long as the shutter button is pressed. You can utilize extremely long exposures with this method, and with enough experimenting, can create some truly remarkable results.

NOTE

If you really want to understand your camera's capabilities, get the specifications, also known as the "spec sheet." Every camera, no matter how basic or inexpensive, has a spec sheet, so finding the technical information for even the most basic cameras should be a piece of cake. To find the spec sheet for your camera, do a web search. (A typical search might be "specifications [camera make] [camera model]".)

Slow Shutter Speeds with a Point-And-Shoot

WITH A POINT-AND-SHOOT CAMERA you may have to resort to trial and error to discover a satisfactory setting. The best way to force a slow shutter speed, for example, is to pick the landscape mode; it sets the highest f/stop, the slowest shutter speed, and the lowest ISO setting (say 50 or 100) because these are usually desirable for landscape photography. Refer to the camera manual or the specifications sheet to determine the lowest possible shutter speed as well as the minimum and maximum apertures.

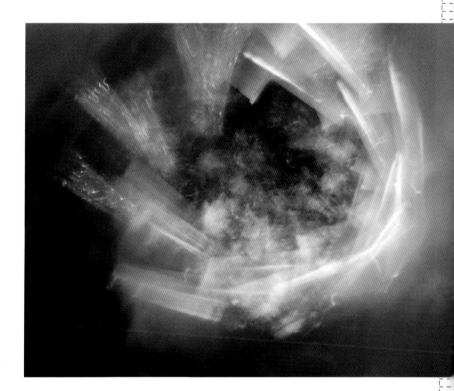

ABOVE
Taken with the Bulb setting, this long exposure of my TV and the window behind it made a kaleidoscopic pattern as I rotated my camera during the shot (exposure time: 8.4 seconds).

Solid focusing techniques are important for all photographers to have, and especially so with experimental photography. In order to break the rules, you have to learn them first. Experimental photographers sometimes produce photos that appear blurred; this effect is created through subject and/or camera movement. To get the sharpest blurry picture—it sounds like a contradiction but it isn't—it's important that the camera be focused correctly. Each point of light acts as a paintbrush, and when taken with movement, that brush should have a sharp point. In other words, you want the subject to be in sharp focus, with a blur effect created solely by motion.

BELOW
Manual focus was essential for this shot, as I wanted to focus on the rain on my windshield; the automatic focus setting originally focused on the landscape beyond the windshield.

Automatic Focus Limitations

The automatic focus feature can be easily fooled. The camera may focus on the wrong object or might just focus improperly. This problem is even more prevalent in low-light situations. Take some time to play with the focus controls. You might spend an hour focusing on objects around your living room, taking a picture, and then looking at the resulting image. Do this in daylight as well as at night.

Try to focus on objects inches or centimeters away and then a few feet (or a meter or two) away. Try to focus using different f/stops to judge depth of field—though with most digital

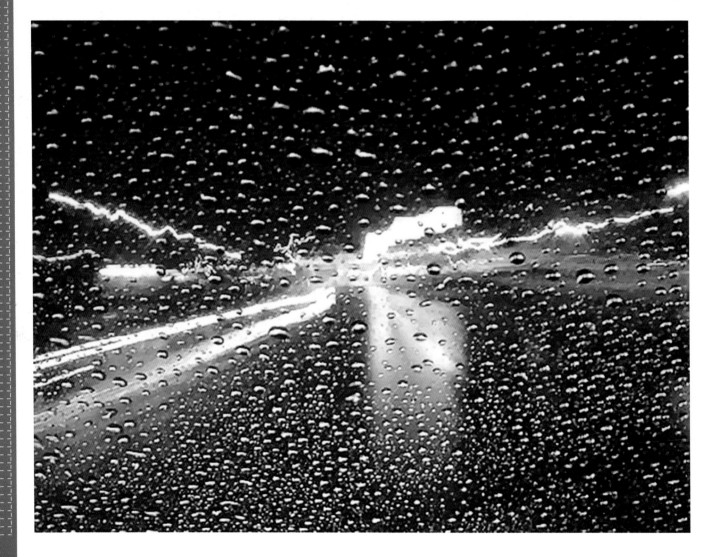

cameras you need to take and review a photo to see the effect of the particular f/stop setting since the preview on the LCD monitor will not show depth of field, unless your specific camera has a depth-of-field preview feature. Focus using different zoom settings, from wide angle to telephoto. When doing a focus test, use a fairly fast shutter speed or even a flash so that you can judge the focus properly and not confuse an out-of-focus blur with a very different blur caused by camera shake (more about this in Chapter 3).

Manual Focus

Many cameras do a poor job of autofocusing in dim light. If for no other reason, you should learn to use your manual focus as a backup plan. You don't want to be caught in a fast moving low-light situation with the automatic focus not doing what you want. To help you manually focus—particularly in low light—many camera manufacturers and some third-party manufactures make replacement focusing screens that are optimized for manual focus and can be installed in your D-SLR. Oddly, in low light, the low-tech solution of simply estimating the distance can be the most accurate way of setting focus. Focus is less critical when using a wide-angle lens and quite critical when shooting at the extreme telephoto focal lengths.

Locking the Focus in Auto Mode

Many cameras will let you "lock in" a focus point when in the autofocus (AF) mode. Typically you press the shutter button halfway until the camera focuses on an object and then, with the button pressed, you move the camera to frame the composition. This method allows you to focus on the object of choice instead of the camera automatically focusing on an object or person that happens to be at the center of the frame. Some more sophisticated cameras let you lock focus for a series of photos. Refer to your camera manual or camera-specific Magic Lantern Guide to see the camera's focus lock capabilities.

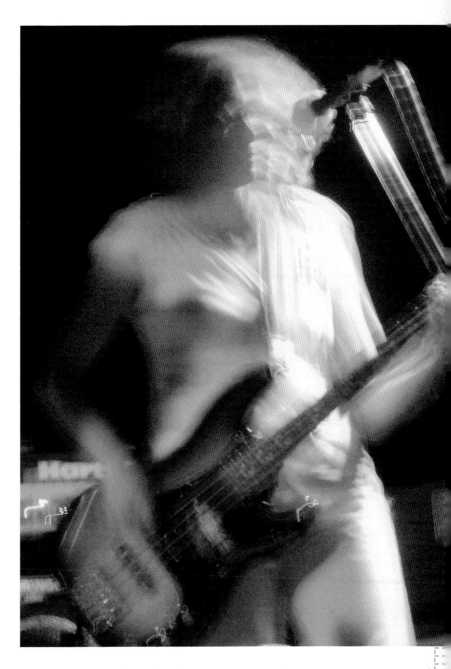

ABOVE
I locked in the focus with this shot because there was enough light for the automatic focus to work properly. I pointed the camera at the body of the performer and then, once the focus was set, moved the camera to frame the picture.

DEPTH OF FIELD

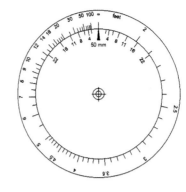

The amount of a frame in sharp focus in front of and behind the subject of your picture is called depth of field. This varies with the f/stop, focal length, and subject distance. The higher the f/number, the greater the depth of field; the lower the f/number, the shallower the depth of field. A good rule of thumb is that there is about a third of the sharp focus distance (for a given f/number) in front of the subject and about two thirds behind.

Understanding depth of field and the zone of sharp focus around a subject for a given f/stop, focal length, and distance is crucial.

Technical Tip: For a variety of technical reasons, digital camera lens focal lengths are expressed in their 35mm equivalent. However, when determining the depth of field you will need to know the effective focal length of the digital camera lens; you can get this information from your camera's handbook, the camera's EXIF data, or online at www.DOFmaster.com.

Focal Length

Given the same aperture, depth of field decreases as the focal length increases and vice versa (see the next page for more on focal length). A wide angle has tremendous depth of field, often from a few feet (or a meter) to infinity even at the lower f/stops, while an extreme telephoto will have a very narrow depth of field.

Distance

In terms of physical distance between the camera and the subject, the closer you are, the less depth of field; the farther you are, the greater the depth of field.

Free Depth-Of-Field Calculators

To really understand these concepts, explore a depth-of-field calculator, such as the one made by www.DOFmaster.com. This marvelous piece of free software allows you to customize the display and print or view a variety of calculators for different focal lengths. If you prefer, you can make the calculations online.

LEFT
The free DOFMaster software lets you calculate the depth of field for various distances, f/stops, and focal lengths. You can even print the calculator and take it with you.

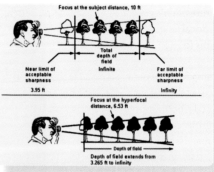

LEFT TOP
The online version of DOFMaster uses pictures to show how depth of field works.

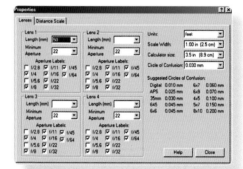

LEFT MIDDLE
The properties dialog lets you customize the look of your depth-of-field calculator.

LEFT BOTTOM
The distance page displays the focus distance, hyperfocal distance, near focus distance, and far focus distance at each aperture.

Digital Cameras and f/stop Range

POINT-AND-SHOOT and advanced compact digital cameras often do not have a great range of f/stops—typically from f/2.8 to f/8. However, D-SLR lenses generally have a much wider range of f/stops from the lowest f/number, such as f/1.4, to the highest at f/22.

FOCAL LENGTH AND ANGLE OF VIEW

Focal length refers to the amount of magnification that a lens offers, and ranges from wide angle to telephoto. For example, a 28mm focal length, which is considered wide angle in 35 mm photography, provides a wider angle of view than a 105mm lens, which would be considered telephoto in 35mm photography. The wide-angle lens includes a wider view of a scene, but renders objects in the scene smaller. The telephoto lens shows a more selective view of the scene and magnifies what it captures. A fixed focal length lens (e.g., 28mm, 105mm) has only one focal length, while a zoom lens covers a number of focal lengths (e.g., 28-70mm, 100-400mm).

However, understanding focal length in terms of angle of view, i.e. wide angle, normal, and telephoto, has become more complicated with digital photography. To keep it simple, I suggest you think in terms of 35mm equivalents, which just about every camera manufacturer also uses since most people have become used to that system (e.g. a 28mm lens is a wide angle). However, the actual focal length may be different for a variety of very technical reasons and which in most cases you do not need to know.

If, however, you are using a 35mm SLR lens on a D-SLR there are additional things you need to consider, so read the sidebar about this on this page.

Focal Length Qualities

It can take time to learn to choose the correct focal length for a particular subject or scene, as each has its own qualities. A wide angle allows the lens to see more and has more depth of field (range of sharpness), but distorts objects close to the camera and tends to make them look farther apart than they really are. A telephoto lens has much less depth of field and tends to enlarge objects in the background and compress them so that they appear closer together.

Working Distance

The term "working distance" refers to the distance between you, the photographer, and the subject. The convenience of zoom lenses allows you to adjust the framing to maintain a certain working distance or to move to a comfortable position and adjust the zoom for that distance. However, you need to know that when you zoom, you are also changing the focal length and a number of things associated with a change in focal length. Many zoom lenses lose optical quality at their longer focal lengths: less light enters a "zoomed-in" lens, and—depending on the lens— the f/stop may automatically change as you zoom in.

Zoom Lenses and f/stops

A zoom lens may come with a basic maximum f/stop listed. But at the far end of its zoom range—the telephoto end—the smallest f/stop may be a somewhat larger number (smaller opening) than the f/stop at the normal range. This is a technical point, but annoying if you purchase one of these lenses, unaware of this quirk. When shopping for a zoom lens, check the specifications to see whether the maximum aperture is listed as a single number or as a range— for example, 4-5.6.

Angle of View

THE ANGLE-OF-VIEW ISSUE (also called field of view) was all fairly basic and easy to understand before the advent of digital photography, but there's one more variable to consider now that there is a multitude of different sensor sizes out there. How much of a scene you capture in a photo using a given focal length— say 28mm—depends on the size of the capture medium. When film was the only capture medium, 35mm film was by far the standard, and a camera that used 35mm film produced a 24 x 35mm negative. That was your frame; no matter which (35mm) SLR you put your 28mm lens onto, you'd get the same angle of view. Now, if you take that 28mm lens and put it onto just about any consumer-oriented D-SLR, you're going to get something different—a magnification factor of anywhere from 1.4 – 2. This means that your 28mm lens will give a narrower angle of view when mounted on the digital camera than it does on the film camera (unless that camera has what is now referred to as a "full-frame sensor"). On a camera with a 1.5x magnification factor, the 28mm lens will produce a field of view identical to that produced by the 35mm film camera with a 42mm focal length lens (because 28 X 1.5 = 42).

ABOVE

The free EXIF Pilot Light displays basic and full EXIF data as needed.

ABOVE

EXIF Image Viewer allows you to browse thumbnails and view EXIF data when needed.

EXIF DATA

In the past, photographers kept notebooks of exposure information and hoped they could accurately match their notes with each negative. Now, in addition to all the wonderful things digital photography has done for photographers, there is the embedded EXIF information saved as part of the image. This info saves the detailed notes about shutter speed, ISO, and aperture automatically when it saves the picture to the memory card.

Cameras are capable of recording virtually every setting that was set when the photo was shot, which can be considerable. For simplicity, you can often read a truncated form of this data in your camera's review mode. Once you have downloaded the photos into your computer, you can read the full list of camera settings. To do this, you will also need a program that can read this data and display it in a way that is useful to you; most image browser programs have this capability now.

The ability to go back and look at this data is especially helpful for experimental photographers, as they can judge the effect of different shutter speeds under the same light or see the difference between two white balance settings for the same scene, for example.

Free EXIF Programs

There are several free EXIF data programs. The more sophisticated programs allow you to sort pictures by EXIF categories, such as sorting a series of pictures from the slowest to the fastest shutter speeds.

- **IrfanView:** This all-purpose program has versatile EXIF abilities that are completely customizable. I also recommend it for editing (see page 168). www.irfanview.com

- **EXIF Pilot Light:** The free version allows you to view and sort EXIF data in columns.

- **EXIF Image Viewer:** This versatile program allows quick viewing of images while looking at EXIF data at the same time.

EXIF Caution

WHEN YOU MODIFY A PHOTO you may lose the EXIF data, depending on the editing program you are using. This is one of several reasons why you should always save the original photo separately, and apply any post-processing to copies of the original.

TOP LEFT
EXIF Image Viewer lets you view pictures both in a filmstrip fashion and as an enlargement while still being able to see the EXIF data when required.

TOP RIGHT
EXIF Image Viewer also lets you access customizable EXIF data in rows and columns. This data can be sorted.

GET COMFORTABLE WITH YOUR CAMERA

The more you play with your camera and the more pictures you take, the more comfortable the camera will feel in your hands and the better your photos will be. Ideally, the camera should become an extension of your body, like a second set of eyes. As you become more accustomed, the gap between seeing a possible photo, picking up the camera, and making the shot will get smaller and smaller until it becomes second nature.

Adjusting Your Camera

With so many options and controls on a digital camera, you should look at the default settings that were set in the factory when you bought the camera, as you may want to change these. For example, you may want to shoot at a higher resolution or a higher-quality JPEG picture setting.

Working Tips

IF YOU PLAN to take a number of experimental photos, arrive early at your location. This will give you time to determine the best settings and to scope out the location. It is often helpful to walk around a place to discover the best vantage points, angles, lighting, and also opportunities (such as being able to climb up a ladder).

KEEP ON TRUCKING

I encourage you to take plenty of photographs. Don't feel that you have to stop at any point if you want to continue. Because you are experimenting, you will be trying things that don't necessarily work, even though you may be experienced. Since digital photos cost virtually nothing, just keep shooting. It is only when you have taken literally thousands of pictures that you will begin to cull the very best ones from your work.

Photography is often compared to painting, since both create two-dimensional visuals. But while a painter works on one canvas for a week or a month or even longer, a photographer shoots hundreds of shots to get the perfect image. Non-photographers are often surprised at the number of pictures photographers take and assume that photographers are using a buckshot approach: if they take enough pictures, something has to turn out good. This is a misunderstanding about how a photographer works.

It might be said that paintings are made from the bottom up; the artist paints a general outline, and then adds more and more detail. This detail can be corrected and changed as the image evolves.

With photography, one entire picture is taken with each shot—it is a top down art form. The photographer must think in terms of whole pictures rather than creating an image with parts and pieces. The odds of getting an entire detailed photo exactly right the first time, at least in a candid situation, are very low. As a result, many pictures must be taken to get that one where all the pieces fall precisely into place.

ABOVE
I took hundreds of photos on this same stretch of highway under different weather conditions to get this one with the right color, composition, and mood (exposure time: 8 seconds).

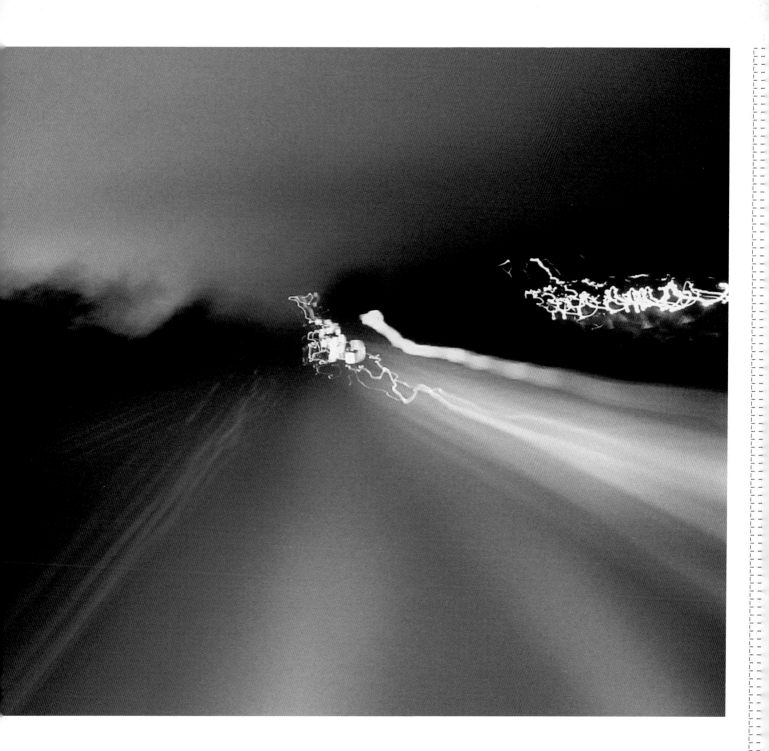

"You see a photograph all at once like a painting."

HENRI CARTIER-BRESSON, PHOTOGRAPHER

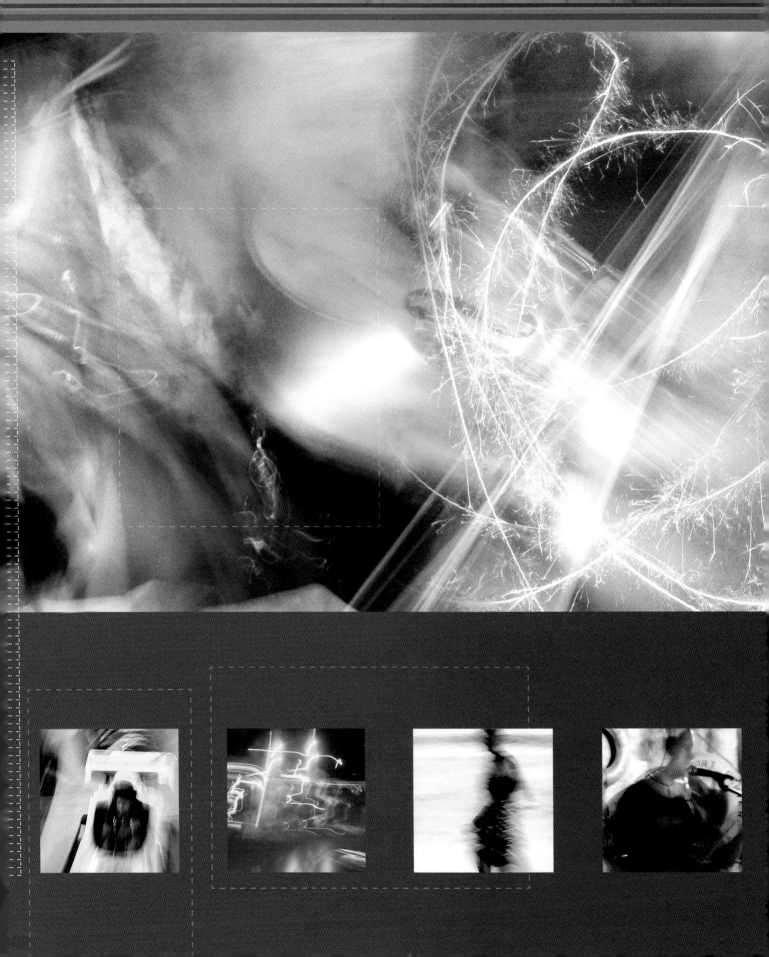

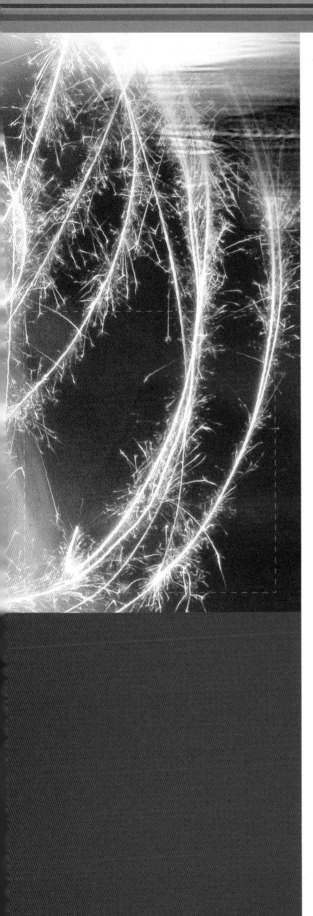

Shooting

AT SLOW SHUTTER SPEEDS

Shooting at slow shutter speeds means taking a photograph of a subject over a period of time. You are no longer taking a snapshot—a crisp, still picture of a moment frozen in time—but rather recording the passage of time, such as the changing expression on a person's face, or their hand gestures.

Advances in photographic technology have enabled photographers to shoot at much slower shutter speeds than were previously possible. This is especially important for experimental photography because slow shutter speeds are such an integral part of shooting experimentally.

"He [Anton Guilo Bragaglia] saw untapped possibilities in photography as a means of experimentation, and was particularly attracted to its potential for capturing the sensation of movement—rather than... sequential stages [as photographed by Muybridge and others]."

AUTHORS CAROLINE TISDALL & ANGELO BOZZOLLA, **FUTURISM**

Learning to master slow shutter speed photography involves artistic choices as well as practical shooting skills. Should the shutter speed be 1/15 second, 1/2 second, or 4 seconds? Images of the same composition taken at different shutter speeds will be completely different. Ask yourself a question: How fast is the subject moving? A fast-moving subject, such as a moving car, doesn't require the slowest shutter speed to convey movement, but a slow-moving subject would need a longer shutter speed to achieve certain effects.

Shutter speed is relative, as is the resulting degree of sharpness. There are no hard and fast rules as to the correct shutter speed, and while there are starting points, you should try a number of alternatives. The best shutter speed depends on a lot of things, such as the amount and intensity of available light in a scene, the aperture setting, how steadily you can hold the camera, and what you are photographing. This is where you begin your decision-making process. But first, you must learn how to shoot at slow shutter speeds, and this means minimizing camera movement.

THIS PAGE
Just the right shutter speed (¼ second) was important for recording the motion of the go-carts, blurring the background, and still creating a clear composition.

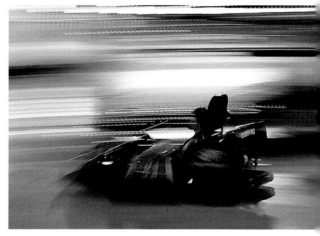

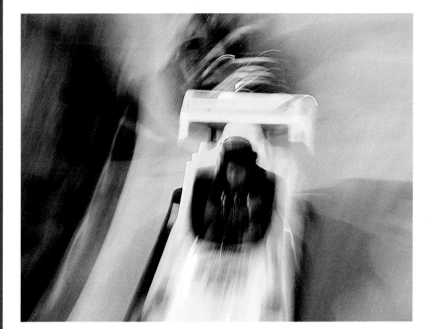

NOTE

Sharpness Is Relative
If you have an image with a very blurred background but a slightly blurred face in the foreground, the face will appear to be much sharper than it really is. This juxtaposition creates the illusion of sharpness. Photographers often rely on this kind of contrast—especially between the subject and background—to create a dynamic image.

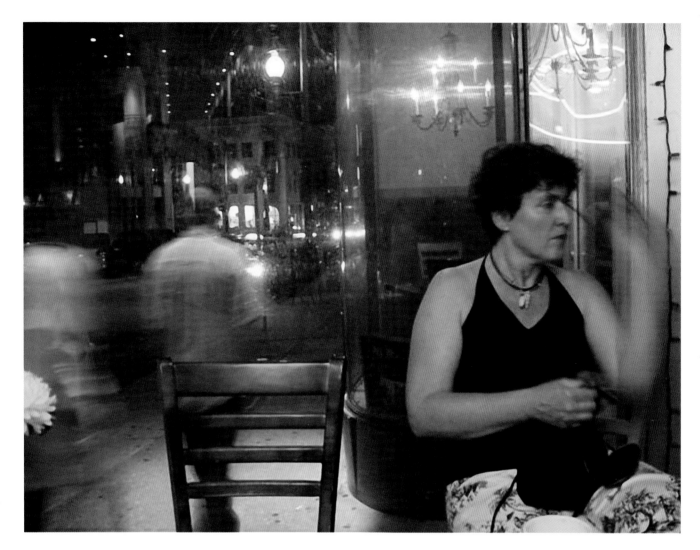

Setting Slow Shutter Speeds

1. **Shutter Priority:** It will give you control over the shutter speed while the aperture (and even the ISO) can be adjusted automatically.

2. **Manual Exposure:** Some of the slower shutter speeds are only available in the manual mode. And even though you will have to set the aperture and ISO, most cameras will alert you to a proper exposure as you adjust those settings.

3. **Bulb setting:** In this mode the shutter stays open for as long as you tell it. This allows very long exposures, but you will have to take a number of test shots as the proper exposure information will no longer be available. This is because with the bulb setting the camera cannot predict how long you will leave the shutter open and thus cannot calculate a correct exposure.

ABOVE
Shot at ½ second, this is a photo of my wife at a coffee house. Because her head and body were not moving, they were sharp, while her left hand was blurred because it was in motion. The people walking outside on the street, however, were completely blurred due to their movement.

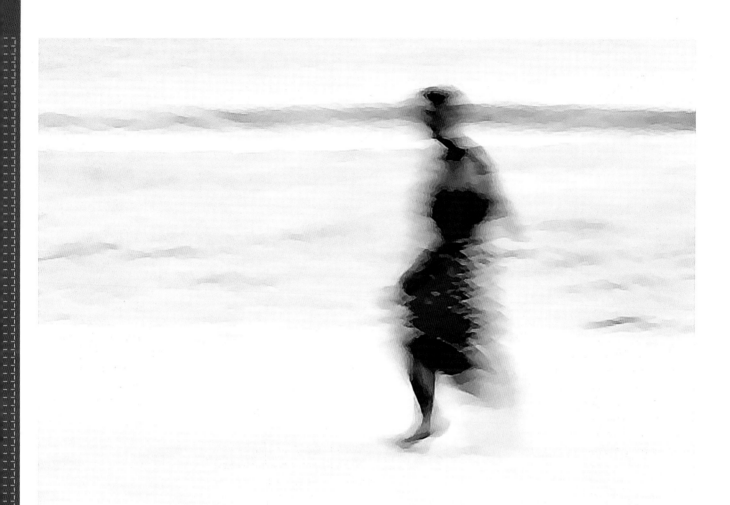

ABOVE
This shot of a person
walking on the beach in
the afternoon was taken
with neutral density filters,
and at 1/8 second.

Shooting Slow Shutter Speeds in Bright Light

If the camera is already set to its lowest ISO, or you want to keep the current ISO setting for some other reason (e g., you're shooting at a high ISO because you're going for a "grainy" look), you'll have to prevent some of that light from ever even reaching the sensor. Enter the neutral density (ND) filter. These filters, which simply block out some light, attach to the front of the lens. They typically come in several gradations, such as 8x (three stops), 4x (two stops), and 2x (one stop). They attach to one another, so you could use all three in combination to knock down the exposure by six stops. Even with these filters, you might still need to set the ISO to its lowest number and avoid shooting during midday.

The Power of the Familiar

INITIALLY IN MY EXPERIMENTS, I decided to work with familiar subjects such as the human figure, people's faces, and automobiles. I thought that if I took these ordinary shapes and distorted them through movement, they would still be recognizable to most viewers. This allowed me to play with these forms along with a wide variety of shutter speeds and camera and subject movements, while retaining the basic identity of the subjects.

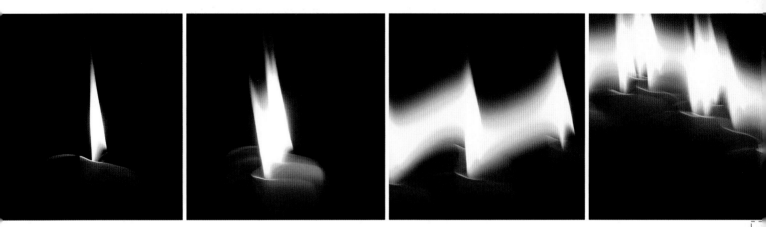

CONTROLLING SHARPNESS AND UNSHARPNESS

There are two kinds of unsharpness—one kind due to subject movement and the other due to camera movement. As an experimental photographer, you should be equipped with the technical knowledge to control the two and use each exactly as you want to achieve specific effects when shooting at slow shutter speeds.

Minimize Camera Shake

First and foremost is the issue of camera shake; camera "shake" is unintentional camera movement that negatively affects image sharpness. If the camera's shutter is open for very long (how long depends on the photographer), the image can appear "shaky." Even though camera movement is a technique you will want to use occasionally (and I discuss this in greater detail in later chapters), you should use it in a controlled way. Some photographers cannot help shaking a camera at a 1/60 second shutter speed or slower, for example, and this shake is usually undesirable. An in-camera stabilizing control can help, but the most important things to learn are how to hold a camera properly and what your own limitations are. As often happens in photography, you may have to find a compromise between the best handholding shutter speed and the shutter speed needed for experimental photos of subject movement.

Tools of the Trade

TO COMPLETELY ELIMINATE CAMERA SHAKE, use a tripod and a shutter release cord; using a tripod ensures a steady platform, and the shutter release cord eliminates any possibility for camera movement caused by pressing the shutter button.

Once a tripod is positioned, however, you tend to become locked into that position with limited options for moving the camera. Naturally, you can just pick up the tripod and place it elsewhere, but this takes time. Nevertheless, some photographers are known for their quick work with a tripod.

Remember, though, you don't necessarily have to go out and buy an expensive photography gadget. Some photographers just place their cameras on a shelf or a table for support.

ABOVE
These candle images were shot at 1/30 second, 1 second, 2 seconds, and 4 seconds. The camera was moved during the slower shutter speeds to create the effect of multiple candles.

"The time at our disposal each day is elastic..."

MARCEL PROUST, AUTHOR

Shutter Speed and Focal Length

Normal handholding shutter speeds must get faster with an increase in focal length. This is because a telephoto lens, for example, magnifies the image as well as the unsteadiness of your hand. The old rule of thumb for cameras with full-frame sensors: Your (non-stabilized) "safe" handheld shutter speed should be close to the reciprocal of the focal length. This is not as complicated as it sounds. For example, while you might be able to handhold a normal 50mm lens at 1/60 (the closest full-stop shutter speed to 1 over 50), you will need to set the shutter speed to 1/250 (closest to 1 over 200) when shooting with a 200mm lens.

D-SLR Technical Tip: With most consumer-oriented D-SLRs, this rule changes just a little. Since the smaller sensor size of most digital cameras effectively magnifies the scene, you must go one stop beyond the reciprocal of the focal length. 1/60 second is safe for 50mm on a 35mm camera; one stop faster than 1/60 is 1/125, so that's what you need to use to prevent camera shake using a 50mm lens on a digital camera with an APS-C sensor. So, find the reciprocal of your focal length and double the bottom number—still pretty easy.

The Image Stabilizing Control

Most digital cameras come with a stabilizing control that you can turn on or off. This control minimizes camera movement, and the default setting is usually "on." The stabilizer may allow you to shoot two to three stops slower than your slowest handholding shutter speed. So while 1/125 second (for a normal lens) is normally the lowest "safe" shutter speed, now with the stabilizer, even a novice might be able to shoot at 1/30 second (two stops lower).

I recommend using the stabilizing control most of the time when shooting handheld. This control will often remove small jerky movements and, even if you are deliberately moving or panning the camera, make your movements much smoother. Of course if you want a jerky effect, you can always turn the stabilizer off to see what the resulting image will look like.

The stabilizer will allow you to control the steadiness of your camera but it will not help with subject movement.

Real-World Handheld Shutter Speeds with a Stabilizer

BEGINNING PHOTOGRAPHER (FOCAL LENGTHS IN 35MM EQUIVALENTS FOR APS-C SENSORS)

- Normal (50mm): 1/30 second to 1/15 second

- Telephoto (200mm): 1/125 second to 1/60

ADVANCED PHOTOGRAPHER (FOCAL LENGTHS IN 35MM EQUIVALENTS FOR APS-C SENSORS)

- Normal (50mm): 1/8 second to 1/2 second

- Telephoto (200mm): 1/30 to 1/8 second

Handholding the Camera

Unlike using a tripod, handholding allows you to move quickly into a situation, and also to move the camera effortlessly in any direction. Handholding is also much less intrusive than using a tripod. If you can learn to handhold the camera in a steady manner, you gain tremendous flexibility in your experimental picture taking. With enough practice, you should be able to handhold for a 1/2 second exposure (with the use of the stabilizer control). Here are some tips and techniques:

1. **Press the shutter button properly:** Although this may seem obvious, the way that you press the shutter button can have a major effect on the quality of your photos. The idea is to move the button, not the camera. This means that you place your shutter button finger slightly above the camera and push down so that only the button moves. You want to move just that finger and not your hand or the camera.

2. **Holding the camera:** Cradle the camera in your hands so that it is resting on one of your hands. With very slow exposures you can add an extra element of stability by resting your left elbow against your chest or side. The trick is to rest the camera on your body using your bone structure rather than trying to hold the camera up with your muscles.

3. **Breathe properly:** Every little movement counts when shooting long exposures, so even breathing correctly can make the difference between a sharp image and a shaken one. Holding the camera as detailed above, take a deep breath, and press halfway down on the shutter button. Release half of your breath and hold it, then gently press the shutter button. Hold your breath until the shutter closes.

4. **Steady yourself:** In addition to knowing how to press the shutter button, you can steady your entire body by finding stable places to work from. For example, if you are standing, try to find a wall or a telephone pole to lean against. The added support of a solid object will make it easier to handhold at slower shutter speeds and it will also prevent fatigue.

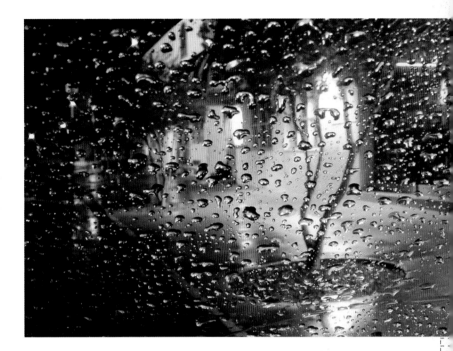

ABOVE
I braced my elbows against the dashboard of my van and focused carefully on the rain on the windshield to get this solid handheld shot taken at 8 seconds.

The Power of Handholding

THE ROAD TO DEVELOPING both the technology and the technique for holding a camera with complete flexibility has been a long one. In 1953, independent filmmaker Morris Engel designed his own 35mm movie camera so that he could shoot his ground-breaking story, **Little Fugitive**, handheld and without a tripod. Francois Truffaut, the French film director, said, "Our New Wave would never have come into being if it hadn't been for the young American Morris Engel, who showed us the way to independent production with his fine movie **Little Fugitive**."

"There is no such thing as inaccuracy in a photograph. All photographs are accurate. None of them is the truth."

RICHARD AVEDON, PHOTOGRAPHER

Determine Your Lowest Sharp Shutter Speed

Test Yourself

This exercise is designed to isolate camera movement as a variable and remove the possibility of subject movement or changing light conditions as variables. This will allow you to accurately assess your handholding capabilities.

In your home at night, place an object under a light—it could be a doll or a pitcher or some other solid object. An object with fine detail is ideal. Avoid things that are flimsy, easily bumped, or that might move with vibration. Set up the light so that the first exposure will be 1/60 second, f/11.

Use Shutter Priority mode—unless you are comfortable with Manual Exposure—to allow the following shutter speeds; Shutter Priority mode will make the corresponding adjustments to the aperture from f/2.8–f/11, depending on your lens' capabilities.

1. Sit at a comfortable distance from the setup described and then take pictures at the following settings.

2. Set the ISO to Auto, and shoot the scene at each of these shutter speeds: 1/60, 1/30, 1/15, 1/8, 1/4 second.

3. Activate the image stabilizer and shoot each shutter speed setting again.

Judge the Photographs

After shooting the pictures, use the zoom control in review mode to view each picture at the highest magnification on your LCD monitor. Look at fine detail for a lack of sharpness. Look at each picture in sequence. A lack of sharpness in fine detail should increase as the shutter speed decreases. The picture at the slowest shutter speed with sharp fine detail is the slowest shutter speed that you can use for handholding without noticeable camera shake.

Next, save these images to your computer. Save them to a folder with a name like "test_shutter_speed." View them in the computer in sequence. Use the free IrfanView software program to view the EXIF data for the shutter speeds you set, or if you took notes while you were shooting you can just use those. Use this program to quickly look at these test photos and identify which shutter speeds were used. Or use a dedicated free EXIF program (see page 168).

Practice Handholding

Every couple of months, repeat the above exercise. This increased skill will add greatly to your abilities as an experimental photographer. With practice, you should be able to hold the camera at least two stops slower than you could in the beginning (i.e., if initially you could only hold a camera steady at 1/30, with practice, you should be able to handhold it at 1/8). With the use of an in-camera stabilizer, you might be able to hold a camera steady at 1/2 second.

LEFT
Shot at ½ second, handheld with a stabilizer, this photograph would have been impossible without an image stabilization feature. The photo is quite sharp, as shown in the enlargement.

Controlled Blur

Panning: Anyone who watches sports is aware of how panning works as a photographic technique. The camera moves in sync with a moving subject, such as a football player running down the field or a racecar driving down the track. When the camera and subject move together, the subject is sharp yet the background is blurred. This is because the subject, even though in movement, is relatively still in relation to the camera while the background is streaked due to the camera movement.

Camera position: The amount of blur in an image depends on, among other things, the camera's position in relation to a moving subject. Movement that is perpendicular to the camera's focal plane—moving straight toward or directly away from the lens—is not as evident and thus needs a slower shutter speed to create a blur effect. Movement parallel to the camera's focal plane—moving from one side of the frame to the other—is much more obvious and can be captured with a faster shutter speed. If, for example, you take a photo of a person walking straight at the camera, the apparent motion of that person is minimal. If, however, you take a photo of that same person, moving at the same speed sideways to the camera, the motion is more evident.

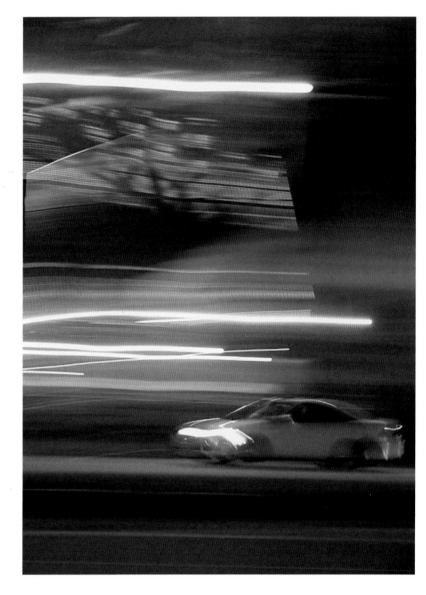

ABOVE

This car is somewhat sharp captured at a 1-second shutter speed, but the panning movement of the camera blurred the background as it tracked the car.

Movement parallel to camera focal plane.

Movement perpendicular to camera focal plane.

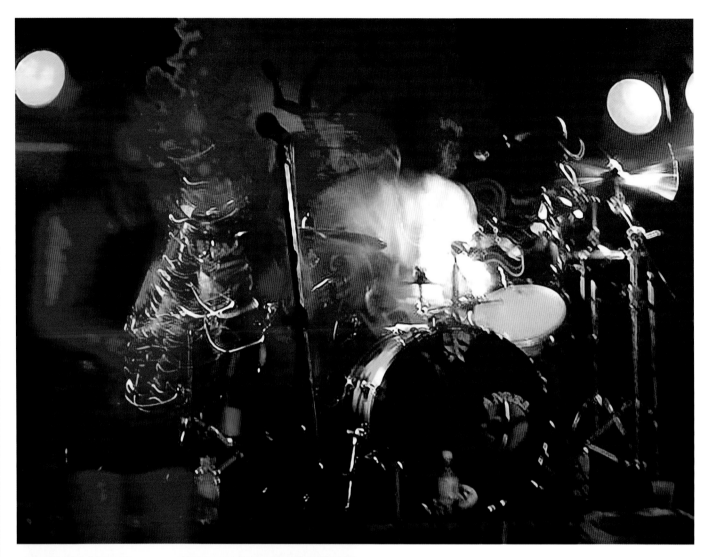

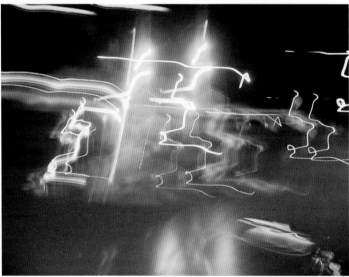

ABOVE
This photo of a band, shot at a 2-second shutter speed, shows their movement under stage lights.

LEFT
The movement of the camera created the blur in this photo of lights in traffic (shot at a 4-second shutter speed).

THE BLANKED-OUT VIEWFINDER

A definite flaw of most digital cameras is that the LCD monitor goes blank while the picture is being taken with a long shutter speed. This actually occurs at any shutter speed, but it happens so quickly that most people don't notice. This problem does not occur in cameras with a separate optical viewfinder, however (i.e., rangefinder cameras).

There is a very low-tech solution. With practice, you will find that this technique works quite well and once you become accustomed, taking long shutter speed photos with a blank viewfinder will not be difficult. The following advice involves switching your concentration from the eye that is looking through the viewfinder or at the LCD monitor to the other eye when the viewing system blacks out. The other eye can now see the actual scene in front of the camera as the timed exposure is occurring. However, if you follow the advice of most experts, you should always keep both eyes open, even when looking through a viewfinder with one eye because the brain tunes out the image in the unused eye. Practice shooting images with both eyes open—as opposed to closing your non-shooting eye—to become accustomed to viewing the scene while the viewfinder is blank. This is especially helpful when panning, because you can follow the subject with your non-shooting eye while the shutter is open.

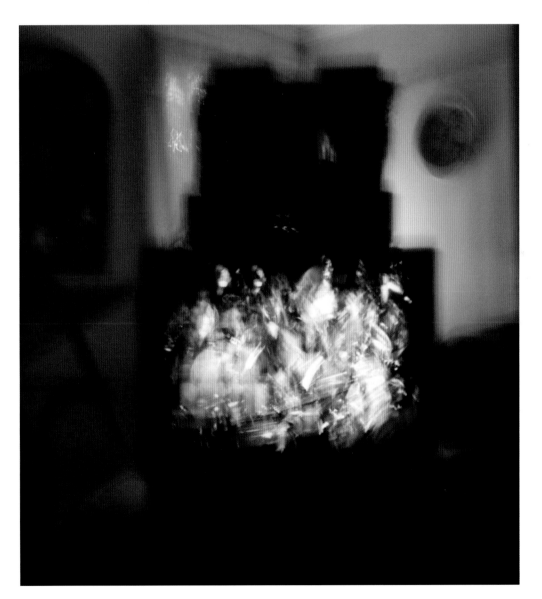

LEFT
When I took this shot of my TV in an 8-second exposure, the LCD monitor blacked out. So I switched my "viewing eye" from my right to my left eye, which then could keep track of the actual scene as it unfolded on the screen.

CAPTURING MOTION

BELOW
Slow shutter speed photography shows the motion of the violinist's playing better than a still, frozen picture would.

For almost two hundred years the goal of photography has been to freeze motion with fast shutter speeds or a fast flash to create detailed pictures of people and objects. Sharp, clear pictures have been and still are the order of the day; most people don't want a blurry photo of a birthday party for the family album. Yet for the experimental photographer there is a range of remarkable imagery and unusual effects that can only be taken using slow shutter speeds.

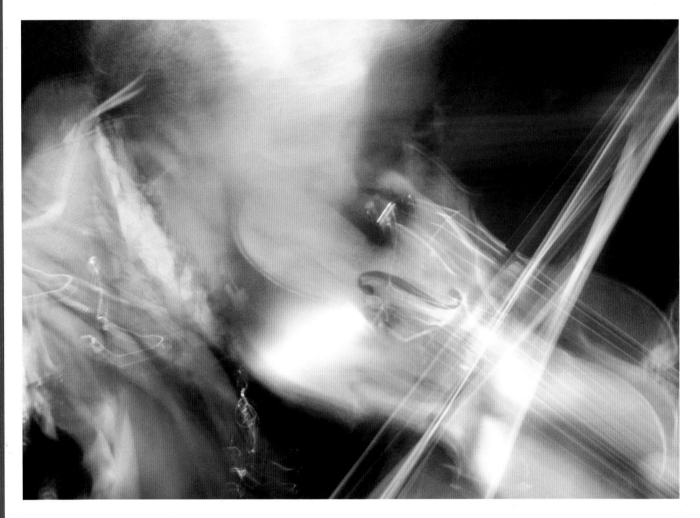

"All things move, all things run, all things are rapidly changing. A profile is never motionless before our eyes, but it constantly appears and disappears."

UMBERTO BOCCIONI,
"TECHNICAL MANIFESTO OF FUTURIST PAINTING"

OPPOSITE
This 13-second exposure of a woman swirling a sparkler at night, shows how digital photography can capture motion in a dynamic and energetic way.

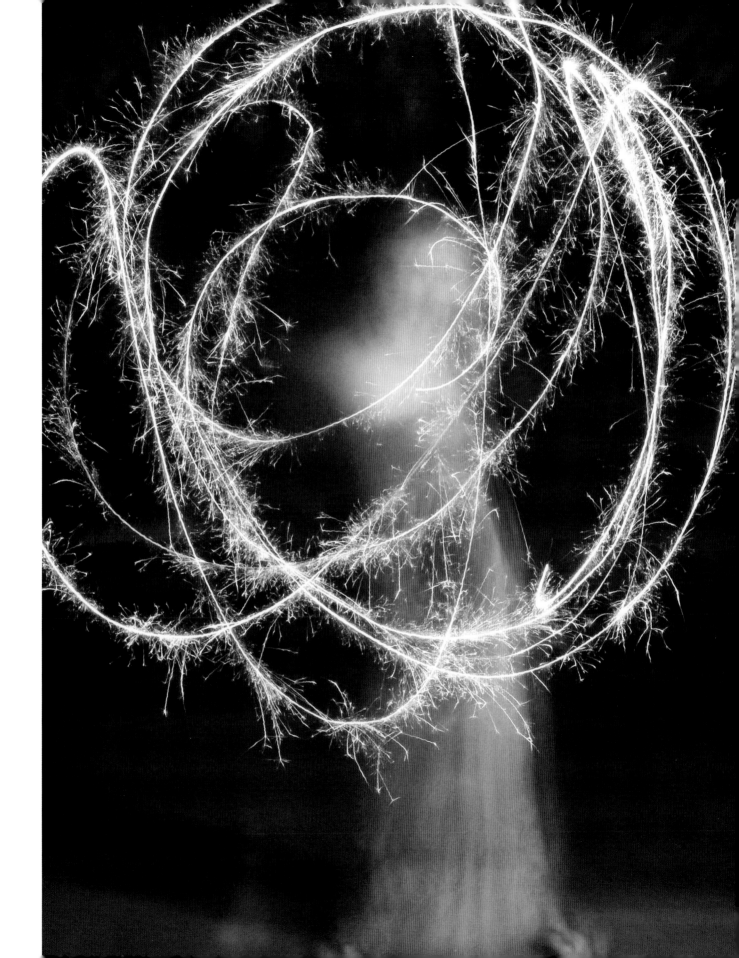

MOTION AND PHOTOGRAPHY

The world is always in motion. Children, traffic, airplanes, football players, dogs in the park, the family at the dinner table, dancers, people who gesture when they talk, trees in the wind, and thousands of other things move. In fact, the real world is in motion all of the time. As a doctor once explained, if a person is alive, they are moving and—he added—a complete lack of movement is a sign of death! So, a photograph that can capture and convey a sense of this movement can be powerful. People and objects (such as cars or trains) in motion can create a dramatic streaking effect not unlike a painter's brush that is swept across a canvas. With bright colors, the effect can be quite painterly.

RIGHT
Shot at 8 seconds, the dim light of an outdoor fire was the light source for this photo of two people standing next to the flames.

"...the most powerful methods of human thought are those that help us find new kinds of representations."

DR. MARVIN MINSKY,
COGNITIVE SCIENTIST,
"THE FUTURE MERGING OF
SCIENCE, ART,
AND PSYCHOLOGY"

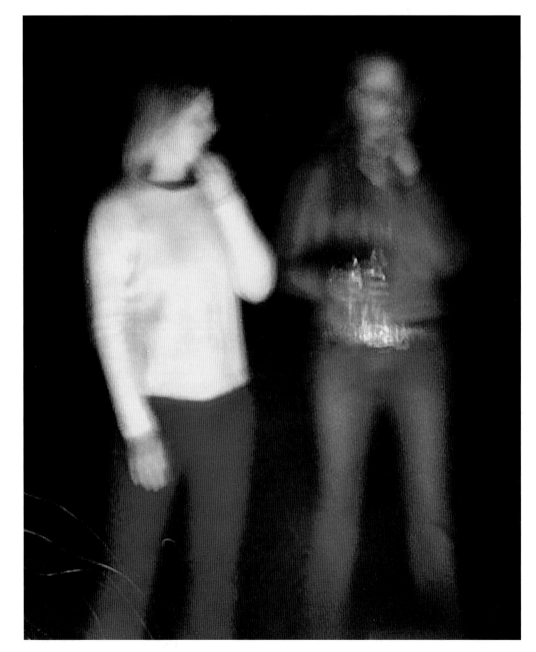

Below 1/30 of a Second

Motion photography was quite difficult and expensive before the advent of digital photography; consequently, very little work was done in this area. Photography of motion with film cameras was impractical without the immediate feedback of the LCD monitor to accurately judge the subtle effects of different shutter speeds with different types of motion under different lighting conditions, and as a result, traditional photographers virtually ignored motion, even to the point of labeling photos that deliberately used blur as flawed photographs. Thus photography, for the most part, has been restricted to shutter speeds of 1/30 or faster unless a camera was anchored to a tripod and the subject was not moving.

However, below 1/30 second there is another world—a world that photography has not studied in much depth. Since there are few photos in this genre, it is a rich area for exploration and there is a lot to be discovered.

Reveal Hidden Worlds

The phrase "exploring new worlds" with digital photography is more than just a metaphor. Experimental digital photography that utilizes slow shutter speeds has the ability to reveal worlds that have not been seen before. This idea is not new in photography. There are many examples of this in photography's short history. The camera can see things that the human eye cannot see and record new worlds at both extremes of slow and fast shutter speeds. For example, when Eadweard Muybridge took a series of high-speed photographs of a horse trotting, he proved that all four legs left the ground and revealed a world that horseriders, trainers, and spectators had not been able to see clearly.

Photography and Time

PHOTOGRAPHY MAY BE THE VISUAL ART best suited to creating still images of subjects in time. This is because a photograph is made by recording an object (via the lens) over time (by opening the shutter for a specific duration). Therefore, a photographic exposure is a combination of space and time, a recording of space and time.

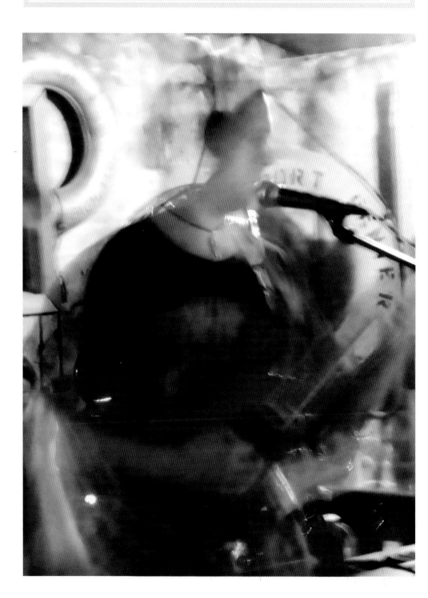

ABOVE
In a 5-second exposure this nightclub guitarist becomes almost transparent and seems to merge with the light background.

Start by Photographing What You Know

When you photograph what you know, you can anticipate many of the moves and be ready to take advantage of your knowledge. If you like football, for example, go photograph a game or scrimmage; the background and lighting are always about the same, and because you know the sport, you can predict the action.

The more familiar you are with an activity, the more you will be able to anticipate both where you should be to get the best photo and just how the subject will move. The more you know about a sport, art, or pastime, the better your photographs will be as a general rule.

"One thing was very clear from Muybridge's pictures: No painter had ever gotten the position of a horse's legs correctly. In fact, many contemporary painters disputed his findings when they were first announced as it meant that their paintings were all incorrect."

EQUINEINK.WORDPRESS.COM

RIGHT
In this 1-second exposure, a fast moving guitarist blurs most of his body and guitar, yet is still clear.

Framing Motion

When it comes to framing, motion photography has its own quirks. Especially in candid situations with subject movement, you may not know exactly how a subject is going to move. Therefore, give the subject(s) more room than you would if you were taking a still photo. You want to give your subjects space to move around within the frame while you are taking the shot. If you shoot at a high resolution, you will have plenty of room to crop if you find you left too much room. While this advice applies mostly to subject movement, I have found that it is a good idea to include a little extra frame room in fast moving candid situations that you crop out later.

Ambient Light and Motion

Because photographs of motion require long shutter speeds, low light and nighttime are often the best times to shoot. So, motion photography requires that you not only learn the technical skills but also that you find situations where you will not overexpose the image. You can shoot in the daylight, but you may have to use a number of neutral density filters to reduce the exposure.

ABOVE
In this 2-second exposure, a musician performs against a white background; his movement creates a ghosting effect around his figure.

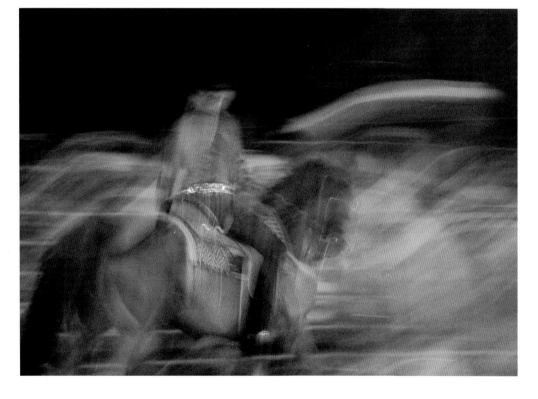

LEFT
Taken under the ambient light of a rodeo at night, this ½-second exposure panning shot captured a recognizable picture of a horse and rider and also blurred the background.

Depicting Motion: A Brief History

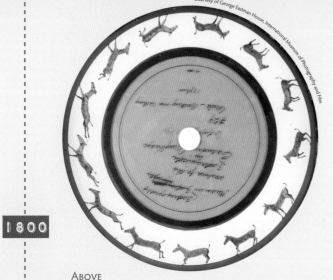

Courtesy of George Eastman House, International Museum of Photography and Film

ABOVE
Eadweard J. Muybridge, **Mule Bucking and Kicking**, 1893

EADWEARD J. MUYBRIDGE (1830 – 1904)
In 1878, Muybridge perfected a method for taking sequential photographs of a horse trotting at a fast shutter speed (1/1000 second). He went on to study human and animal locomotion, and invented the zoopraxiscope, which projected a sequence of his locomotion photos in motion.

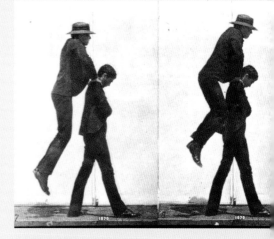

ABOVE
This sequence of "Jumping over boy's back (leap-frog)" is from Muybridge's **Animal Locomotion** series in 1887.

THOMAS COWPERTHWAIT EAKINS (1844 – 1916)
In the 1880s, American painter Eakins developed a system for recording sequential phases of motion on a single negative.

ÉTIENNE-JULES MAREY (1830 – 1904)
In 1882, Marey perfected a system where a sequence of distinct phases of an animal in motion could be recorded on one photograph.

CHRONOPHOTOGRAPHY (1880 – PRESENT)
Muybridge and Marey, in particular, were responsible for inventing the field of chronophotography—the photographic study of motion.

MOTION PICTURES (1893 – PRESENT)
In 1893, Thomas Edison built the first movie studio called the Black Maria or the Kinetographic Theater, used to shoot short filmstrips for the Kinetoscope, an early motion picture viewing device.

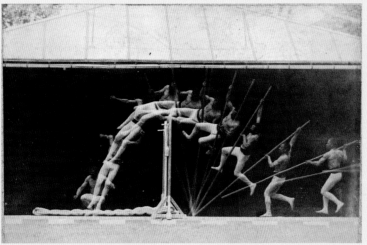

Courtesy of George Eastman House, International Museum of Photography and Film

LEFT
Étienne-Jules Marey, **Chronophotographic study of man pole vaulting**, 1891

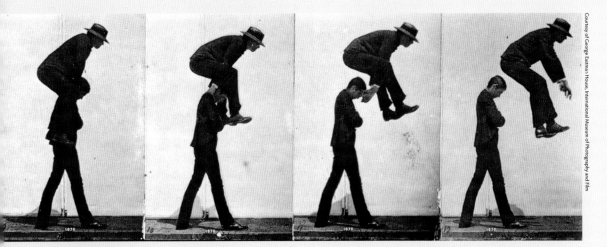

Courtesy of George Eastman House, International Museum of Photography and Film

1900

FUTURISM (1910 – 1914)
The Futurist art movement was a response to the rapidly developing technology of the day, such as automobiles and airplanes. A major aim was to depict continuous movement rather than the images of sequential phases of motion.

ERNST LUDWIG KIRCHNER (1880 – 1938)
From 1908–1914, this German expressionist painter depicted the human figure with a sense of motion.

"BIRTH OF A NATION" (1915)
Motion pictures reached a significant milestone in 1915 with this silent film by D. W. Griffith—one of the first large-budget, full-length movies ever made. After 1915, with the perfection of movies, the desire by artists to record continuous motion in a still image began to fade.

MARCEL DUCHAMP (1887 – 1968)
In 1912, the revolutionary and hard-to-classify artist Duchamp created a sensation with his painting entitled "Nude Descending A Staircase." In retrospect, it is seen as a mixture of the sequential and the continuous techniques for depicting motion in a still image.

ANTON GIULIO BRAGAGLIA (1890 – 1960)
Between 1912 and 1916, Bragaglia, a photographer associated with the Futurist Art Movement, took a number of photos using slow shutter speeds to depict continuous, rather than sequential, motion. He coined the term "Photodynamism" to label these kinds of photographs.

KINETIC ART (1913 – PRESENT)
Kinetic art includes motion. The kinetic movement may have begun with Marcel Duchamp's 1913 "Bicycle Wheel" sculpture—a sculpture in which the wheel of a bicycle was free to rotate. Around 1940, Laszlo Moholy-Nagy completed an important kinetic sculpture called the "Light-Space Modulator" that incorporated movement and light.

HENRI CARTIER-BRESSON (1908 – 2004)
In the 1930s, Cartier-Bresson was the first major photographer to use 35mm film and a small Leica camera with a 50mm lens. He developed candid and street photography into major art forms and added the element of chance to his imagery. Most of his images contain a delicate sense of the moment where viewers feel that they are seeing an instant in time.

HAROLD EUGENE "DOC" EDGERTON (1903 – 1990)
Starting in the late 1930s and for a period of about 40 years, Edgerton pioneered very fast photography, typically using flash and strobes to reveal a world unseen by the human eye.

JACKSON POLLOCK (1912 – 1956)
Around 1950, Pollock created what were called "action paintings" in which he often threw or dripped paint onto the canvas. As a result, the paintings were a record of his movements when he created them.

AARON SISKIND (1903 – 1991)
Around 1953, Siskind created a photographic series of extreme movement that was frozen in time, known as "Terrors and Pleasures of Levitation."

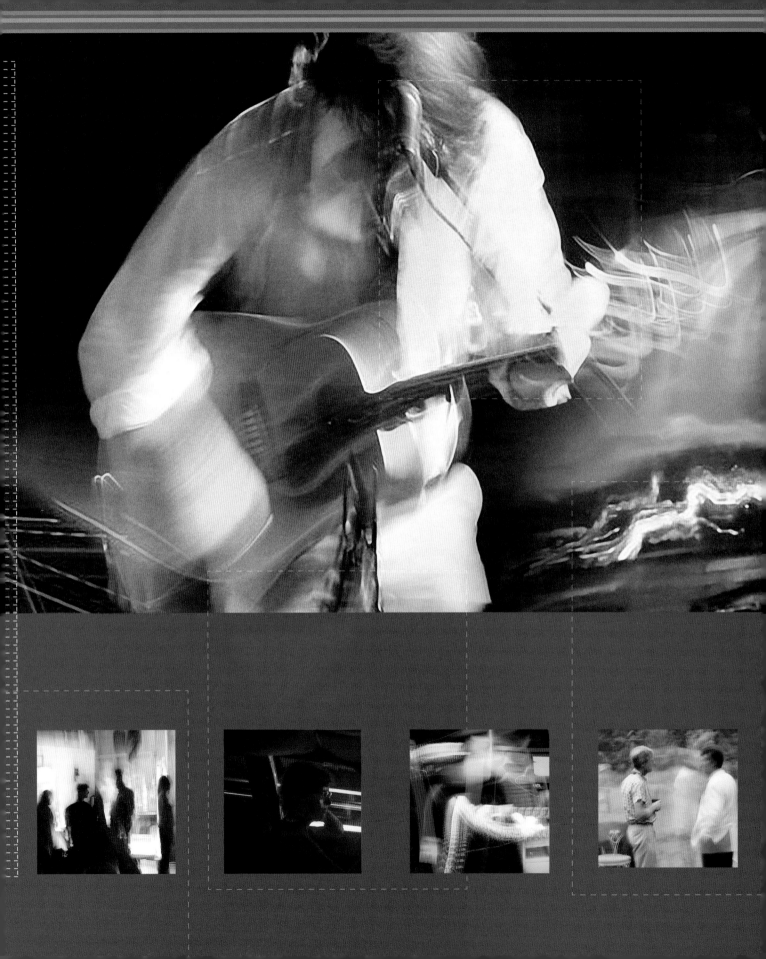

Movement

Shooting at slow shutter speeds means that you will inevitably capture some sort of movement with your camera. There are two types of movement: camera movement and subject movement. You can utilize each—separately or combined—to create original images that convey motion and depth, as well as capture abstract imagery.

Creating Blur Effects

Two elements usually create blur in an image: subject movement and camera movement. Subject and camera movement are often confused. To the untrained eye, a blurry photo is a blurry photo—but the causes of blur can vary. When you understand why a photo contains blur, you gain more control over the imagery that you create.

SUBJECT MOVEMENT

All of us move throughout the day, even when watching TV or working on the computer. Digital photography offers incredible flexibility to record the subtle rhythms of living in ways that convey a sense of the pulse of life. In order to photographically portray this movement, we must use slow shutter speeds as discussed in Chapter 2; this chapter covers a number of specific tips and techniques for doing so.

In photography, a "subject" is the object in front of the camera when a picture is taken and, generally, the reason for taking the photo.

Subject movement refers to anything in the scene that moves during the exposure. This is distinct from camera movement, which involves the motion of the camera (see page 69).

Subject movement blur: Subject movement blur is easy to identify. It happens when one person in a group photo suddenly sneezes. While everyone else in the photo is sharp, this one person is blurred. To zero in on subject movement as the cause of blur, compare one subject to another. If one subject is blurred and the rest of the scene is sharp, the cause is the movement of that subject.

BELOW
Although this photo is complex, the effects are due entirely to subject movement—the fireworks and the rides at this fall festival were all in motion but the camera was still (I shot it at 1 second).

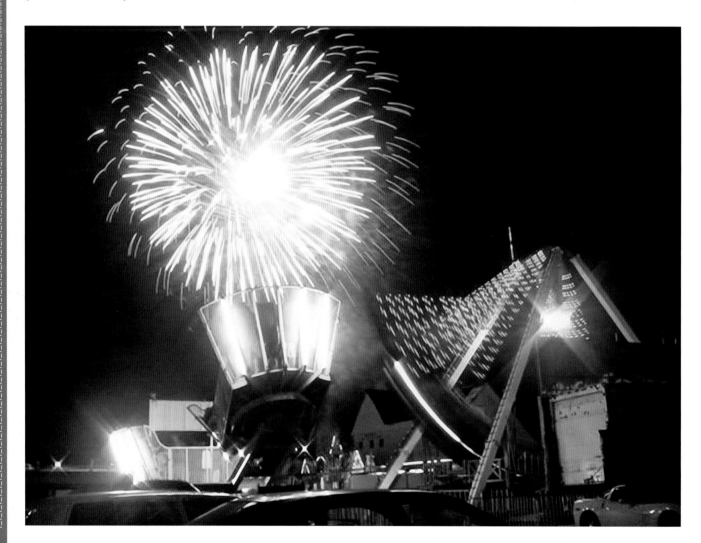

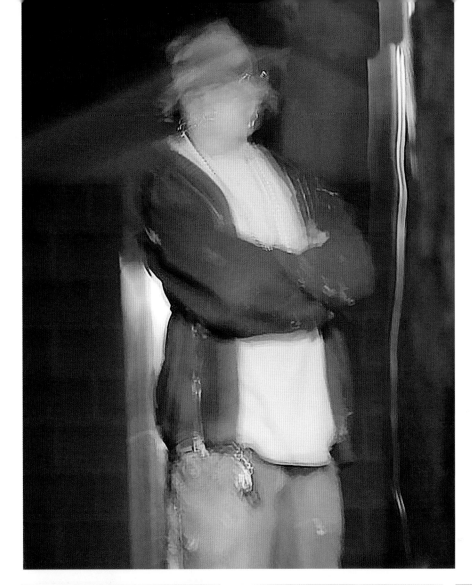

THIS PAGE
These four portraits show how subject movement together with a slow shutter speed can capture as much about a person as a frozen image.

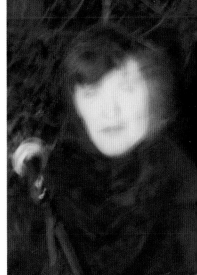

Subtleties of Subject Movement

When you look at the way the world moves, you will notice a lot of variation—some is more predictable than others. Since each situation is different, the shutter speed you pick will depend on a variety of factors: the light, the type of movement, and the predictability of the movement. There is no hard and fast rule—you will simply need to start at some point, take a test shot, review the shot on the LCD monitor, take another shot, and so on, until you begin to zero in on the best shutter speed for the particular subject and situation.

Absolute and relative movement: About 100 years ago, the Futurist artists in Italy attempted to define an "algebra of movement" (Anton Bragaglia), which they wanted to make a part of their artwork. They noticed that with people and many other subjects, there are two kinds of movement: absolute and relative.

- Absolute movement is the general direction in which the subject is moving, whether the subject is a person walking, a dog running, or a car accelerating.

- Relative movement is the internal movement within a subject's motion such as the wheels on a car, the legs of a dog, or the arms that swing as a person walks. So, for example, while a photographer might pan a camera with a walking person so that the person appears sharp (see page 81), the person's arms may be blurred because they were swinging back and forth.

One of your decisions as a photographer will be to chose the appropriate shutter speed for a particular subject's movement—both the absolute and relative movement of that subject.

BELOW
The relative movement of the wheels is very clear in this shot.

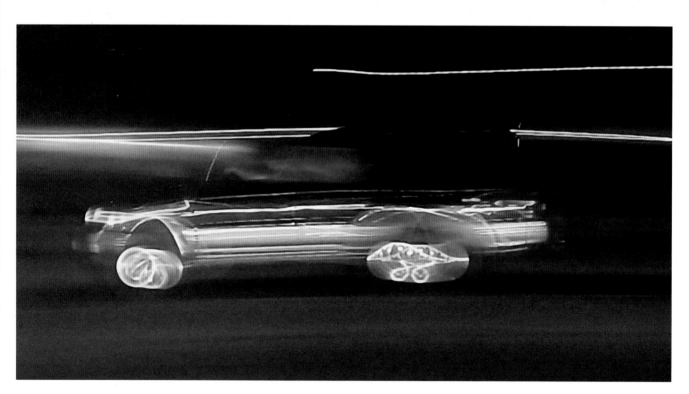

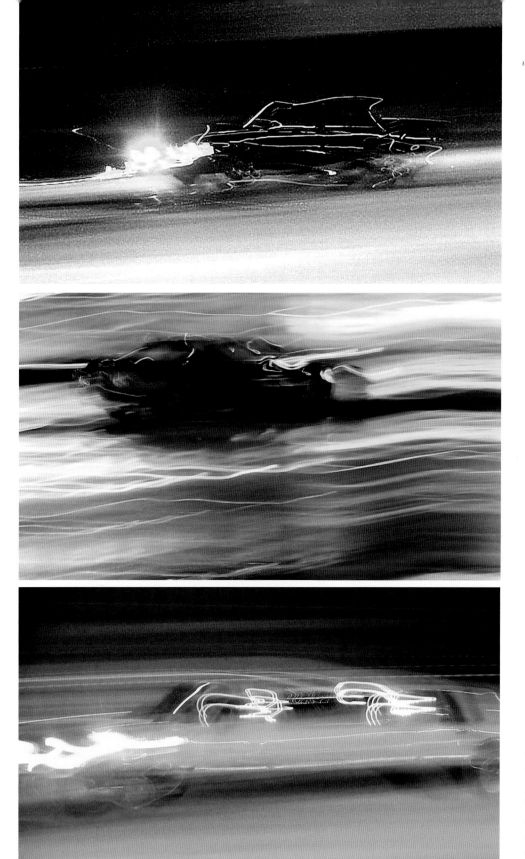

"When you see a fish you don't think of its scales, do you? You think of its speed, its floating, flashing body seen through the water... If I made fins and eyes and scales, I would arrest its movement, give a pattern or shape of reality. I want just the flash of its spirit."

CONSTANTIN BRANCUSI,
SCULPTOR

THIS PAGE
These 2-second panning shots of cars in available light show how the dynamic motion of vehicles can be captured in candid and spontaneous photographs.

Regular movement: Some movement is unchanging, like that of a train; it moves at a fairly steady pace in a predetermined direction. A car's movement is also regular but with some variables, such as swerving a bit to the left or right and slowing down or speeding up.

Predictable movement: Less precise than regular movement is predictable movement. A car heading down the road will continue to head in that direction; a car with its right turn signal blinking will turn right. A first baseman will probably catch the baseball being thrown to him. A dancer doing a traditional dance will repeat the same steps but not in exactly the same spot.

Irregular movement: Some movement repeats but in an irregular fashion, such as a dancer who moves in a free-form manner. Nevertheless, this dancer will repeat many of the same motions and, after a while, a photographer might gain a sense of how that particular dancer is likely to move.

Erratic movement: The movement of a singer on a stage or a child playing with a dog can be hard to predict, however, scenes such as these can yield exciting and unusual imagery.

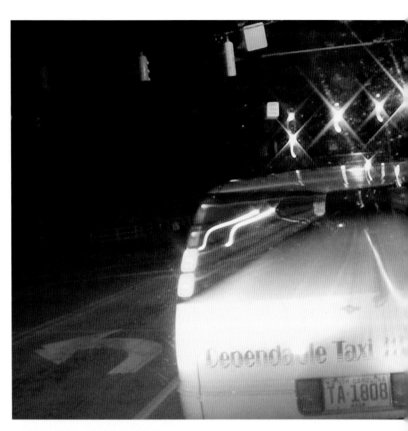

THIS SPREAD
These four pictures show some different ways to photograph brake lights through the windshield of a car.

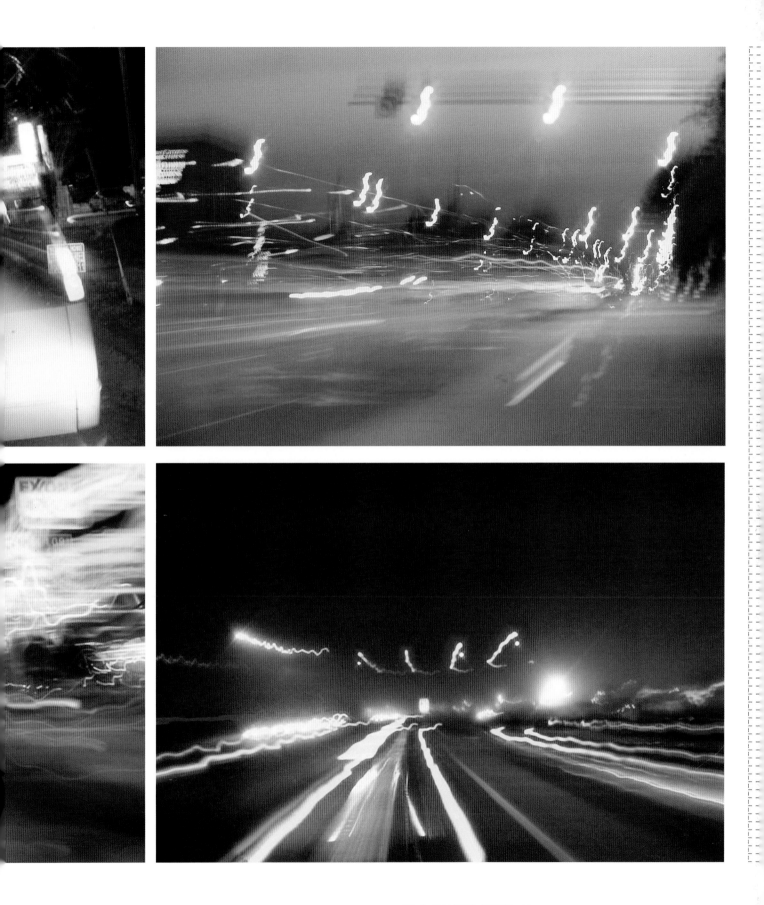

Isolating Subject Movement

For the experimental photographer, subject movement by itself can create a number of visual effects. Slower shutter speeds often produce more abstract, unexpected results. It is easiest to start with a subject that is positioned in one place—such as a man sitting, a woman singing into a microphone, a child playing a video game. In these cases, the figure of the person will be fairly sharp while the movements of their hands, mouth, or face may change. These can produce a blurred sweeping effect or multiple images in part of the photo, so that a picture of a man playing the guitar may look as though that man had four hands. The camera should be held as steadily as possible (or on a tripod) so that the sense of motion will be created entirely by the subject's movement.

Find the right slow shutter speed: With subject movement, the art is to find the right shutter speed to match the movement of the subject, whether it's a person playing the guitar or a car moving at a high rate of speed. If the shutter speed is too fast, it can make the photo uninteresting by "freezing" the movement of the car. However, if the shutter speed is too slow, the subject can be too blurred and even unrecognizable. Between these two extremes are a number of shutter speeds that can depict a photographic sense of motion. At the higher shutter speed end, a person may be mostly sharp but with streaks of motion here and there. At the slower end the person will be streaked and yet parts may still continue to be relatively sharp. This is your choice and a principle artistic control.

THIS SPREAD
This musician was moving so fast, I had to shoot at ¼ second (a relatively fast shutter speed for this type of subject) to avoid blurring the motion too much.

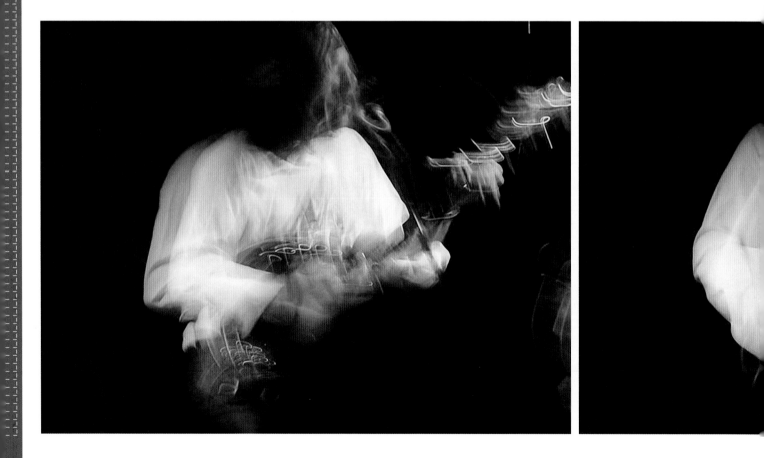

MOVING SUBJECT IDEAS

Find a Local Band: A band might be perfect for learning subject movement. A standard band might include a guitarist, a drummer, a singer, and a bass player. Each of these performers will photograph well but each will have different photographic requirements. The bass player might move very little, for example, while the singer could move a good deal. The drummer might sit in the same spot while his hands might move quickly. And on stage, each musician could be in different lighting.

Traffic: For stunning shots of a city at night, set your camera on a tripod overlooking a highway or busy street and shoot at several seconds. The lights of moving cars, both their headlights and taillights, now become like water in a stream. In a sense the roads turn into rivers of light. The slower the shutter speed, the longer the streams of light will be.

BELOW
The movement of people can be recorded in a variety of ways using slow shutter speed photography.

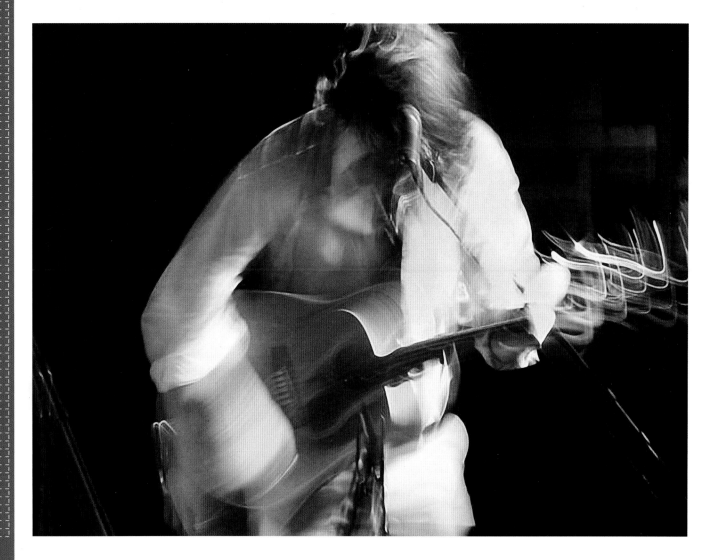

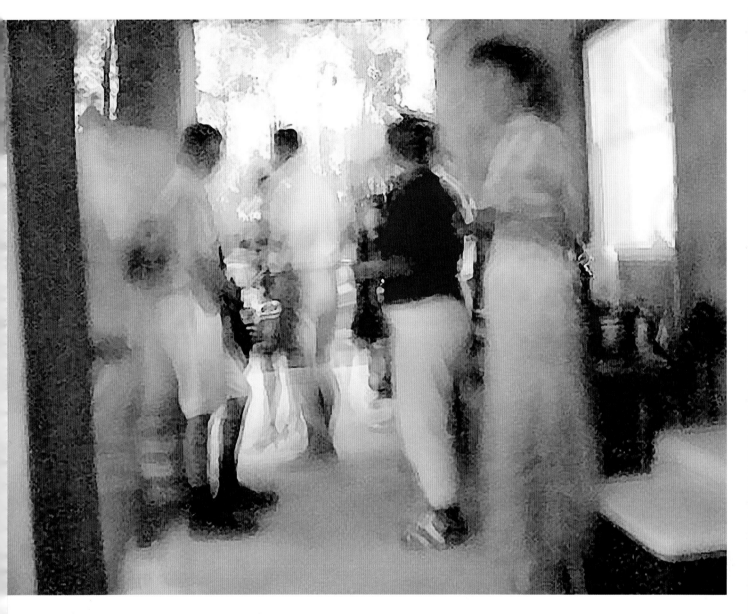

Groups of people can be difficult to photograph with slow shutter speeds due to the different directions of their movements.

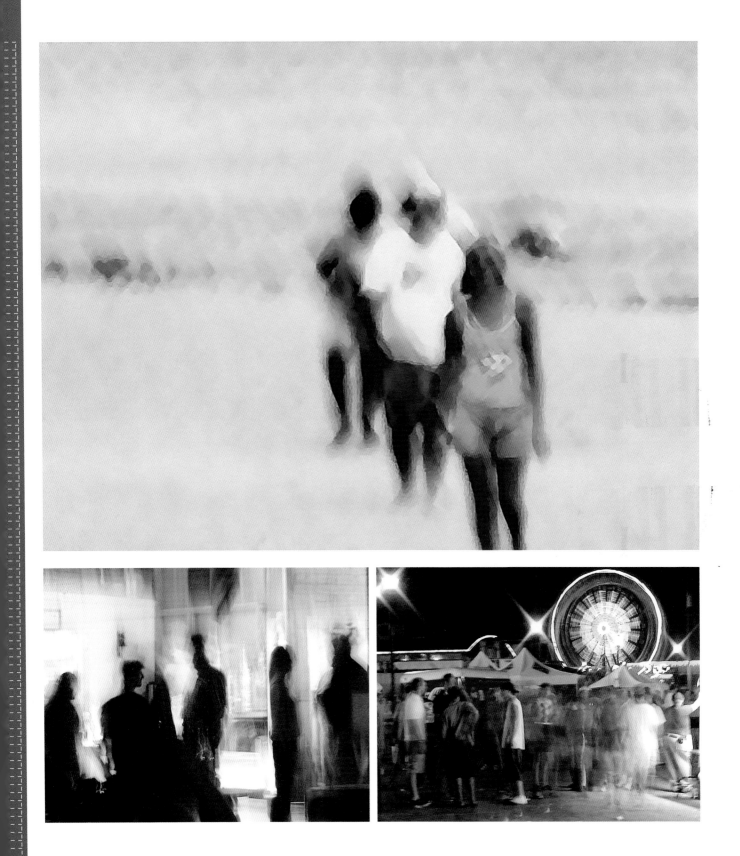

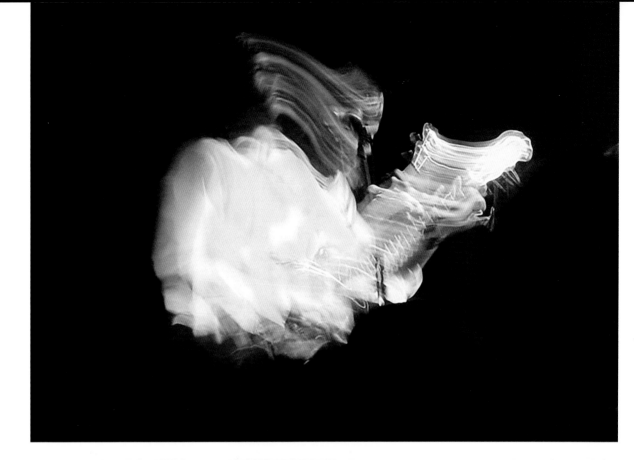

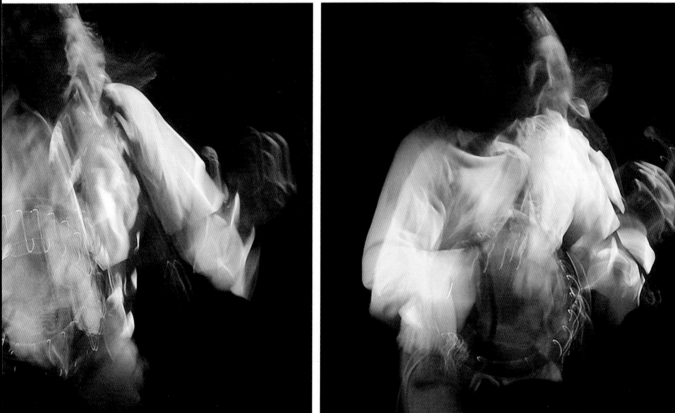

Motion and candid shooting: If you like to take candid shots in public places, but do not feel comfortable photographing people without their explicit permission, subject motion photography has another added benefit. Long exposures will blur the faces and figures of most people so that they are unrecognizable.

When you are taking candid photos, do not be guarded—in fact, you should be just the opposite. Let people know what you are doing and show them some images on your LCD monitor if they are interested. While many may not understand what you are doing, most will not mind the fact that you are taking blurry photographs.

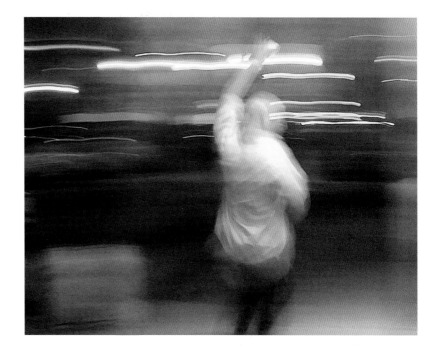

This 1-second shot was taken through the large window of a coffee shop. The panning movement of the camera that tracked the subject created the streaked lines.

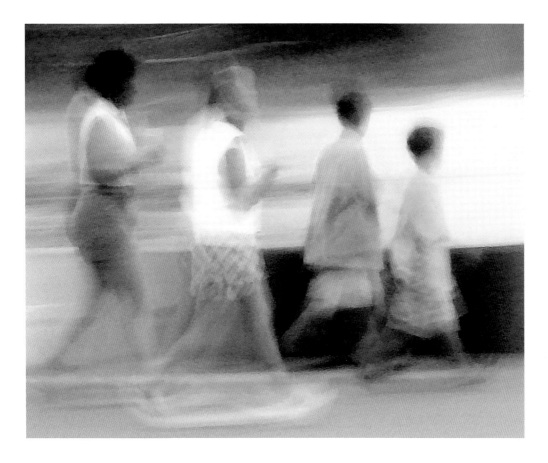

LEFT
This 1-second panning shot of people walking on the waterfront of a coastal town illustrates how a photograph can record a sense of motion in a candid situation.

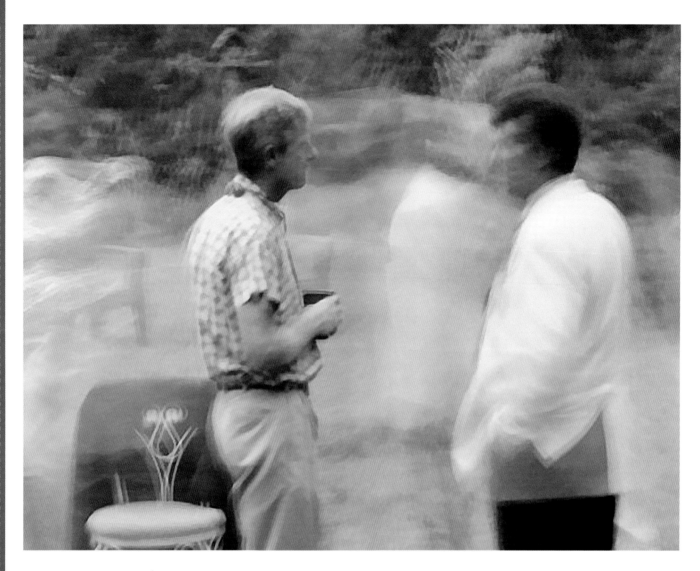

ABOVE

At a lawn party, two men stood talking while the people behind them moved quickly. The effect was that of the people nearly disappearing, leaving only a ghostly smoke. If the shutter speed had been even slower, they would have completely disappeared. This was shot at 4 seconds.

Make people disappear: A favorite photographic trick is to make people in a busy city disappear altogether. How? Easy. Set up your tripod, and set a shutter speed of 1 minute on a street where everyone is walking and no one is standing still. The people will not stay in one place long enough to register in the exposure, so they just vanish, and all that will be left is the buildings and anything else that did not move.

As you will read later (page 131), this same idea works when you are using light painting techniques. If you are dressed in dark clothes and move around quickly, you will never register in the exposure, so you will "disappear."

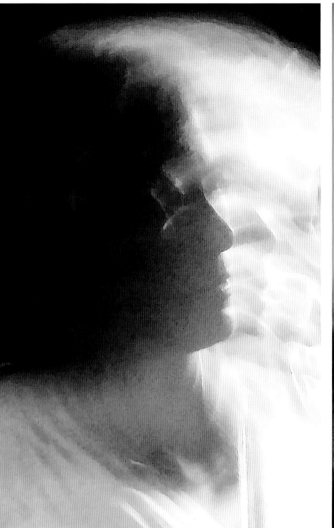

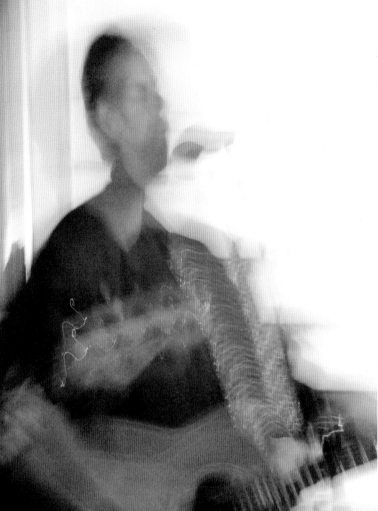

ABOVE LEFT
The dark background of the night allowed this multiple-image ghosting effect when the performer moved her head.

ABOVE RIGHT
This is an example of negative ghosting due to the light background, and it is the opposite effect as seen in the previous picture. The white background erased the performer's movements, except where the man's head did not reveal the white behind him.

Ghosting and negative ghosting:
Dark backgrounds have very different characteristics than light backgrounds in slow shutter speed photography. A dark background often leads to a "ghosting" effect, where multiple motions are recorded. A light background does just the opposite and could be thought of as negative ghosting since portions of the movement can be excluded.

"To me photography is discovering rhythms, lines, and gradations in reality."

HENRI CARTIER-BRESSON, PHOTOGRAPHER

Test Shutter Speed for Subject Movement

This exercise is designed to allow you to isolate subject movement. See also the hands-on exercise on page 72, as that exercise is meant to help you see what camera shake looks like and determine what your own limitations are.

In your home at night, ask a friend to sit next to a table with a lamp. Choose a person who speaks or moves in an animated way. Move the light so that the required exposures are possible. The initial exposure should be 1/30 shutter speed at f/11. When you are taking the pictures, encourage the person to move their hands—talking, playing a musical instrument, or knitting, for example. Since each person's movement will be quite different, do this exercise with other sitters for comparison, if you have the time.

1. Place the camera on a tripod and frame the person so that they more or less fill the frame, taking care to include in the frame any part(s) of them that will be moving.

2. Make the following exposures:
 1/30, 1/15, 1/8, 1/4, 1/2, 1, 2, 4

Judging the Results

Use the zoom control in the review mode to view each picture at the highest magnification on your camera's LCD monitor. The photos should show subject movement without any camera movement. The furniture, walls, etc. around the subject should be clear and sharp.

If you take notes, you might write down what parts of the subject's body he/she moved when you were shooting. Next, look at the photos along with EXIF data—especially the shutter speed setting—to see just how the movement was registered in the picture. Finally, save these images to your computer. Save them to a folder with a name like test_subject_movement so that they're easy to locate.

NEAR RIGHT
This typical test shot was taken at ¼ second and shows some subject movement.

FAR RIGHT
This 2-second test exposure was taken at the same time as the previous test shot and shows much more subject motion and blurring.

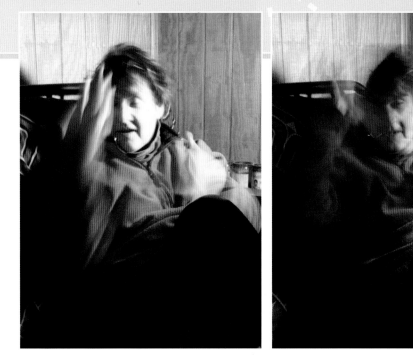

CAMERA MOVEMENT

Camera movement is exactly what it sounds like: the movement of the camera. Until now, camera movement has been generally avoided, except occasionally when panning the camera with a moving subject. In this section you will learn to break all the rules and let the camera move. Yet, as pointed out earlier, you will want the camera movement to be controlled, not jerky or random.

Camera movement shots can be quite unusual. Of course, the pictures you create initially may be a bit of a mess—but not to worry. Over time you will learn different techniques that produce stunning photos.

Like many things in experimental photography, you have a choice of carefully controlled camera movement such as panning on a tripod, or anchoring a camera to the dashboard of your car, or free-form handheld movement, any of which can have considerable variations.

The Difference Between Camera and Subject Movement Blur

Unlike subject movement, camera movement affects the entire photo; everything is blurred. When you zoom in on detail, you will often notice a streaking pattern. If the entire picture is streaked, then camera movement was the cause. The camera moving across the scene causes the streaks, and they occur in the direction of the movement. However, when only one element in a scene, a person for example, has a streaked look, the person moved when you took the photo—ie, subject movement—not the camera.

> "I suppose I am interested, above all, in investigating the golden ability of the artist to achieve a metamorphosis of quite ordinary things into something wonderful and extraordinary..."
>
> EDUARDO PAOLOZZI, SCULPTOR

Beware of Unintended Movement

WATCH OUT for shaky floors, motors vibrating, the wind blowing—the point is to control the movement and avoid unwanted and uncontrollable elements in your images.

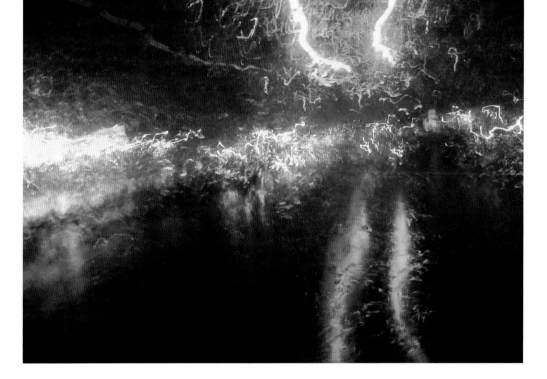

ABOVE
This 8-second exposure of a green traffic light in the delicate drizzle was taken through a van's windshield.

RIGHT

These four shots were taken with a mini tripod mounted on the dash of my van. The rigidity of the tripod allowed the camera to record the straight lines that you see.

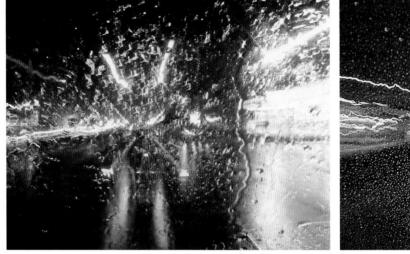

RIGHT

These four photos were shot handheld at 8 seconds through the windshield and side window of my van. The movement of my hand created the irregular lines that are quite different from the straight lines of the tripod shots in the previous series of photos.

Tripods

If you want to move the camera in a controlled way, a tripod works quite nicely. However, pick one with a head that is designed for movement, such as a tripod for a video camera. These heads are often designed with a fluid mechanism that makes panning and other types of camera movement very smooth.

Monopods

It isn't always convenient or even possible to carry and use a tripod. It has three legs, so it requires a certain radius of floor space, and

any good tripod will weigh enough that you'll know you're carrying it. A monopod is a great alternative; it doesn't offer quite the stability of a tripod because it only has one leg, but it comes close. It allows total flexibility of movement while letting the camera rest on a platform that is solidly on the ground. A monopod is also very easy to adjust in a matter of seconds, which certainly beats the minutes a tripod can take to get all three legs in the proper position. When you become comfortable with a monopod, collapsing, moving, and pivoting becomes almost second nature.

Image courtesy of Bogen Imaging

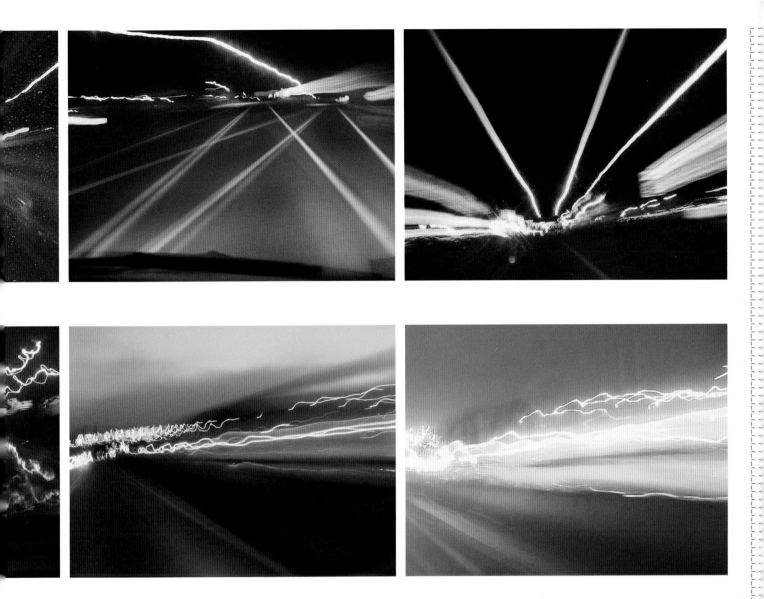

Flexible Tripod

THERE IS A NEW STYLE OF TRIPOD with flexible legs that can be folded around an object in a room (see right) or outdoors. One ad for this type of tripod showed its legs wrapped around a fire hydrant for support! Light, small, cheap, and portable, this could be a good all around solution if you want to always carry a tripod with you. These are typically designed for lighter digital cameras.

Camera Movement

This exercise is designed to allow you to isolate camera movement by taking photos of lights and lighted signs while the camera is moving. It illustrates what you can achieve using camera movement purposely.

Shooting instructions

This exercise requires two people. One person will drive the car, while you, the photographer, will take the photos through the passenger side windshield. This exercise should be done at night. Safety for you and others on the road is always the first priority, so you should be careful not to distract the driver or tell them to suddenly turn in an unexpected direction. Caution and patience are essential.

While the results will initially be hard to visualize, you will soon get the hang of it. In essence, the lights will be drawing exposure onto the camera's image sensor for as long as the shutter is open. This means if you go under a green traffic light while the shutter is open, for example, it will appear as a long, green line starting about the middle of the photo and stretching until it goes above the car or it's outside the image frame.

1. Set the ISO to the lowest possible setting.

2. Use Shutter Priority to access these shutter speeds if possible: 2, 4, 8, and 15 seconds. Some cameras will only let you set those slowest shutter speeds if you set the camera to Manual. Yet, to keep it simple and to get you started, experiment for now with whatever slowest speeds are available to you on Shutter Priority.

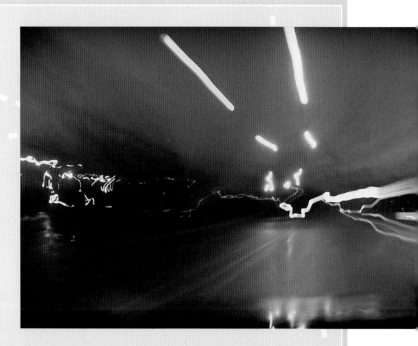

ABOVE
I shot this photo by stabilizing the camera on the dashboard of the car so the lines of the streetlights through the windshield were straight. As a result, the camera movement was limited to that of the car. There was no up and down "camera shake" caused by me handholding the camera. The dashed yellow lines are from a blinking yellow traffic light.

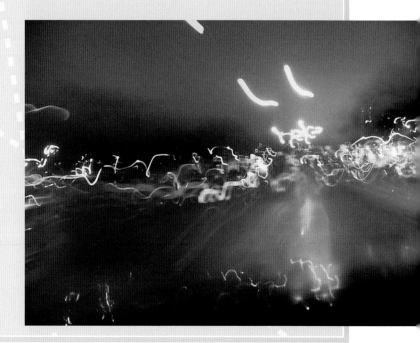

RIGHT
Taken just a few seconds after the previous photo, I handheld this shot of lights through the windshield of my car. This created more complex lines because the camera wasn't as stable as it was when I had it sitting on the dashboard.

NOTE

These settings will vary with the darkness of the night and the amount of ambient light. If the first images are too dark, set the exposure compensation setting so that more exposure is added. If the camera has already set the widest possible aperture and your images are still underexposed, you could change the ISO setting to a higher number, like 400. If the first images are too light, set the exposure compensation setting so that less exposure occurs.

3. Sitting in the passenger seat, handhold the camera and take photos through the windshield using the wide-angle zoom setting and the focus set to infinity. Ask the person who is driving to go to places where there are a variety of lights at night. Stoplights are always a good bet, and blinking lights often produce unexpected "dashed" lighting results.

4. Next, if possible, position the camera on a tripod, or place it on the dashboard or wedge it a bit between the windshield and the dashboard, taking care not to damage the camera. Use books or other shims if needed; place these under the camera so that it can be positioned properly to get good shots through the windshield. Don't worry if part of the dashboard shows or the photo includes the windshield wipers—these can be cropped out later.

5. Make the following exposures: 2, 4, 8, and 15 seconds.

RIGHT
With my tripod anchored in my wife's car, the hood of her vehicle appeared quite sharp in the photo because it was stationary relative to the camera—even though the shutter speed was 8 seconds.

Reviewing your shots

Use the zoom control for your camera's LCD monitor in review mode to view each picture at the highest magnification. When reviewing these shots, compare the ones that were handheld to those that were taken with a more solid support. Surprisingly, a little handheld camera movement can make a shot more interesting by adding a bit of a squiggle to the lines; a very steady shot will result in only straight lines.

Next, save these images to your computer in a folder with a name that makes them easy to locate. View them in the computer in sequence and view the EXIF information using a free software program like IrfanView or Pilot Light.

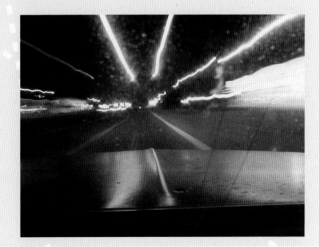

More Camera Movement Ideas

You can test out a variety of camera movement effects by doing one or more of the following:

- After completing the first exercise as outlined on the previous pages, determine which shutter speeds produced the most dramatic imagery and then redo the exercise, only concentrating on those shutter speeds.

- Walk through your home with the camera set to a long shutter speed. Or walk from one side of a room to another.

- Go outside and walk down your sidewalk at night with your camera's shutter open to a long shutter speed.

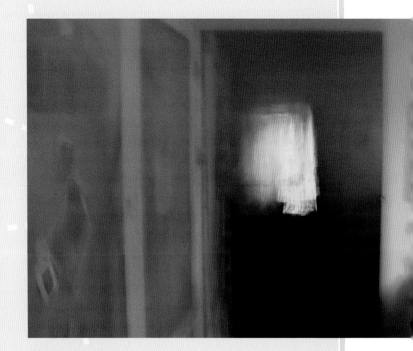

LEFT
I shot this bowl of tomatoes at 8 seconds as I walked around it.

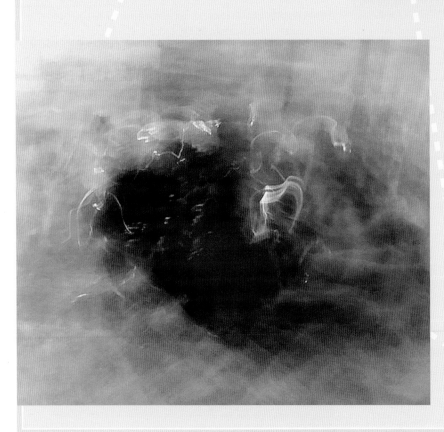

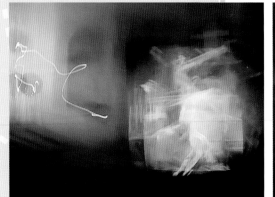

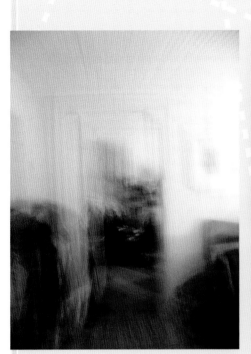
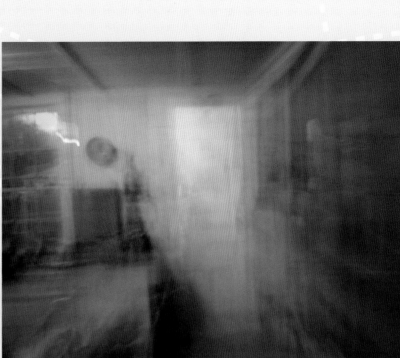

ABOVE
These photos were taken at 4 and 8 seconds as I walked through my home with a camera.

BELOW
In these four photos, I used my TV as a subject. By moving the camera, I was able to abstract the images on the screen.

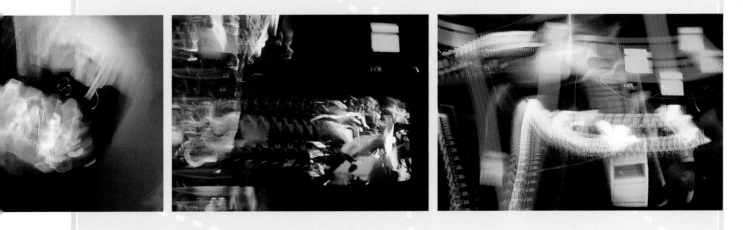

COMBINING CAMERA AND SUBJECT MOVEMENT

Working with both a moving camera and a moving subject brings intense dynamic motion to a photograph when combined with slow shutter speeds. However, for these elements to work together, photographers must be both skilled and tuned into the way the subject is moving. In addition, while concentrating on a moving subject, photographers must also be aware of the world around them so that they don't accidentally step into the path of a moving car and get injured, for example. When both the subject and camera are moving, the odds are against you—you will have to take many shots to get one that works.

RIGHT
I took this shot of my wife as she was driving. Both the movement of the car and my wife's movement can be seen in this shot.

Panning

The most common example of camera and subject movement combined is panning the camera with a moving subject. Moviegoers and football fans have seen this effect thousands of times—yet doing it is a different kettle of fish.

To pan successfully, you will need to move the camera so that it tracks the subject in synchronized motion. This means that the camera is locked into the movement of the subject—and in a perfect pan, the two movements, camera and subject, are in unison. Typically, the subject is a moving car or a person walking or running. And even though you may be tracking the subject correctly (absolute movement) there will still be internal movement (relative movement) such as hands swinging back and forth, which will not be in-sync with your panning.

But wait, there's more. Panning is a bit like a stroke in golf or a swing in tennis. To pan successfully, you should start panning long before you take the shot and continue to pan after the shot is completed—like a follow-through in a tennis swing. Also you should move the camera as smoothly as possible so that there is no unwanted additional camera movement; i.e., no movement other than a close tracking of the subject at precisely the same speed. As you can see, this can take some practice. Use the stabilizer setting to create a smooth pan.

THIS PAGE
I panned my camera with shutter speeds of 1 to 2 seconds to create these candid pictures of cars in motion. I shot these in a downtown area where the cars were moving slowly and the lighting was good.

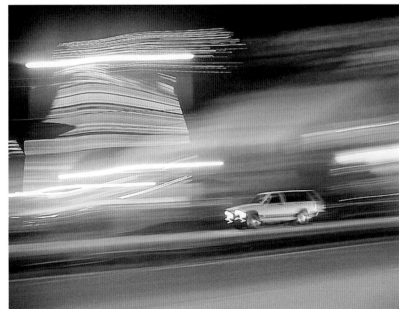

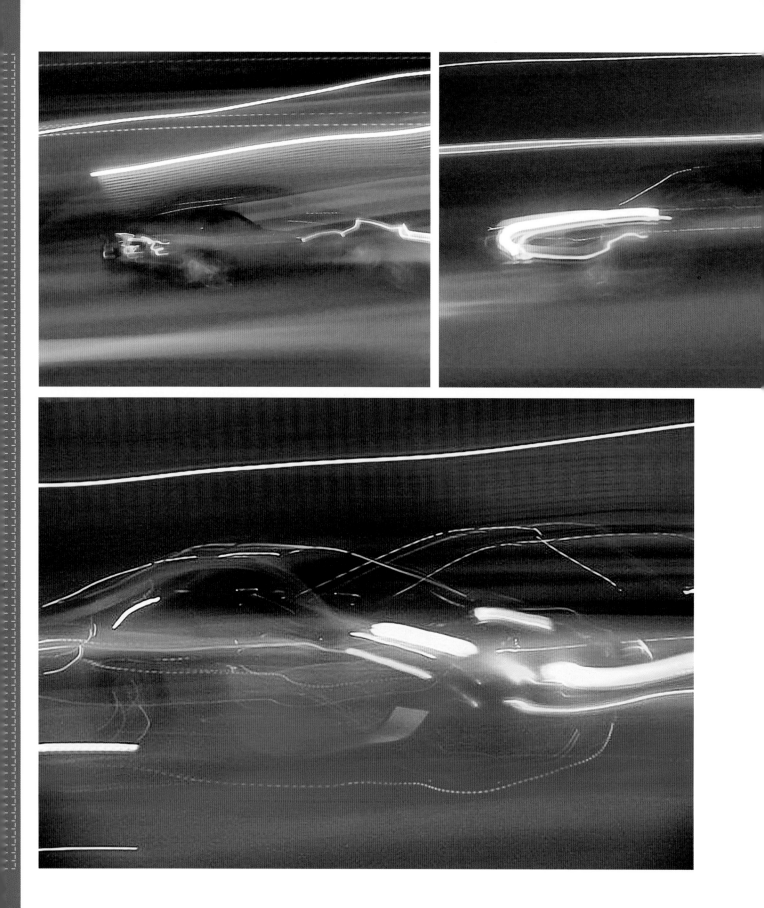

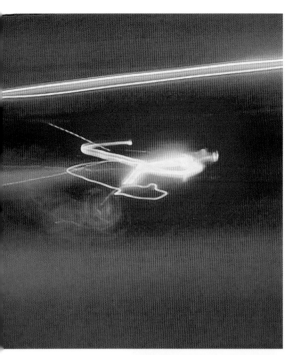

Panning with a Tripod

As with most movement techniques discussed in this book, you can use a tripod. In this case, you can anchor down the camera so that it does not move up or down, but only horizontally. You can adjust the drag on the tripod head so that it moves smoothly and without jerking. Also, a monopod can be quite helpful and versatile in a situation where panning is necessary.

"I kind of dance with the camera in front of the dancers."

MIKHAIL BARYSHNIKOV,
PHOTOGRAPHER,
BALLET DANCER.

THIS SPREAD
These more abstract pictures of cars came about as I looked for new ways to record an automobile in motion.

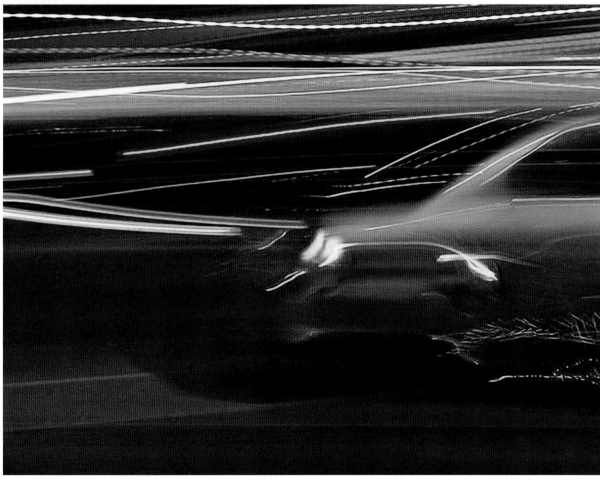

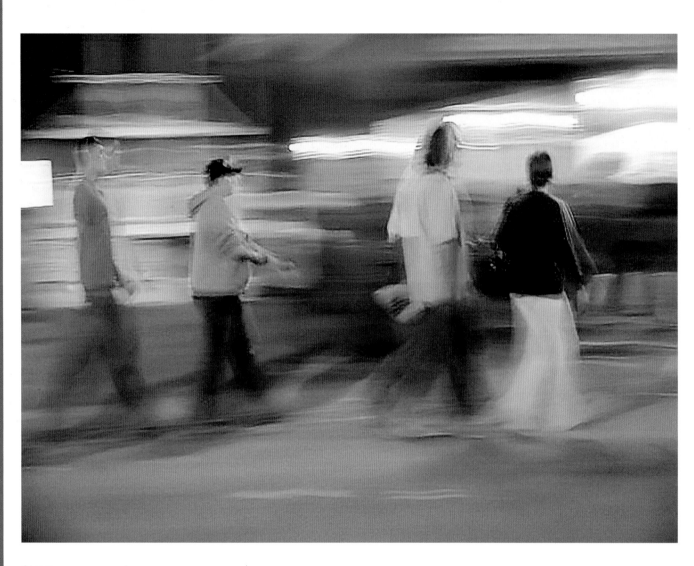

ABOVE
I found a staging area
to take this shot. After
locating a place to sit that
allowed me a view of a
well-lit area with a good
background, I waited for
people to appear.

Backgrounds: In all cases, be aware of the
background and try to form some idea of how
it will look when blurred. In fact, before you
start panning with a moving subject, you can do
some test shots, moving the camera across the
background at different shutter speeds to see
how it will look. Take a minute to do this before
you begin shooting, as the background is very
important to the final image.

Look for staging areas: A favorite technique—
and well kept secret—among many candid
photographers is to find a kind of stage

where the light and the colors are right. The
photographer then waits for people to walk into
this spot. Although it requires patience, many
great photographs are made using this technique.

Moving in rhythm with the subject: While
horizontal panning is the principle way of
combining camera and subject movement,
it is not the only way. A photographer who
understands the movement of the subject,
for example, could try to move in close
synchronization with that movement even if it
went back and forth or up and down.

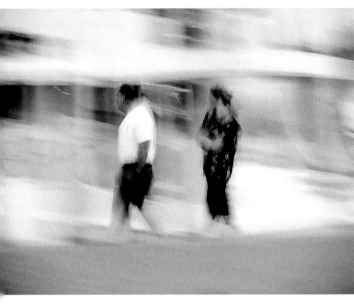

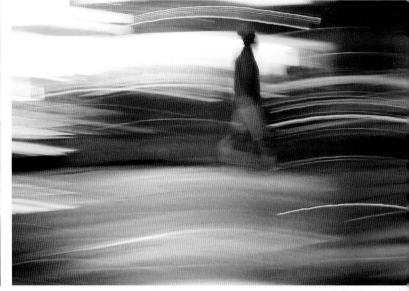

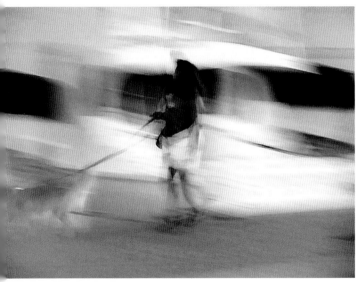

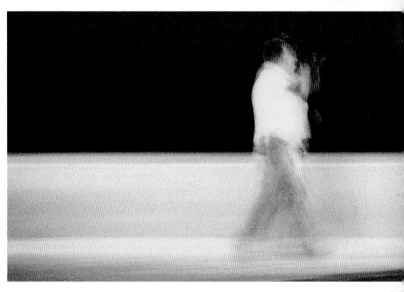

LEFT
In this early self portrait with a simple and low-res digital camera, I held the camera into position so that when I moved, it moved. This allowed my face to be sharp while the background swirled behind me.

THIS PAGE
I panned the camera in these candid shots of people in motion. The background is very important; it becomes the backdrop that the subject(s) are set against.

The French photographer Robert Doisneau had this to say about stage areas, "You get in position and wait for people to appear...it happens all by itself."

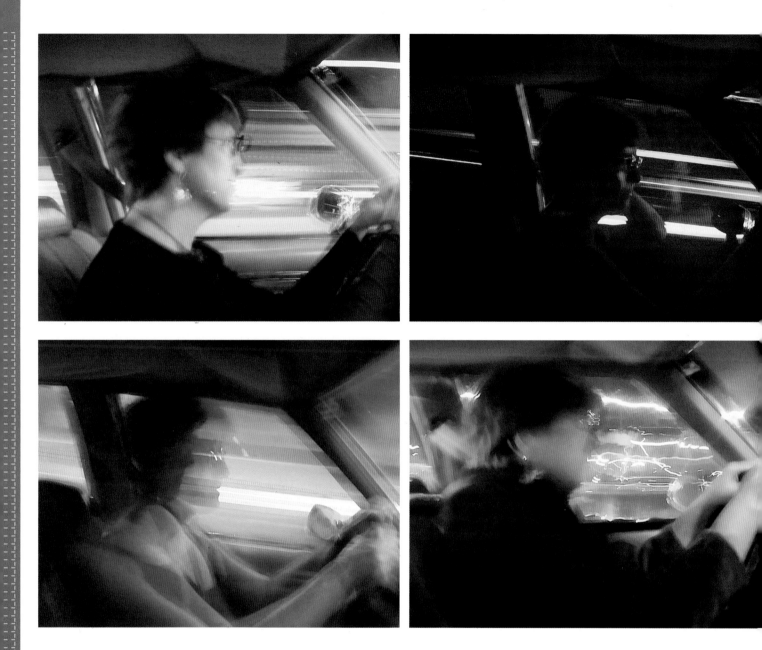

Moving in lockstep with the subject: In some special situations, you may be able to virtually lock the camera so that its position and movement relative to the subject do not change or change very little. For example, when I took the photos of my wife driving, I tried to lock myself into a position so that the camera did not move relative to her. She did move a bit as she drove, but she's basically sharp in relation to the lights that moved behind her as we went down the highway, which were wildly blurred and looked like broad brush strokes.

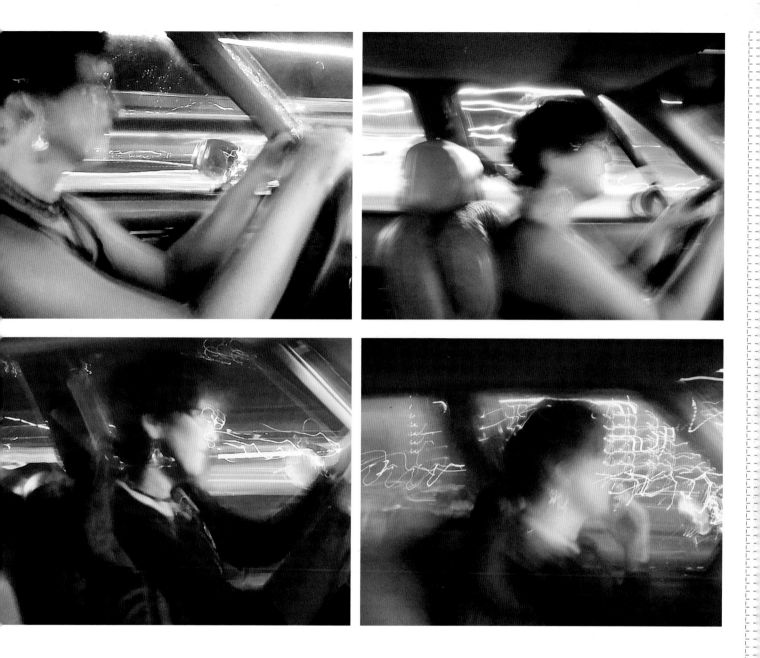

THIS SPREAD

This series of eight photographs shows the possible variety from the same camera setup. I sat in the passenger seat and took photos of my wife as she drove. I held the camera steady so that her movements, as well as the movement of the car in traffic, would create the effects in this shot. The change in color was due to the changing lights of the highway. The shutter speeds used here range from 2 to 8 seconds.

Mixed Subject Movement: What happens when you pan with one person standing in a crowd, but all around that person, people are moving in various directions? Often, the other people turn into a mixed blur while the person featured stands out against them. People moving in the same absolute direction as the principle subject may be recognizable but distorted, while people moving in an opposite direction will be completely blurred. Their movement, in a sense, becomes the background. Mixed movement is an exciting area to explore, with randomness and accident being an important part of the creative process.

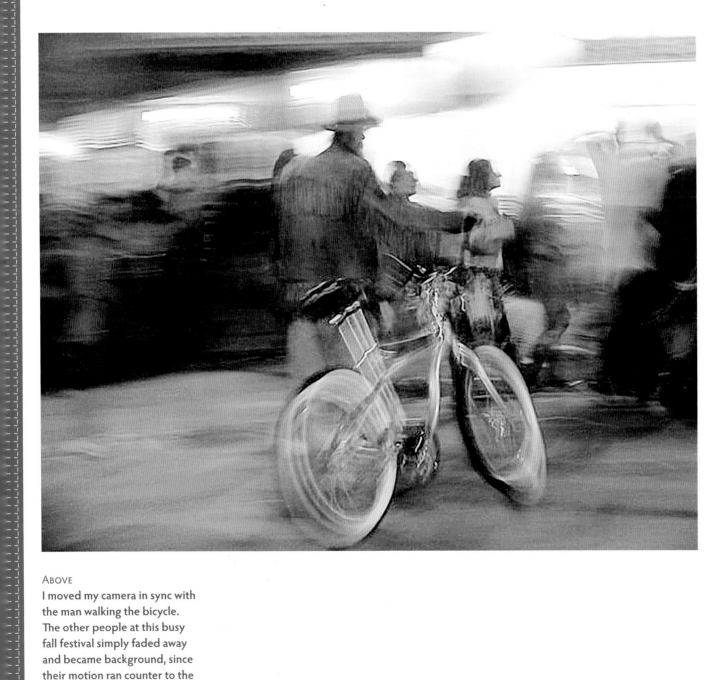

ABOVE
I moved my camera in sync with the man walking the bicycle. The other people at this busy fall festival simply faded away and became background, since their motion ran counter to the movement of my camera.

Panning and Slow Shutter Speeds

Finding a moving subject that you can photograph over and over can be a bit of a challenge. If you have a willing dog or a child, these might be good subjects. Cars are also good subjects if you can find a place where there is a steady but not overwhelming stream of traffic and you can be some distance from the moving vehicles.

You can get some excellent panning and motion shots around twilight. So, photos of your kids or your dog in the backyard at that time could work well. However, keep in mind that twilight fades fast, so you may only have a half an hour to shoot. And, don't forget that during that time, you will probably have to readjust the exposure as the light fades.

Instructions:

1. Set the ISO to its lowest possible setting.

2. Use Shutter Priority and try the following shutter speeds: 1/15, 1/8, 1/4, 1/2, 1, 2, and 4 second(s). Change the shutter speeds according to the amount of available light.

Reviewing your work:

To judge the resulting photos, you will need to consider the various aspects of both camera and subject movement. To begin with, the subject should be relatively sharp since the camera was moving in concert with the subject; and the background should be extremely blurred since the camera was moving against the still background.

Spend a good deal of time looking at these photos in sequence and also viewing the EXIF shutter speed data. A week later, look at this same sequence of photos again. After you have gotten used to the look, you will begin to see what worked best and what did not, and you'll be able to see how you might improve future photos and/or find a better environment for taking these kinds of pictures.

NOTE

When taking photos of cars, try to find a place where you can be some distance away, where the cars will be moving slowly and at a predictable speed, where there are a few streetlights, and where the headlights will not shine directly into the lens. I found a downtown area at night with a number of stoplights and a 20 mph speed limit. I positioned myself in a parking lot next to a park that bordered the main street so that I could take my photos.

Photographer Profile Ted Dillard

"This work is based on the notion that all of the elements of the image are in motion. The camera moves, the subject moves, and individual elements in the composition move in separate ways. The image captured by the camera is about resonance; the elements of the composition that move out of resonance with the camera are rendered as complete blurs over the time of the exposure. The elements that move in resonance come together in synchronous movement with the camera, and those are the elements that appear sharp and precise.

"My explorations of this work started with medium format film and, due to the unpredictable nature of the images, I quickly moved to 35mm out of sheer economy. I would come back to the studio with dozens of rolls of film, often to cull only one or two images. Early on in the process I was experimenting and learning, trying to understand how the process worked and how I could control it, all the while trying to develop the ability to visualize the final work. When I could shoot with a digital camera, it took the work into an entirely new level.

"Digital photography allowed me to see, understand, and direct the process of making the photograph. The work has always been very true to the camera and photographic process, and with digital capture I could use the instant display of the actual image to help form my vision. Rather than waiting for the film to process only to have forgotten the specifics of that image, I could shoot, see, evaluate, experiment, and retry immediately. The result was a leap in my ability to see and understand the entire process.

"For all the tools available to the digital photographer, the simple ability to see the photograph immediately is what makes it a perfect medium for my work." —TED DILLARD

Photo © Ted Dillard

Photo © Ted Dillard

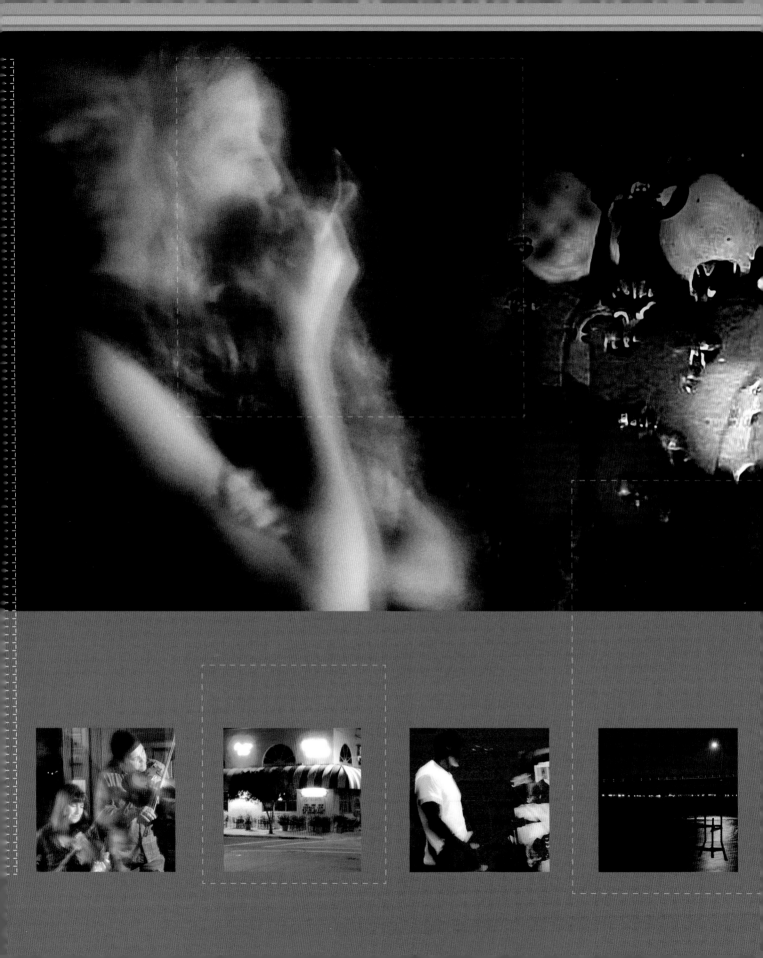

Light
AND WHITE BALANCE

P hotography is the art of light. Photography literally means "light writing" or "light drawing" (from the Greek entomology, "photo" means light, and "graphy" means writing or drawing). And it is because of light that a photographer can capture an image.

Yet the picture-taking ability of photography is so powerful that even seasoned photographers forget it is not the objects themselves that make the photograph, rather the light that falls on these objects. You can take photos of children or buildings or mountains only because light reveals them. Without light, there is no picture.

"You really don't have to know too much in order to be a photographer. What you need to do is simply to look."

ELLIOT ERWITT,
PHOTOGRAPHER

Light has many characteristics—there are entire books on the subject—but perhaps this brief introduction will help.

Intensity: Light intensity is the amount of light in a scene. The amount of light—measured by your camera's built-in light meter—determines the exposure variables of your picture and defines your choices of f/stop, shutter speed, and ISO.

Quality: Light can be crisp and clear, such as sunlight; light can also be soft and diffused such as light on an overcast day. Crisp light creates deep, well-defined shadows, contrast, and bright highlights; diffused light creates softer, lighter shadows and less contrast.

Direction: The direction of a light source is critical. A light that hits your subject or scene from the front produces flat, one-dimensional imagery while a light that is angled from the side creates depth with shadows that give a sense of shape and texture. This is why a flash photo with the flash directly on the camera creates flat pancake type pictures, while a photo with the flash from the side produces pleasing shadows. Light that comes from behind the subject—backlight—creates silhouettes.

Shadows: The opposite of light is shadow. Shadows are extremely important as they can give an object dimension and depth. Shadows can vary greatly depending on the direction and the quality of light. Shadows can be dark and hard-edged due to bright, direct light, or soft and low contrast because of diffused light. The angle of light can create shadows that help reveal the object. For example, with a low angled light the texture of fabric or even pores in skin can be revealed.

Ambient Light: This term refers to the light that occurs naturally within an environment; this can be natural light, such as the sun, as well as artificial light, such as fluorescents in a grocery store. Many photographers try to work just with ambient light in candid situations, for example, since a flash is noticeable and can change the mood of a situation.

Color: Cameras record light very differently from how the human eye sees it. In the modern world, with so much artificial lighting, there are often a variety of colors from different light sources and a number of choices about how to take a photograph in these situations. The following section is about the color of light so read on.

Flash: This artificial light is now a part of most cameras, and is a catchall solution for situations where there is not enough light. However, flash can have drawbacks and limitations as well as being a convenient light solution. We discuss this further on in the chapter, so read on.

Mixed lighting: More often than not you may have a number of light sources with different intensities, qualities, directions, and colors. In fact, just one light source can produce pictures with too much contrast or with little sense of dimension—especially if the light source is limited, or you are shooting in low light—so more than one can be desirable as well as challenging.

Photographer position: If you are in a situation where the light is not good, move around a bit. Often moving to one side, for example, will produce a much better picture since your relation to the light hitting the subject changes.

OPPOSITE

These two photos of an outdoor fire were taken just seconds apart, the only difference being the white balance setting. The natural color of the firelight is an orange hue, but altering the white balance creates a color shift.

BELOW

This shot shows three different colors of light. Notice that the brightest areas of light are white in all three cases, but the color of the light can be clearly seen as it moves further from the light source.

If you are unfamiliar with the way cameras record the color of light—the different colors that various light sources can produce —it can be a bit confusing. Our eyes adjust automatically to the color spectrum emitted from different light sources, but the sensors in a digital camera "see" the light's color as it actually is, and reproduces that in an image quite distinctly.

Part of the reason you may not notice the color of light is because the human eye tends to focus on one area of light and then see that light's color as white. Yet with some practice you can learn to see colors of light as the camera sees them. A helpful place to start is by looking at what the light falls on, not directly at the light itself; the actual light source will almost always appear white. The light that hits the side of a building or on an object can give you a sense of the light's color because the falloff light is dimmer than the source itself. The dimmer the indirect light, the more distinct the color will be.

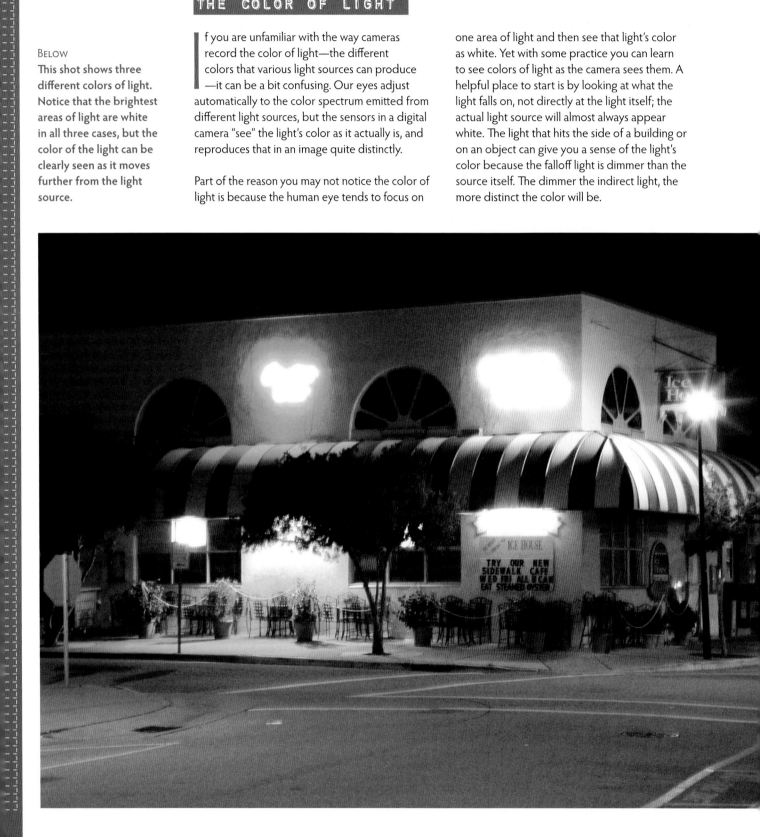

Warm/Cool Colors

Artists often talk about colors in the general terms of warm and cool colors. Red/orange/yellow colors are considered warm and blue/green colors are considered cold. Opposing warm and cool colors is an effective and simple way to work with the color of light.

Complimentary Colors

Powerful color compositions often deal with what are known as complimentary colors—colors that are opposite one another on the traditional color wheel. These colors set each other off such as red and green, yellow and purple, and blue and orange. In fact complimentary colors appear brighter when they are next to each other.

Blue and Orange

After many years of experience with photography, I have found that blue/orange complimentary colors are easily found and can be played with in the same way that painters play with their palette. Late afternoon sunlight, incandescent light bulbs, and candles are on a continuous blue-orange scale. This scale is known as the Kelvin scale, and measures the color temperature of light in degrees Kelvin. While this scale applies to many common light sources, it does not work for all—such as neon and fluorescent.

Some blue light is bluer than others, and some orange light more orange than others. Overcast daylight is bluer than sunny daylight, for example, and candle or kerosene light is much redder than standard house bulbs. So if you set your white balance for standard house bulbs—the incandescent light setting—the light from these bulbs will be white but light from a kerosene lamp in the same scene will still be orange. (See page 101 for more on white balance.)

Some digital cameras include a blue to orange adjustable color range setting. With this feature, you can fine-tune how the camera's sensor records the color of light further than a preset white balance setting. This means that after selecting the white balance incandescent preset, for example, you can further adjust the white balance towards the blue side of the range if the scene is still too orange; you can also use the blue to orange range setting creatively to add more orange or blue to the image as well.

Where To Find Blue/Orange Light

Examples of Blue Light
Overcast cloudy daylight
Open shadows outside
Bright sunny outdoor light
The light from a flash
Examples of Orange Light
Candles
Kerosene lamps
Bonfire
Very early sunrise or sunset
Standard house bulbs
Halogen lights

NOTE

A Study in Blue/Orange: If you want to see a classic example of how well blue/orange lighting can work—frame after frame—watch a DVD of the old western movie, Shane.

Different Colors of Light

The modern world is full of a variety of different light sources; in a word, mixed lighting abounds. In film photography, different colored lights were a constant source of aggravation. Now that digital technology has enabled photographers to directly adjust how the camera responds to the color of light, it can be an exciting and creative element to work with.

Experiment with Mixed Lighting

MIXED LIGHTING can be an experimental photographer's dream. In fact, the different lights are similar to a painter's palette and experienced experimental photographers can use those light sources to "paint" their composition. Look for places with mixed lighting, because you can use these to play with the different colors by adjusting and readjusting the white balance to see what kinds of effects are possible.

THIS SPREAD
The lighting available in clubs and stage setups often provides interesting scenarios for working with mixed lighting.

HANDS-ON EXERCISE:

Mixed Light Sources

- Ask permission to take photos at the local video arcade. You will find a variety of colors there.

- Play with the cloudy daylight—which has a blue cast—coming in through a window and the orange light cast by standard house bulbs. Around twilight you will find that these two light sources will be about the same intensity, which is a good time to work with both of them in the same picture.

- Take portraits with a neon sign as the light source. Play with the white balance to record all the possible color variations (see page 101 for more on white balance).

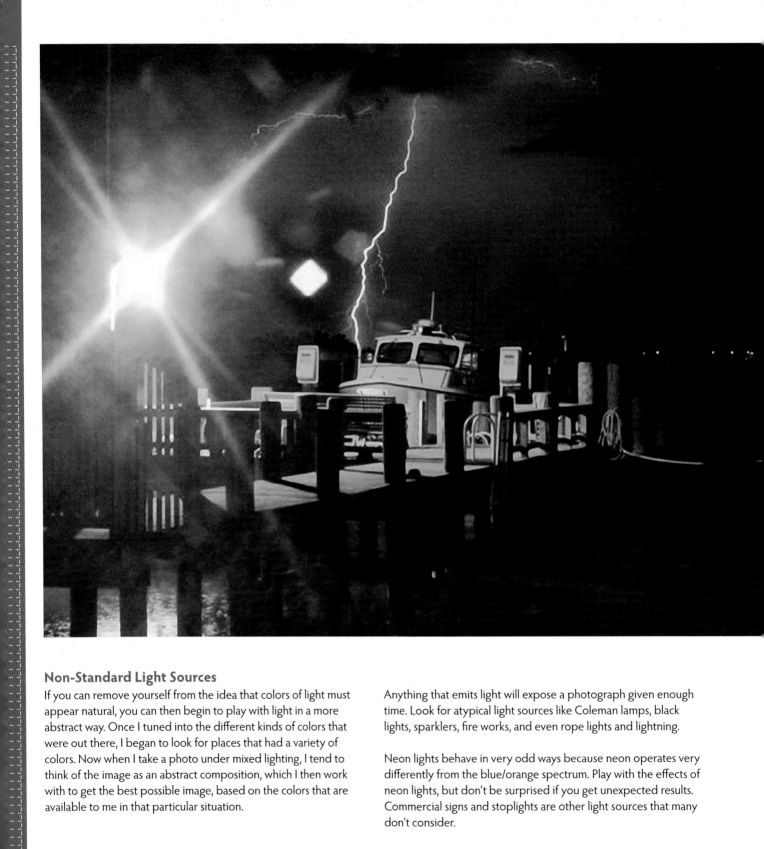

Non-Standard Light Sources

If you can remove yourself from the idea that colors of light must appear natural, you can then begin to play with light in a more abstract way. Once I tuned into the different kinds of colors that were out there, I began to look for places that had a variety of colors. Now when I take a photo under mixed lighting, I tend to think of the image as an abstract composition, which I then work with to get the best possible image, based on the colors that are available to me in that particular situation.

Anything that emits light will expose a photograph given enough time. Look for atypical light sources like Coleman lamps, black lights, sparklers, fire works, and even rope lights and lightning.

Neon lights behave in very odd ways because neon operates very differently from the blue/orange spectrum. Play with the effects of neon lights, but don't be surprised if you get unexpected results. Commercial signs and stoplights are other light sources that many don't consider.

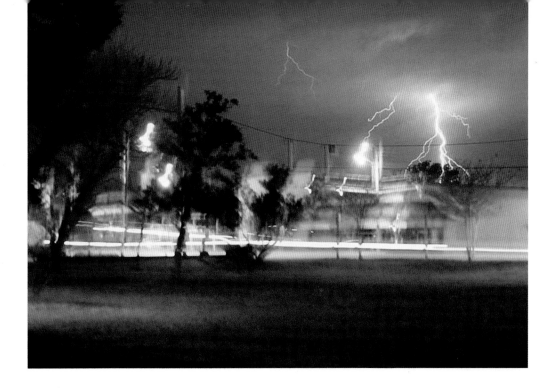

OPPOSITE
While caution is advised, lightning is a fascinating light source. The first picture was taken at a boat dock with a mercury light and with lightning in the background.

NEAR LEFT
The second shot was taken next to moving traffic.

BELOW
The third shot was taken of cloud lightning.

Artificial Outdoor Light Sources

You will come across these common area lights outdoors at night. These lights fall outside the blue/orange Kelvin spectrum and may be hard to photograph as white light.

• Mercury lamps give off a bluish light. The overcast white balance or custom white balance setting is your best bet to photograph this light as white or whitish.

• Sodium lamps have a yellow cast. The tungsten (house bulb) or custom white balance setting should work best to photograph this light as white or whitish.

• Fluorescent lights are available in several variations and give off different colors. Many digital cameras now have a number of fluorescent white balance settings to choose from; try each one to determine the best white balance for your particular light. You should be able to find a setting that will record this light as white.

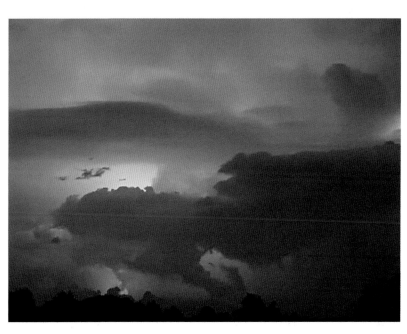

"Instead of using the camera only to reproduce objects, I wanted to use it to make what is invisible to the eye visible."

WYNN BULLOCK, PHOTOGRAPHER

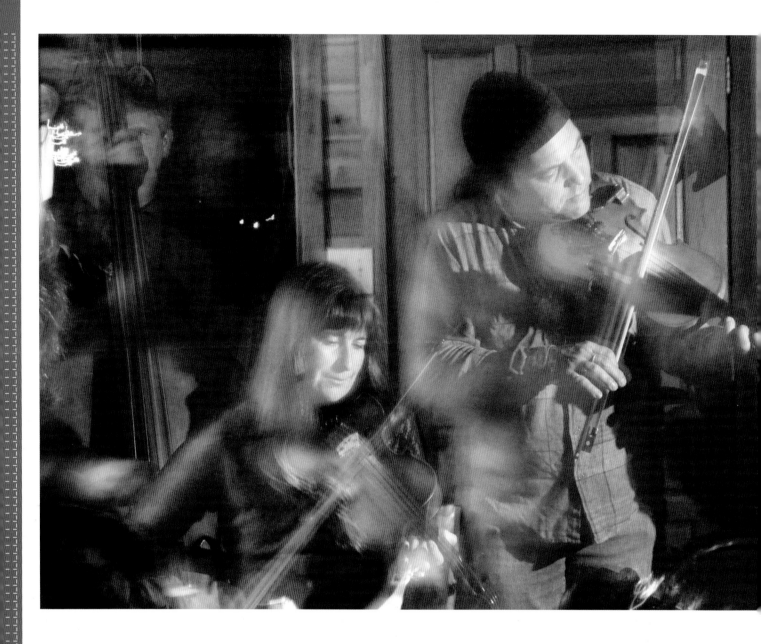

Flash with Mixed Lighting

If you want to have control over the color of your principle light source, use a flash. If you want to use flash with other light sources, adjust its intensity so that it does not wash out and overpower the other light sources in the area. Play with this feature for a couple of shots until you find the right balance. When you are using flash, most cameras will automatically set the white balance to match the color of the flash, which has a slight blue cast.

Better Flash Techniques

Flash that comes directly from the camera is often very harsh and flat. This is because the light is coming at the subject from the front rather that from the side. Side lighting is much more pleasing and creates texture, depth, and angled shadows. If you use flash often, you may want to consider an accessory flash. You can mount this to your camera's hotshoe (if the camera has one) for direct flash, or you can connect it with an extension cord or a wireless setup. This enables you to shoot the flash off from the side, the top, the bottom, or even from behind the subject.

OPPOSITE
I mixed a very slow shutter speed with an off-camera flash. The red light in this photo came from the tungsten house bulbs and the blue color came from the flash.

NOTE

Off-Camera Flash with Slow Shutter Speeds

Assuming your camera is anchored or on a tripod and you are shooting very slow shutter speeds—such as 15 seconds up to several minutes—you can simply hit the shutter button, walk over to the side of your camera, and pop an accessory flash with the "manual" or "test" button.

Circles of Confusion

NO DISCUSSION OF LIGHT AND COLOR would be complete without mentioning the rather odd term, "circles of confusion." A circle of confusion is commonly known as a point of light that is not in perfect focus. When a point of light is out of focus, the point of light spreads into a circle. The more out of focus, the more the light spreads. The color of these circles reflects the color of the light source, and the size of the circles increase with less focus, a lower f/number, and a long focal length, such as a telephoto setting.

Photographers often use circles of confusion as a backdrop to a portrait, for example. The background renders as both colorful and out of focus, while the portrait is clear and sharp.

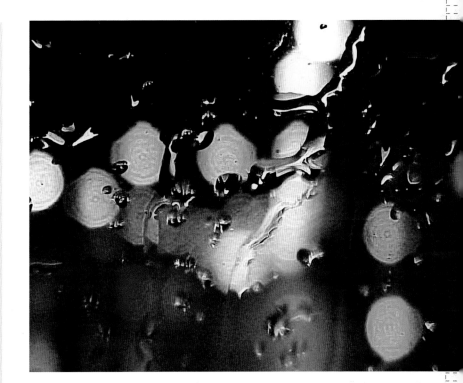

ABOVE
Focusing on the rain in the foreground and using a low numbered f/stop created these large circles of confusion in the background. This threw the lights in the distance out of focus and created the classic large circles of confusion effect.

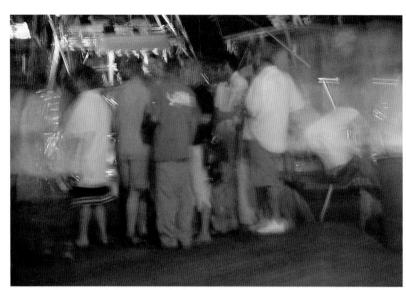

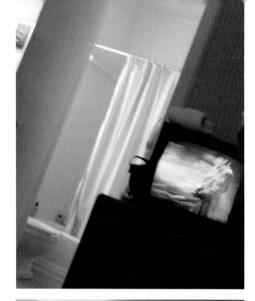

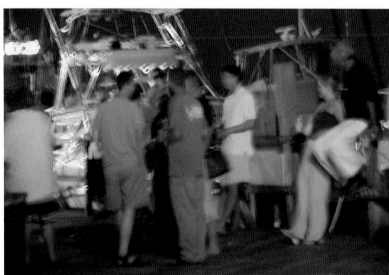

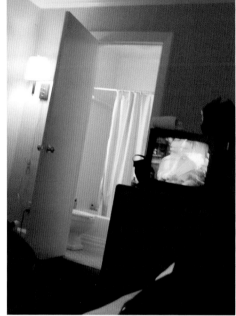

WHITE BALANCE

The white balance setting is a major change from traditional to digital technology. You can set the balance to a specific setting such as tungsten (incandescent house bulbs), daylight, or overcast, to name a few. Each setting alters how the camera records the color of light; for example, the tungsten setting will record the light from house bulbs as white by adding blue to remove the orange hue. If you photograph the same light without the white balance adjustment, it appears orange. You can judge whether the camera has captured the color you want simply by previewing your photo on the LCD screen.

Like so many things in photography, the colors the camera renders are relative. For example, if you are using the auto white balance setting outdoors at twilight and include a window in your frame that is lit by a standard house bulb, the outdoor light will be rendered a normal color, but the light in the house will be orange. To reverse that example, if you were to walk inside your home and take a picture from inside the room with outdoor light coming through the window, the room's colors will look normal and the light from the outdoors will look blue. The reason is simple: When shooting outdoors, the outdoor light is the reference light for the camera's white balance feature so the indoor light looks orange; when shooting indoors, the indoor light is the reference so the outdoor light looks blue.

For the experimental photographer, it means that you can play with the overall color of a scene to work with in a natural way or an experimental way. For example, I have taken pictures of the same white door in my house under the same lighting so that the door was white, or blue or beige simply by changing the white balance setting.

THIS SPREAD
Each of these pairs of photographs were taken just seconds apart with the only difference between being a change in the white balance setting.

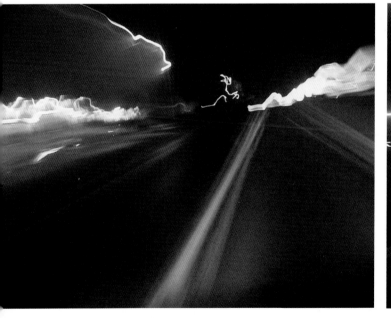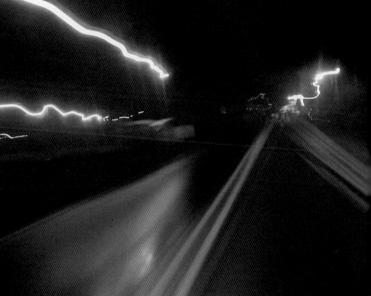

AUTO WHITE BALANCE

The automatic white balance setting directs the camera to determine what light source will reproduce as white. Using that tone as a reference, the camera records all the other colors in the photo in relation to the reference tone. In most cases, the auto setting works quite well.

Shortcomings of the Automatic White Balance Setting

If you are trying to create an ambience or mood with the lighting—such as a warm tone from candlelight—the auto white balance does not work as well. In this case, you can try the other settings (such as the daylight preset) for a better creative color rendition, at least in theory.

BELOW
I put the white balance on automatic for this handheld night shot of a drag strip that was lit by large area lights. The exposure was ½ second.

OPPOSITE
The color of these camera painting photos of daylight coming around the edge of my door was determined by setting the white balance. In the first photo (top, right), I used the tungsten setting, which rendered the daylight very blue. In the next (middle, right) I used the daylight setting, so the light was now recorded as white. In the last photo (bottom, right) I used a fluorescent setting, so the light then looked beige.

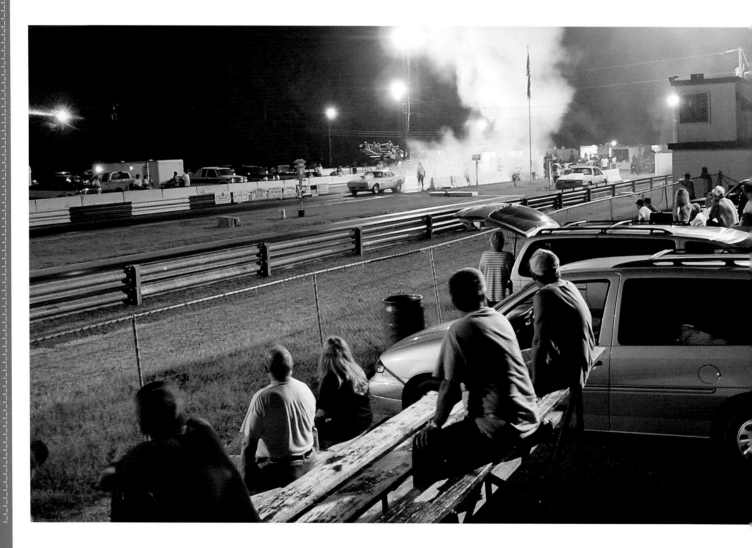

While each camera is different, the following is a list of white balance settings that are included in a typical digital camera. Each preset adds color to the image to create white. When the setting is matched with the appropriate light source, the result is white light.

Daylight (adds no tone; records true light color): This setting is most commonly used for outdoor shots on sunny days or for daylight coming through a window. When used with house bulb lighting, the house bulb light will be orange; under fluorescent lights, the result may be green.

Cloudy (adds orange): Cloudy conditions are bluer than daylight. This setting removes the bluish cast on overcast days. When used with tungsten light, the color of light will be very orange.

Tungsten (adds blue): Use this setting for indoor shots with house lights. If used in daylight, the daylight will be blue, and under cloudy skies, this blue effect will be even more pronounced.

Fluorescent (adds magenta): There are usually several different settings for fluorescent because there are various kinds of fluorescent lights that emit different colors. Simply try each setting to determine the one that gets you the most natural lighting under a particular fluorescent light. Play with these in the "wrong" lighting scenario for interesting color results.

CUSTOM WHITE BALANCE

Some cameras allow you to create a custom white balance setting. To set the custom white balance, you must usually take a reading from a white object under a specific light source. When you push the custom balance button, it will adjust the white balance for the scene. You may have to play with this setting for a while until you get exactly what you want. (For example, what is the correct white balance under a black light?)

Shoot Different Light Sources

Learn to recognize the colors that lights cast; these can be a part of your palette. If you have a variety of lights in your home, for example, you might be able to step outside to see the different colors at night. Walk down the street in your neighborhood and you will undoubtedly notice different colors of light. Remember that the color of light really stands out most when it reflects against a wall or a sidewalk; avoid looking at the brightest part and instead look at where the light falls.

For this exercise, pick a place where you can see two or more different light sources from the outside. Then, like the night photography exercise in Chapter 5, set up a tripod or plop your camera on the hood of your car and fire away.

Adjust the Color Balance

Once you have determined a pleasing exposure, adjust the color balance settings on your camera. Don't limit it to what the light sources actually are. Put the setting on daylight in the middle of the night, set it to tungsten under fluorescent lights, or set one of several fluorescent settings in a music venue with multi-colored stage lights. Keep the exposure the same while taking a shot for each setting. The idea here is to change only one variable at a time. If you keep the exposure the same, the only variation will be the way that you changed the color balance. A notebook also might be handy for recording your settings but keep in mind that the EXIF will most likely record your camera's settings for each image.

Use Exposure Compensation

After making your initial series of shots under a certain lighting situation, try this next exercise: Under- or overexpose an image at night to make a distinct difference in the way the colors of light appear in your picture. Underexposure generally makes the colors of the light more pronounced, while overexposure reduces their effect by bringing them closer to white. In addition to the exercise listed above, try under- and overexposing a scene plus or minus 1 - 2 stops to see how the colors are rendered.

OPPOSITE
Don't shy away from odd lighting situations, such as bonfires. If there's light you can take a photograph! The flickering reddish light of fire has its own characteristics. Since the light is very red, set your white balance to tungsten, if you want the fire light to be whitish.

BELOW
While the primary light source was a bonfire on the right in this photo, the greenish cast on the left came from a mercury area light.

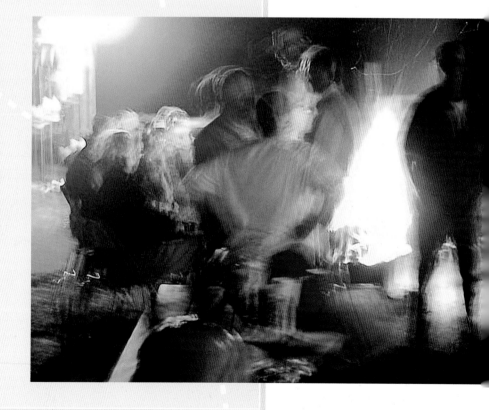

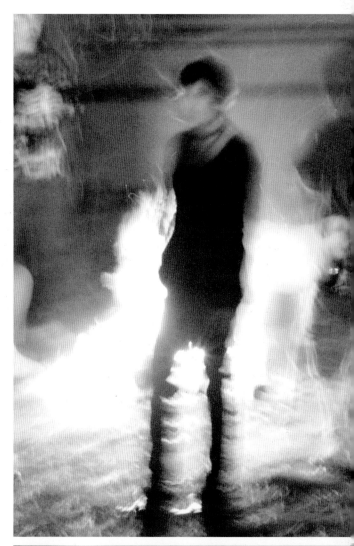

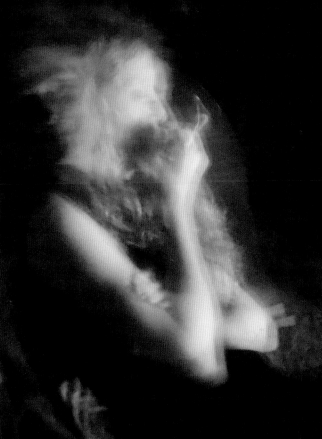

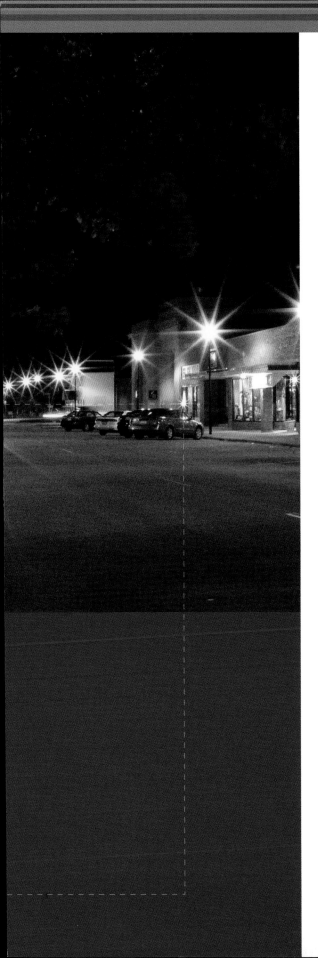

Night

AND LOW LIGHT PHOTOGRAPHY

Nighttime photography was perhaps the least explored area of traditional photography for a number of legitimate reasons: Night photography—especially shot in color—required fast film which was not developed until recent decades; the lighting at night is often high contrast, making subtle gradations difficult; mixed light sources made it hard to work with color film at night; and finally, exposures were hard to determine until the images were developed. Some photographers certainly have worked with the night environment, but they have been few and far between (see the timeline at the end of this chapter).

> "A painter's canvas is white; a photographer's canvas is black."
>
> RICK DOBLE, AUTHOR

ABOVE
While the ambient light in this scene lit most of the photo, the 8-second exposure allowed the lights of a car crossing the bridge to light the bridge—even though the car itself is not visible. The reflected lights in the water add depth.

Digital photography changed all of this, and night and low light photography has flourished as a result. The reasons are clear: the LCD monitor makes testing and determining exposures quite simple; the ISO can be set, judged, and changed on the spot; and the exposure variables of most digital cameras can be easily adjusted to more accurately capture the lighting conditions at night.

There are other reasons that digital photography and nighttime go together. The colors at night are intense, and when set against the black background of night, they jump out. This ability to create visual drama against the darkness works well since the starting place for all photography is an empty black frame—an unexposed shot.

Low light photography is a catchall term for situations that are dark but not necessarily at night. Twilight and dusk, for example, are low light; while nighttime photography has large areas that are completely black, twilight often has dim lighting throughout the scene. Clubs and homes lit with only a few lights also qualify as low light situations.

"I often think the
night is more
alive and more
richly coloured
than the day."

VINCENT VAN GOGH,
PAINTER

The Magic Time

FOR NIGHT PHOTOGRAPHERS, the magic time can be
right at twilight when the intensity of the sky and the
brightness of the artificial lights are close together.
This delicate period only lasts for 15-30 minutes
depending on the time of year. To record a rich blue
sky, set your white balance to the tungsten preset.
Don't be afraid to try other settings as well.

ight and low light photography are quite different from standard photography. If you are not used to their specific demands, here are some things you need to know.

Overexposure

Oddly, a common problem with night photos is not under-exposure but overexposure. The reason is that the range of light values—or the dynamic range—at night far exceeds daytime values and what the sensor can capture. For example, a dimly-lit alleyway can be next to a brightly lit store window. In many cases, the range of light is more than the light sensors can handle: either the alleyway will be too dark so that the exposure can accommodate the lights of the store window display, or the store window will be overexposed so that the detail in the alley can be revealed.

Reciprocity Failure

Think back to our reciprocity discussion in Chapter 1; reciprocity calculations in photography assume that one change in lens aperture equals a corresponding change in shutter speed, and for most photographic situations this is true. However, in dark environments with very long exposures this reciprocal relationship often breaks down, usually resulting in a much longer exposure than might be expected.

How to take Long Exposures

FOR EXPOSURES OF 15 SECONDS OR LONGER, you will need to set the camera to the Manual or Bulb setting. Only higher-end cameras, such as advanced compact cameras and D-SLRs, come equipped with these settings. Either setting allows the photographer to determine how long the shutter stays open. For very long exposure times, you may need to use your watch. Some cameras require a shutter cable release that can be locked so that the shutter stays open; some may require that the shutter button be held down the entire time; other cameras require pushing the shutter button twice for an exposure—once to open the shutter and once more to close it. For long exposure settings, check your camera manual. Make sure to stabilize the camera for extremely long exposures, unless you are experimenting with camera movement techniques.

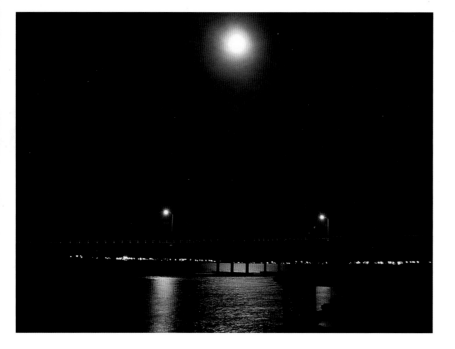

LEFT
This 4-second exposure shows the range possible with night photography—the water, the bridge, the moon, and even the sky are visible.

Flare and Blooming

When light enters the lens directly—especially when the rest of the scene is dark, such as night and low light situations—it often flares in a uniquely digital way known as "blooming." Blooming is bright light that bleeds beyond where it should, and often creates a look particular to each camera such as a star pattern. There is no complete cure for this other than to avoid allowing bright light to come directly into the lens.

Changing the aperture often changes the look of the blooming. Higher f/numbers produce more defined blooming and lower f/numbers diffuse the blooming a bit. Try shooting at the lowest numbered f/stop and then the highest numbered f/stop to see the difference. The best solution may be to work with this blooming pattern and make it part of the image.

While flare and blooming are closely related, they are technically not the same. Blooming refers to the way the image of a bright light source bleeds with digital image sensors, while flare refers to the way a lens handles a bright light source. Flare is caused by internal reflections in the lens and occurs when a bright light enters the lens; it bounces around in the lens and camera and affects the image by lightening it and reducing the contrast.

ABOVE
Bright lights bloom and flare in a uniquely digital way in this shot.

Noise

Noise or "digital grain" often becomes a major factor at night especially with very dark or underexposed photos. Noise is similar to grain in film photography and occurs in the same situations such as photographs taken in very low light with a high ISO setting. In digital photography, noise is caused in a sense by random sampling errors of the digital image sensors when these sensors are pushed to the limit as in a dark, high ISO environment.

Enhancing Noise: You can discover some very unusual effects by deliberately underexposing a photo at night to create noise. Doing this takes some practice since you will need to guess at what the final image will look like. Underexposing also has the advantage of allowing you to use a faster shutter speed or higher f/number.

Because you are underexposing in a dark situation to begin with, digital images tend to become quite grainy or noisy,

Resolution and Noise

I HAVE FOUND THAT higher resolution photos with slow exposures at night often produce a lot of noise—random flecks of blue and red pixels that can interfere with your image. Oddly, going down to a lower resolution may solve the problem. So don't assume that you have to shoot at the highest resolution always; at night shoot at the highest resolution that has minimal noise.

especially when lightened in the digital darkroom. While noise is expected in nighttime digital images, it becomes even more pronounced when a picture is underexposed. The results can be a pleasing artistic effect, yet it is hard to predict.

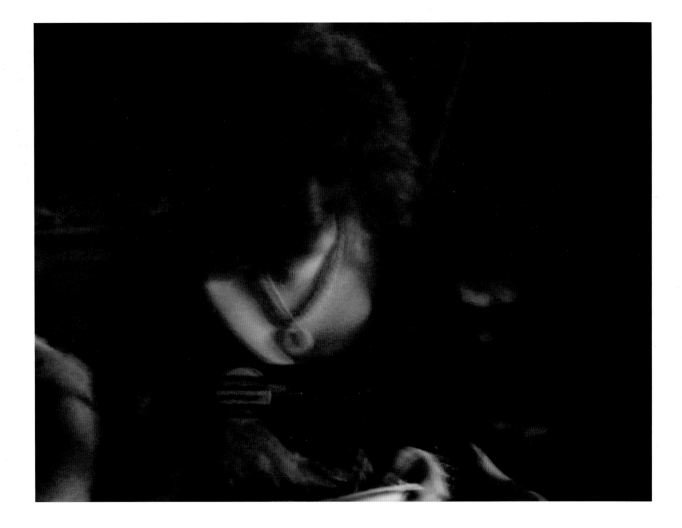

Preventing Noise: If you want to prevent noise from the outset, you can try one or more of the following:

• Use a lower ISO; any setting above 400 can produce noise in a dark lighting situation.

• Don't underexpose the image and hope to fix it later in the darkroom. Underexposed images often have significant noise issues when lightened.

• Don't use the highest resolution. High resolution under low light will increase the look of noise.

• Avoid very dark situations; the darker the environment, the longer the exposure and thus more noise will be created.

• Use flash to light the scene.

Noise does not have to be bad. If you want to live with it and/or use it as an effect, you should. The noisy, grainy look can be a significant part of your photograph.

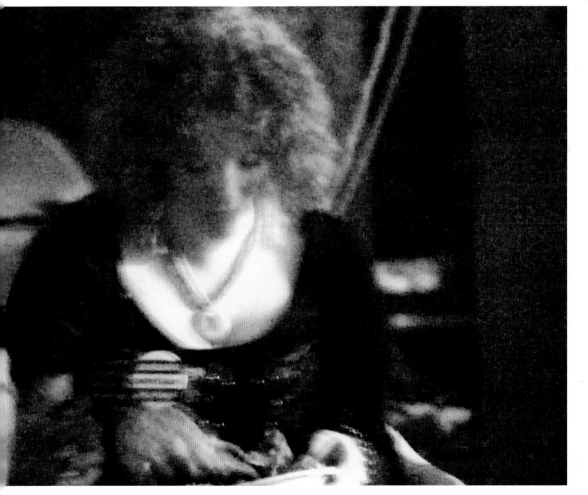

THIS SPREAD
This is an example of an underexposed photo that was corrected in the digital darkroom. The photo to the left is the original. The photo to the right is the corrected one. The noisy effect happened because of the underexposure.

There is no such thing as a scene being too dark to take a photograph unless you are in an underground cave. Virtually all scenes have some kind of light; if you have the patience and your camera will allow you to make the necessary settings, you can take a photo.

Real World Nighttime Exposures

I found the most complete list of nighttime situations along with exposure data in Robert Klep's Exposure Calculator. If you want to get an overview of different nighttime environments, the following list covers the full range. Starting with an exposure value of 0, you can see that there are nine typical night situations you will encounter in everyday life. When you use the calculator (explained Chapter 1), you can determine and also change the shutter speed, f/stop, ISO, and exposure compensation for each of these situations.

Nighttime and Low Light Situations from Robert Klep's Exposure Calculator:
http://klep.name/programming/expocalc/calculator

Ev (Exposure Value = 1 stop):

0: Lit by dim ambient artificial light

+1: Lighted skyline (distant)

+2: Lightning, total moon eclipse

+3: Fireworks

+4: Candlelight, Christmas lights, floodlit objects, under bright street lamps

+5: Night home interiors, average light, lit by campfires or bonfires

+6: Brightly lit home interiors, fairs, amusement parks

+7: Brightly lighted nighttime streets, indoor sports

+8: Store windows, campfires, bonfires, burning buildings, interiors with bright fluorescent lights

If these typical night situations are not enough for your experimental blood, consider going even further down the exposure ladder with these extreme low light and night situations.

Ev (Exposure Value = 1 stop):

-6: Starlight

-5: Crescent moon

-4: Half moon, meteors

-3: Full moon

-2: Snowscape under full moon

-1: Lit by dim ambient artificial light

ABOVE

Above are examples of nighttime exposures under a full moon using Klep's Exposure Calculator. Notice that a photograph is possible in starlight with no moon. It would require a 120 second—or 2 minute—exposure at ISO 400 with an aperture of f/2.8, or about a one-hour exposure at f/8 and ISO 100.

Christmas yard ornaments lit from inside are perfect for night photographs.

Metering

Night and low light photography can be particularly hard to meter because of the lighting extremes that exist in the darker situations—light sources surrounded by deep, dark shadows. Finding an area that will give you a correct initial exposure reading can be somewhat difficult. As a starting point, I suggest you use the spot metering capability if your camera has one to find an area in between light and dark. For example, the concrete sidewalk under the lights of a store's window display will be darker than the display but lighter than the black tar road next to the sidewalk.

If your camera does not have a spot metering feature, move your camera so that it points to an in-between area, and then lock in that exposure which is usually done by pressing the shutter button down half way. Then move the camera back to frame the picture itself.

Determine the exposure first; do not pay attention to the shutter speed in the beginning. Once you have found and tested your exposure, adjust the ISO and aperture until you bring the shutter speed into the range you want.

BELOW
I caught this man rearranging the film titles on a movie marquee. I metered for the sign's light so that the backlight put him and the letters in silhouette.

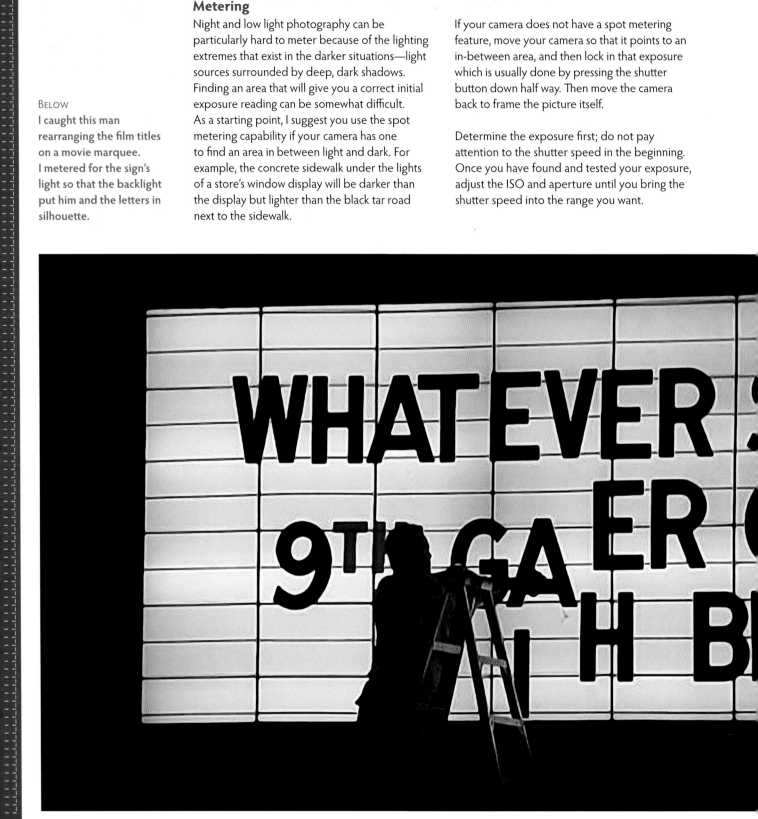

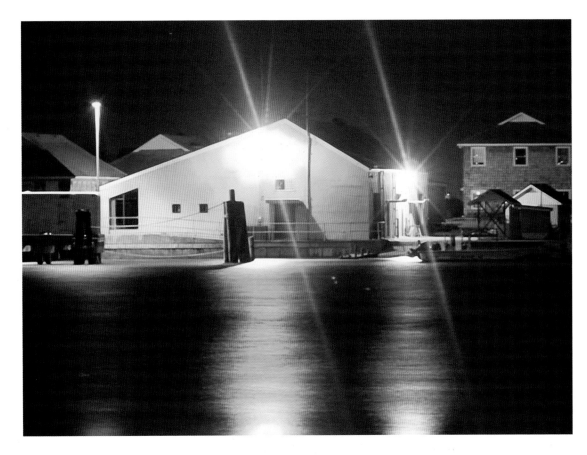

Bracket Your Shots

Once you have determined a basic exposure setting, bracket your images, which means you take a number of shots in which you overexpose and underexpose. Add and subtract as much as seven stops in one-stop increments. You can use the exposure compensation setting for this, and some cameras have a bracketing feature included. Most cameras will automatically take three exposures when you activate the bracketing feature, compose a shot, and press the shutter button: one basic exposure at your current setting, one overexposure, and one underexposure.

When you review your photos you might find that overexposure revealed areas that were in total darkness in your basic exposure. Or perhaps the bright highlighted areas looked better underexposed. In any case, a full set of exposures within a seven-stop range will show you the full display of the possibilities for a given lighting situation.

Reflections at Night

Reflections play an important role in night photography because they light up areas that would otherwise be hidden and they add depth. If you become a skilled night photographer, you will become sensitive to areas that reflect light such as windows, chrome, mirrors, water, and shiny surfaces.

ABOVE
Reflections in the water and mixed lighting add to this night shot of a building.

Reflection Tips

- A reflection is always darker than what it is reflecting; use it to add shading and depth.

- A reflective surface is like a mirror and what you see in that mirror varies considerably with your position as a photographer. Like photographing images in a mirror, you can make reflected areas fill the reflecting surface or almost disappear simply by changing your angle.

- Depending on the smoothness and quality of the reflecting surface, the reflection can be crisp and clear or distorted and abstract.

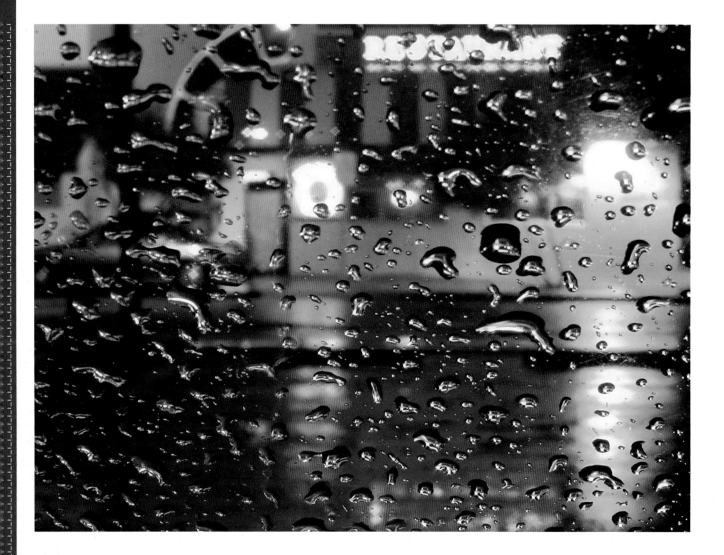

Rain, Rain, Rain

Rain opens up the world for the night photographer by adding depth and light to a scene. Filmmakers have known this for years and often wet the streets before shooting a night scene. It is no accident that one of the very first well-known night photos (entitled "Reflections At Night," 1896, by Alfred Stieglitz) was taken after a rain.

The best time to shoot is right after the rain has stopped but before the scene drains or dries off. This is a short window of time to take advantage of this wonderful photographic opportunity.

Asphalt streets, particularly at night, are almost impossible to photograph in normal circumstances because they are already so dark. However, they appear completely different after a rain. The highways suddenly become visible with reflections, and the roads glimmer with depth and subtlety.

The streets become like mirrors. You will find that you prefer one particular camera angle; however, like all reflections and mirrors, if you move your position and camera angle, you can change the amount and intensity of the reflections considerably.

Other Night Photo Considerations

Dark Subjects: Generally you will want to avoid dark subjects at night such as black cars, people dressed in black, or black objects. These are quite difficult to photograph at night since they have no internal reflections. However, you will find that a photograph of a person in lightly-colored clothing contains many areas of reflected light.

Angle of Light: If you take a photo of a car coming at you head on, the bright lights of the car will overpower the image and create large white areas that, to my taste at least, are not very artistic or interesting. However, if you take pictures of a car from the side, the lights will not be entering the lens directly (reducing flare), and the side angle will lessen the intensity of the headlamps.

ABOVE
This simple composition was made by the shadow of the steering wheel on my open notebook as I sat in my van. The light from the street and the rain on the windshield created the pattern on the white paper.

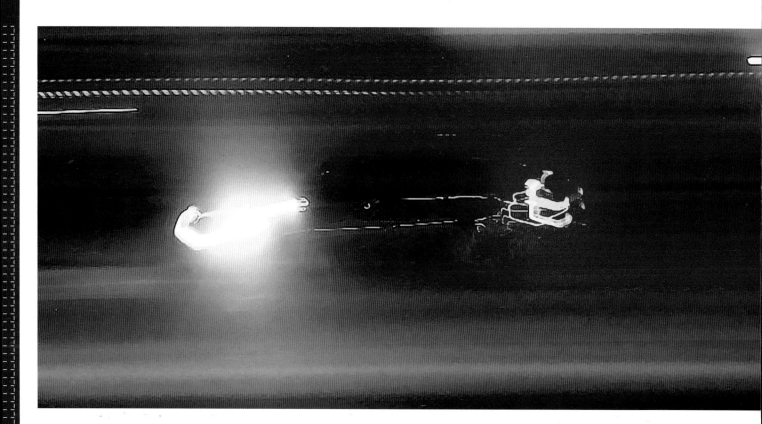

The impressionistic look of this photo of a car in motion was due to fog that spread and diffused the lights.

Mist, Fog, and Atmospheric Conditions

Fog and Mist: Night photography and mist go well together for creating moody images. Fog diffuses the available light and makes flare less likely. Mist also diffuses the light so it is not as directional; it lights a much larger area with soft gradations in tone rather than stark dark and light.

Drizzle: Drizzle has similar characteristics to fog and mist, but adds reflections to wet surfaces.

Clouds: Low cloud cover can reflect the light from towns and cities, giving it an unworldly glow. In addition that light also bounces down back onto the land so that the night landscape can be much better lit during these conditions. This kind of lighting is very quirky and will vary from area to area and from night to night.

Moon: Full moon light can open up shadows plus add another layer of colored light in the right conditions.

Nighttime Photography

Getting Started

Because there will be so much variety in the exposure for shooting at night, there is little point in listing the range of possible exposures. The main idea is that the camera should be locked into position if you want sharp photos of stationary objects. When the camera is locked down, you can shoot at a very long shutter speed and take advantage of the resulting higher f/number for greater depth of field. This large depth of field is often important in a landscape or outdoor shot.

Getting started with night photography is easy. Step outside you home at night and start taking photos. If you are just starting, you may want to take these photos with your camera mounted on a tripod.

Where To Take Night Photos:

1. Outside your home right at or after twilight

2. In your backyard away from main lights

3. Outside your home so that the road is visible; wait until a car passes by and use a slow shutter speed to show both the scene and the sweep of car lights

4. Streets under streetlights

5. Stores with brightly lit windows; the photo reveals the contrast of very bright and very dark areas

6. Nighttime hangout spots such as theaters (see right), arcades, or restaurants/bars

7. A place with water such as lights on a river, pond, or fountain

8. A landscape under full moonlight

Bracket Your Night Test Shots

As we discussed on page 117, bracket your shots. Your camera may come equipped with an exposure compensation setting, making it easier to bracket your compositions.

Spot Meter Nighttime Exposure

If your camera has one, use the spot metering feature. It will make it easier to meter for high-contrast situations. As mentioned on page 116, find a point between the lightest and darkest parts of the scene and take a meter reading there. Then, lock the exposure, reframe your composition, and shoot.

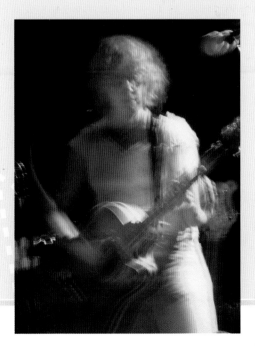

Flash is the most controllable light source available to photographers. When the available light is dim or doesn't exist, a flash can be quite effective for filling out an exposure. Night and low light photography in particular benefit from using flash, if you know what you are doing.

Light Falloff: The Inverse Square Law

The inverse square law states that the strength or intensity of light is inversely proportional to the square of the distance from the light source. In more common terms, an object that is twice the distance from a light source will receive a quarter of the light's intensity. A subject lit by a flash from 10 feet (3 meters) receives a quarter of the light that the subject would receive at 5 ft (1.5 m) from the flash.

You can use this physical characteristic for artistic purposes. For example, if you want a portrait of a person to be against a primarily black background, simply place the person a good distance away from any background. The light doesn't reach the background, thus making it black or a very dark. If you want to illuminate the background, set the subject closer to it. The images on the next page illustrate how the background drops out—and how it quickly drops off—when using flash at night.

In-Camera vs. Accessory Flash Units

While we could devote an entire book to flash, perhaps this brief introduction will help. There are essentially three kinds of flashes:

- The built-in/in-camera flash
- A dedicated flash that is designed to work with your particular camera but which must be bought separately
- A third party flash made by an independent company

Each flash unit has its strengths and weaknesses. The built-in flash unit cannot be moved since it is part of the camera. It typically creates very flat, one-dimensional lighting. In addition these flashes are not very powerful yet can drain the batteries in a camera quickly. However, the built-in flash is already paid for, works with a camera's features, and is easy to use.

A proprietary dedicated flash—made by your camera company for your camera—is often the best bet for people who want a more powerful unit. This unit can be controlled directly from your camera. It can be used on or off the camera, and can create a much more dimensional light than the built-in unit. It uses its own batteries so the ones in the camera are not drained.

A third party flash may have additional features not found in either the built-in or dedicated flash unit, but because it was not designed for your particular camera, might require a learning curve in order to use it adeptly. Third party flashes may not work with all of your camera's features or programmed functions, however, many manufacturers (such as Sunpak) design units to work with the more popular cameras.

Adjusting the Flash Intensity

Many high-end cameras allow you to adjust the intensity of the flash, especially if you use an accessory flash unit. Using a higher ISO will also allow you to lower the flash power. And remember, the lower the power, the longer your batteries will last, as even new flashes tend to eat batteries.

| Distance from light source | 5 ft (1.5 m) | 10 ft (3 m) | | 20 ft (6 m) |

LEFT
Light falls off exponentially as the distance between a point light source and the subject increases. In this illustration, the figure at 10 ft (3 m) gets one quarter of the illumination as the figure at 5 ft (1.5 m), and the figure at 20 ft (6 m) gets a quarter of what the figure at 10 ft (3 m) receives.

ABOVE AND BELOW
A well-lit subject set against the blackness of night can make for a dramatic photo, especially when shot with flash.

Weegee, the Flash Photographer

IF YOU LIKE TO USE flash at night with very dark backgrounds, look at the work of Weegee—a.k.a. Arthur Fellig—a New York photographer who perfected this technique. See the timeline at the end of this chapter.

ABOVE
An early flash photo with a basic point-and-shoot digital camera taken ten years ago.

Getting Ready for a Shoot

If you plan on taking a number of photos at an event, work out the kinks of your flash setting by taking a number of test shots before the activities start. You don't want miss great opportunities because you are not prepared. Remember to pack plenty of batteries; flash uses a significant amount of battery power.

Slow Sync Flash

The slow sync flash setting allows you to mix flash and ambient light when shooting at slow shutter speeds. The burst of light emitted from a flash unit is very fast, as fast as 1/1000 second even for an in-camera or low-end accessory unit. Because flash is so fast, the camera's shutter speed often does not determine the sharpness of the image; instead, the flash's speed determines image sharpness. Also, because the flash burst is so fast, the image should be very crisp. This means that experimental photographers can combine a subject's face lit with flash, for example, with the sweeping blur of traffic lights at night into one exposure. This is accomplished by using the slow sync flash feature to create a long exposure that captures the ambient light, such as traffic lights in the background, and the flash burst to expose the subject.

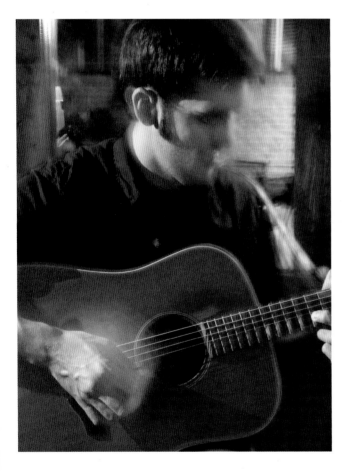

ABOVE
Off-camera flash mixed with a 6-second handheld exposure created this shot of man as he played the guitar. The blue light of the flash both added color and also froze the parts of the player that the flash illuminated. The white balance was set to the tungsten preset in this shot.

To create a well-balanced slow sync image, you will need to make two decisions: how you want to expose for the ambient light, and how the flash will light the scene. The first decision deals with a number of things, including evaluating the general environment and determining the overall exposure for the image. Take a number of test shots to find the appropriate shutter speed and f/stop for your surroundings; for experimental photography the shutter speed might be several seconds or more.

The second decision you must make involves the flash. Take some test shots with the flash at the normal flash shutter speed (usually about 1/125 second) along with the f/stop you determined for the surroundings in the first exposure. Think about how you want to adjust the intensity of the flash. Also be aware that the distance between the flash and the subject is important; remember light intensity diminishes at the square of the distance. (For example, if you are including a person as your flash subject in the picture and the person is too dark even at the highest intensity, move that person closer to the camera or move the camera closer to the person.) Keep the background of the composition in mind; any object close to the subject will pick up more light from the flash, and objects at a distance will reflect a significantly less amount.

Once you have made these decisions, combine them in this manner: set the camera shutter speed and f/stop for the exposure you determined for the ambient light and set the flash intensity to the level you choose. Lastly, choose when you want the flash to fire—at the beginning or at the end of the exposure.

NOTE

Front or Rear Curtain Sync In high-end cameras, slow sync flash often comes in two modes. You can adjust the setting so that the flash goes off at the beginning (front curtain) or at the end (rear curtain) of the exposure.

Slow Sync Flash

- Take a friend outdoors at night where there is traffic or moving lights in the background. Avoid places where the person's face is close to other objects like a tree or lamppost as the flash will illuminate these as well.

- Set the flash to slow sync and decide if you want the flash to go off at the beginning or at the end of the exposure and make the necessary setting changes.

- Next take a 4 to 8 second exposure of the friend; you do not necessarily need a tripod in this case. However, do it both with and without a tripod if you want to see the difference.

- Adjust the flash so that it illuminates only the person's face and not much of the surroundings.

Some variations:

Handhold the camera with the flash set to go off at the beginning; move the camera around before or after the flash fires. This "paints" the lights into the background while the shot of the person is still sharp. (See Chapter 6 for more about painting with light.)

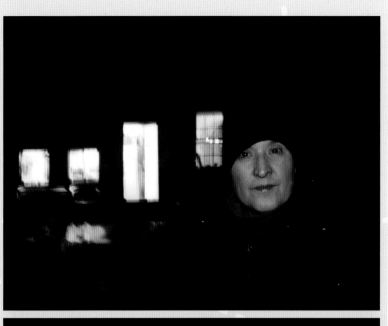

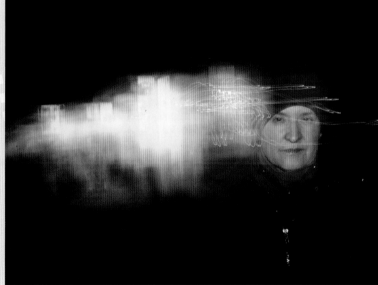

ABOVE

These two handheld 15-second exposures show how slow sync flash can be used at night. In the first image, flash was used in a normal way and the lights in the background are fairly sharp. In the second photo, I moved the camera so that the background lights were blurred, but the face of the person was sharp due to the speed of the flash.

1800

○ VINCENT VAN GOGH
PAINTING: **CAFE TERRACE AT NIGHT** (1888)
Van Gogh's painting is a textbook example of expressing light and color at night. He was a careful observer; he saw that the intensity and the color of that light spread out from the cafe along the street pavement, progressing from bright to black.

○ ALFRED STIEGLITZ
PHOTOGRAPHS: NIGHT SHOTS OF NEW YORK (CIRCA 1896)
Stieglitz used reflections in the rain to enhance what would have been a poorly-lit scene.

○ BRASSAÏ
BOOK: **PARIS BY NIGHT** (1933)
Brassaï loved the night and photographed Paris in the rain and mist around bars and dives.

○ RUDOLPH TAUSKEY
PHOTOGRAPH: **EXPLOSION AT NIGHT, WORLD WAR I** (CA. 1916)

1900

BELOW
This photo is from a series that Stieglitz took of New York at night and after it had rained.
Reflections: Night—New York (1897)

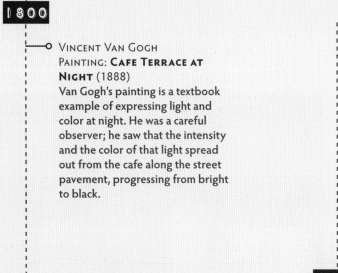

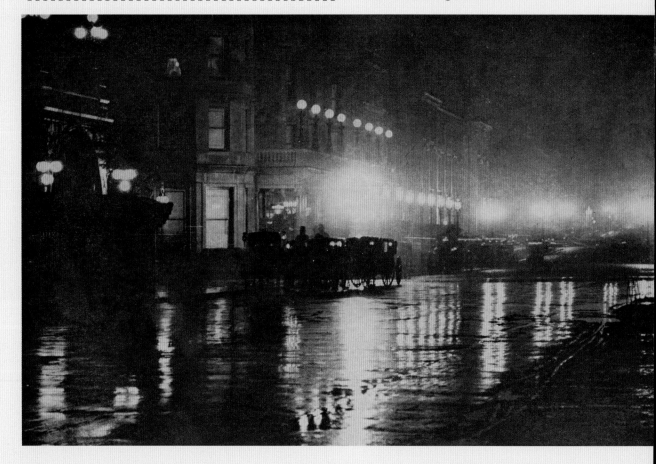

BILL BRANDT (1940s)
When London was blacked out during World War II, Brandt took photographs in moonlight.

ANDREAS FEININGER (1940s)
Feininger pioneered a number of night shots of New York City.

FILM NOIR (CLASSIC ERA: 1940-1960)
Discussion of night photography isn't complete without mentioning the film noir genre, though it is a motion picture art form and not still photography. Most film noir stories happen at night. Originally these films were shot in the studio, but as equipment and film became more sophisticated, the genre evolved to include night scenes taken under existing light and shot on location (such as the films **Crime Wave** and **He Walked By Night**).

WEEGEE (ARTHUR FELLIG)
BOOK: **THE NAKED CITY** (1945)
Using flash at night, Weegee photographed street life in New York City, and became the most accomplished photographer of his time in this genre.

STANLEY KUBRICK
FILM: **BARRY LYNDON** (1975)
This film became a landmark in night photography because of the many famous atmospheric candle scenes. Kubrick used the newly developed F/0.70 lens, allowing him to shoot in the low lighting.

MODERN NIGHT PHOTOGRAPHY (1970s-1990s)
Faster film and color film enabled the growth of night photography. Work by: Steve Fitch, Richard Misrach, Arthur Ollman, Steve Harper, Jan Staller, Michael Kenna, William Lesch.

NIGHT PHOTOGRAPHY COURSE (LATE 1970s)
COLLEGE CLASS: ACADEMY OF ART COLLEGE IN SAN FRANCISCO
This was the first college course for night photography, taught by Steve Harper.

BELOW
This remarkable night photo, **Explosion at night, World War I**, by Rudolph Tauskey was captured in the early part of the twentieth century when film speeds were quite slow, but was possible because of the incredible brightness of the explosion.

Courtesy of George Eastman House, International Museum of Photography and Film

Courtesy of George Eastman House, International Museum of Photography and Film

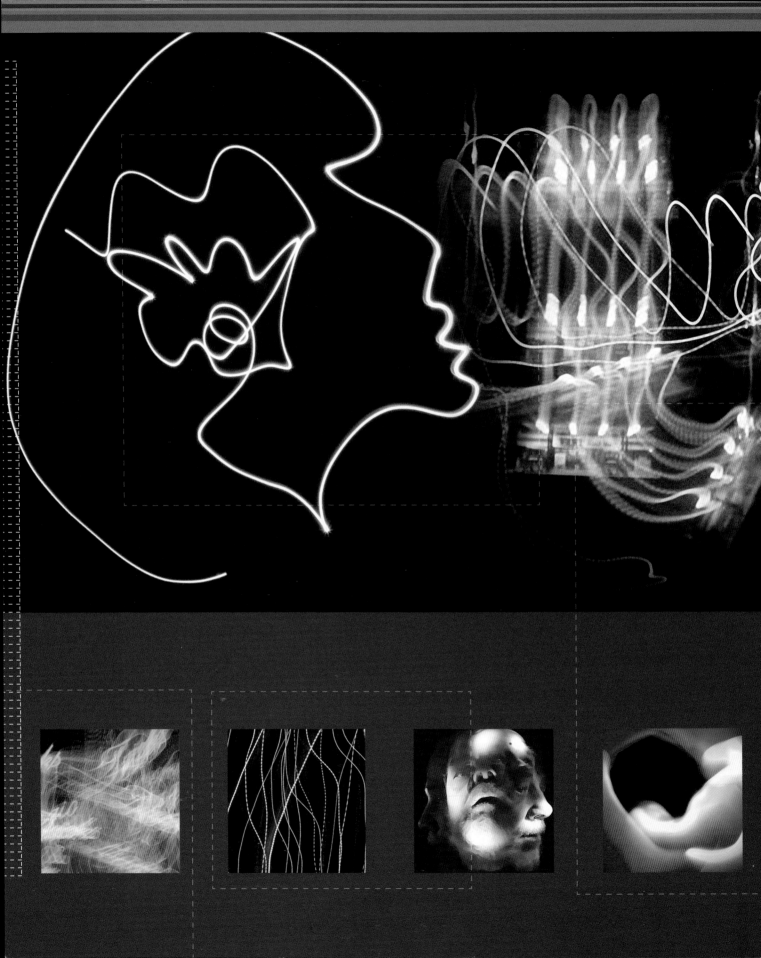

Experiments

WITH LIGHT

"Light painting" and "drawing with light" are special cases of slow-shutter-speed photography. In most painting-with-light shots, the shutter speed will be a few seconds or longer. Although the basic concept is quite simple, the variations are endless. And again, because of the immediate feedback available with digital technology, this branch of photographic arts has been opened up in ways that film photographers never before dreamt of.

> "Light used in its own right, gives to photography the wonderful plasticity that paint gives to painting without loss of the unmatched reality of straight photography."
>
> WYNN BULLOCK,
> PHOTOGRAPHER

The Medium: Light

The motion of light—whether it is subject movement or camera movement—can create very different effects. A light source or each point of light is like a painter's brush. For example, you can move your camera so a source sweeps delicately across the frame or move your camera so it records bold strokes. You can use this approach to draw sharp subtle lines or broad colorful swatches of color. The color of these brush strokes will be the color of the light.

The Canvas: Black

Black is the background on which you will create your painted image. It is a particularly powerful background because any light source contrasts dramatically against this darkness. Think of the nighttime or the complete darkness of a room as your canvas. Almost total darkness is essential, as light-painting photos are often exposed for 30 seconds or more. Yet, bear in mind that with a very slow shutter speed, any ambient light will start to creep into the photo and possibly change the effect (although that, of course, is an area for experimentation as well).

However, like many things in photography, the concept of complete darkness is relative. If you can shoot a photo with a shutter speed of 8 seconds, for example, you may be able to keep the background totally dark, while the same photo shot at 60 seconds might show a good deal of ambient light. Knowing what shutter speed to use to create the effect you are looking for marries technical skill with artistic vision, and this is why experimenting with your images is so important.

The Limits: Overexposure

Remember this basic rule of digital photography: Once an area of the frame gets so much exposure that it goes completely white, you have lost all detail in that area. In many cases, overexposure cannot be corrected, while underexposed parts of a scene more often contain considerable detail that can be brought out later in the digital darkroom.

The Space: Framing

If you are light drawing in front of the camera, you may want to give yourself a lot of room in the frame so that you will not feel confined in your movements. Crop the picture later if needed. When selectively lighting areas of your composition, however, you may prefer to frame the shot precisely, since this style allows for more control over the how final image looks.

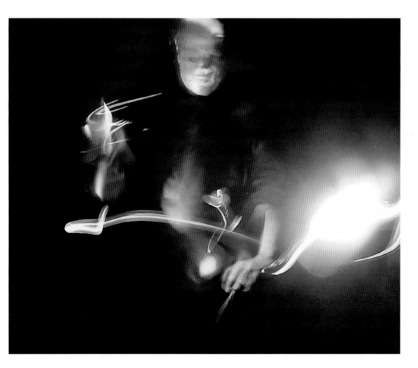

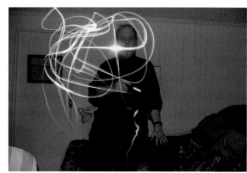

ABOVE
This was my first experiment with light drawing, which was not very good. You can see the room, the light I drew, and the flashlight in my hand.

LEFT
Just two days later, after some trial and error, I learned to underexpose the background, hide the flashlight, and use the light to create its own atmosphere.

PAINTING AND DRAWING WITH LIGHT

There are two ways to use light to create a photo. The first method, called "painting," involves lighting areas of a scene or subject by pointing the light to illuminate specific spots. The second method, called "drawing," is to point the light directly at the camera and draw with that light like you would a pen or a brush.

Painting with Light: A photographer can paint with light the way a painter uses a brush: instead of using a paint-filled brush to create a composition, you can use the light to "paint" over a scene, revealing areas of the composition it touches. The most common way of recording it is by using a light source, such as a flashlight, like a painter's brush; the sweep of that brush across a scene is recorded. As I mentioned above, a photographer's canvas is black and uses light as the medium to create an image. The light reveals the existing colors in a scene, and is easily manipulated by the photographer—just like paint on a white canvas. There is a huge range of possible imagery with this kind of photography. The pictures can be intimate, such as self portraits, or they can be general, such as selectively lit sweeping landscapes that include the moon or city lights in the background.

BELOW
I used the headlights of my van to selectively light the fence and the sign in this scene.

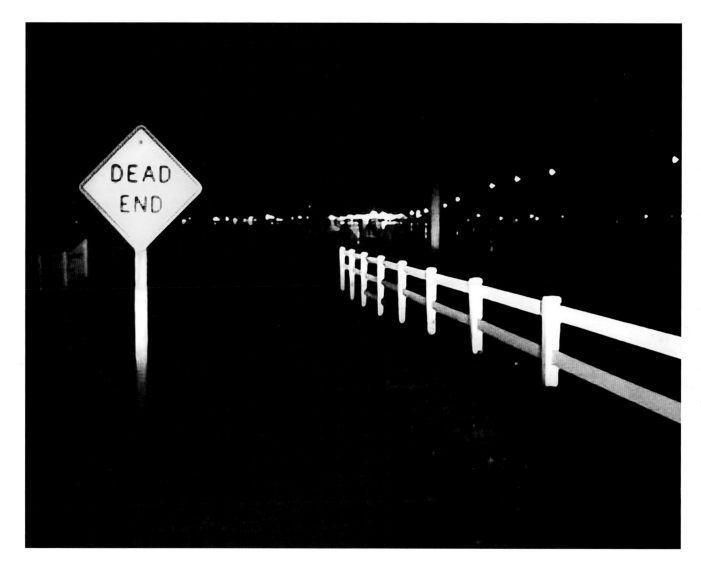

Drawing with Light: Drawing with light uses a flashlight or other light source pointed directly at the camera to create an image. The light itself becomes the subject rather than the lit objects in a scene, and just like sketching on a pad of paper, you can create any design or drawing that pops into your head. A photographer or assistant can draw a picture, doodle, or run around carrying the light. Try it a few times; you'll soon get the hang of it. Depending on your light source and the angle at which you point it into the lens, you may get some blooming, which you may or may not want. If you can angle the light away from the camera a bit, you can reduce or even eliminate the flare.

Combined Painting and Drawing: There are no rules with these techniques. You can paint light on selected areas and then turn around and draw with the light source for as long as the shutter stays open.

ABOVE
These three-color images were made with this inexpensive light pen.

LEFT
I created these three photos by drawing with this novelty light pen (above) that automatically changed colors.

Light Drawing Tools

THERE ARE HUNDREDS OF LIGHT SOURCES you can use for painting and drawing with light. Here is a small list of readily available and easy-to-use lighting tools.

Flashlights: A Mini Maglite is the perfect light tool to begin with. It's cheap, rugged, light, and uses inexpensive AA batteries. It fits easily into your camera bag. A Mini Maglite really shines when it comes to the quality of the light. The light source can be focused or diffused simply by turning the head. In addition, you can pull the head off to expose just the small bulb, which is ideal for light drawing. I suggest you get one with the black finish so that only the light of the flashlight will be recorded and not the flashlight itself.

LED lights: Light-emitting diode (LED) lights are everywhere. There is a huge variety available, from very small indicator lights on computers to general lighting applications. LEDs can emit a variety of colors, from infrared to ultraviolet to white light. Take test shots and play with the white balance setting to determine how the color of an LED will be recorded.

Lighters and candles: These light sources will be very orange or red. Use the tungsten white balance setting to begin with if you want a less reddish look. Since these light sources are dim, they can be used for long exposures.

Cell phones: Like computer screens, most cell phone screens are liquid crystal displays (LCDs), which emit a bluish-white light. Photograph these light sources using the daylight or overcast white balance setting to reduce the blue or set the white balance to tungsten to enhance the LCD's eerie blue light.

Sparklers: Sparklers are so bright that they will record as white in your photographs. To take pictures with sparklers have your subjects move them quickly and draw clear lines in the air.

Laser pointers: When pointed away from the camera, laser pointers will draw crisp sharp lines on just about any surface. Make several test shots to determine the correct white balance setting.

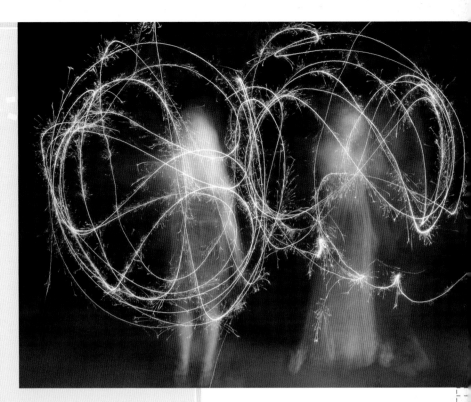

ABOVE
Two women stood outside an open garage door in the night and swirled sparklers. There was just enough light from the garage for them to appear as ghostly figures behind the sparklers.

ABOVE LEFT
A variety of small and inexpensive light sources, like these small flashlights, are widely available.

ABOVE RIGHT
The Mini Maglite is small and versatile. When you remove the head, the delicate bulb will stay lit. Be careful not to bend the exposed bulb or you can break it. Also, once you are done drawing, hide the flashlight from the camera, as the bulb will not turn off without the attached head.

Light Drawing

I highly recommend you use the Mini Maglite as your light pen. If you don't own one, you probably know someone who does and who will let you borrow it for a session.

To get started, find a place that is completely dark. Then put your camera on a tripod and set the shutter speed to 15 seconds or longer if possible. Mark a spot where you will be standing and frame the shot so that there will be plenty of room around your body.

Next, use manual focus to lock in the focus to that point where you will position yourself. If your camera cannot do this, set the zoom to wide angle as this will provide a wide range of clear focus.

Now put the camera in the self-timer mode and click the shutter. Move quickly to the spot you have marked out, wait for the self timer to open the shutter, and then draw with the light. That's it. Of course, check your results each time and give yourself some time to learn. It will take a number of tests before you understand the process.

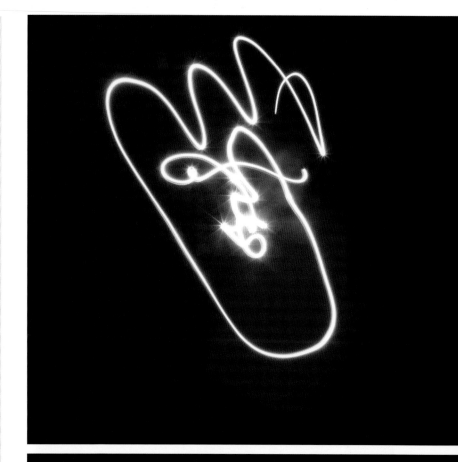

THIS SPREAD
My wife drew these pictures in the air with a Mini Maglite. In the first one (near right, top) you can see her holding the light and drawing a somewhat fuzzy line. But after only a few minutes she and I got the hang of it and she was able to draw clear pictures in the air.

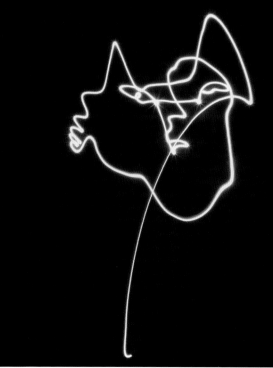

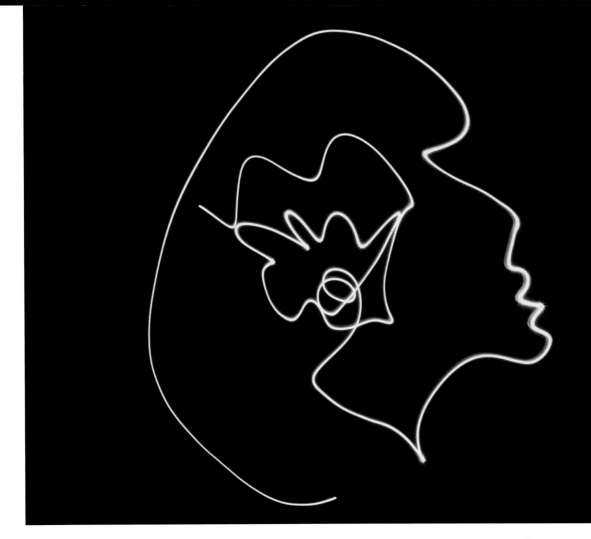

Like every aspect of photography, painting and drawing with light has its own unique requirements. Here are a few things to work on and think about throughout your experimenting.

Control the Quality of Light

The slower you draw with a light source, the brighter, thicker, and fuzzier the light will be. Conversely, the faster you draw, the dimmer, thinner, and crisper the line will be. Crossing lines of light builds up exposure; the crossing points tend to go white.

Get the Color Right

While you can do some color balance corrections in the digital darkroom, you will generally get much better and more predictable results if you adjust the white balance setting on your camera at the time of the shoot.

Wear Dark Clothing

If you want to be invisible when you stand in front of your camera with your light pen, wear dark clothes. If you want a trace or more of your body to be in the photo, do just the opposite.

Get Wild

Some photographers have set their camera on a several minute shutter speed and then thrown lights back and forth into the air. Still others have walked in front of the camera turning the flashlight on and off to create a dashed effect. You can also attach a string to the end of a flashlight and swing it for dramatic patterns.

When lighting different areas of a scene, keep in mind the basic rule of lighting: light diminishes at the square of the distance. Rather than being a limitation this can be quite useful as an artistic tool. This allows you to dramatically light different portions of a scene, especially at night with the light rapidly fading to black.

Accessory Flash

A low-cost accessory flash unit that allows you to pop the flash as needed is a portable and easy to use light source. For example, if you mount your camera on a tripod and set the shutter speed for 30 or 60 seconds, you can then walk around your scene and selectively aim and fire the flash at different areas. The final picture will just show those lit areas; the rest will be in darkness. Look for a flash that has a rapid recycling time; this determines how many flashes you will be able to shoot off in your time period.

Combining Light Painting with Other Imagery

LIKE MANY PHOTOGRAPHIC TECHNIQUES, you can combine light painting with other types of photography such as landscape photography or cityscapes at night. For example, adding some light to the foreground—say a shaded park bench in the foreground of a composition that is revealed when you pop your flash—might enhance a straightforward, slow shutter speed shot of a city at night.

The same technique can be used for portrait lighting, such as using your flash to light a person close to the camera. This can be combined with a timed exposure of the background. Or, with your camera on a tripod with a timed exposure, you can have the subject light his or her face using a moving flashlight.

Other Light Sources for Selective Lighting

Small area lights: Any of the lights mentioned in the light drawing section work well for lighting small sections.

Large area lights: With landscapes, buildings at night etc. the sky is the limit. But perhaps the best source is your car's headlamps. Headlights have many advantages as they are already paid for, you take them with you when you drive your car and you usually don't have to worry about the battery running out. While aiming these lights vertically may be a problem, moving them forward, backward, and horizontally are not. You can also buy spotlights that can be aimed in virtually any direction.

Powerful and inexpensive: If you are determined to light large areas, a slew of quite powerful, yet fairly inexpensive, lights are available. For example, the Cyclops Thor X Colossus 18 Million Candle Power Spot Light with a halogen bulb and rechargeable battery can be found online and at popular retail stores. It features "adjustable swivel stands, two power levels and durable rubberized construction," and includes "AC/DC adapter or the 12V DC car plug adapter." And this behemoth costs less than $70.

If that is too rich for you blood, consider the Brinkmann Q-Beam Max Million III Spotlight for less than $30. Its "high-intensity bulb produces 3 million candlepower" and in addition "spots objects up to 10 miles away" plus it gets its power from the 12V DC car plug adapter.

Powerful and sophisticated: The most sophisticated lighting equipment is found in the filmmaking industry and theater productions, so if you want even more power, check out websites that sell or rent lighting equipment and professional setups.

Make your own: With lighting, the technically minded can use their skills and resources to create unique equipment. In addition, aluminum foil or large reflectors can be used to bounce lighting. Adjustable "barn doors"—which are small flaps around a light—can be easily created to narrow the light to direct it and keep it from spilling over to other areas. Temporary barn doors can be made on location out of aluminum foil.

Combine selective and ambient light sources: Combining selective lighting with existing lighting such as twilight or moonlight can create some very interesting and engaging images, but you must take care to expose the image correctly. Set your exposure for the ambient light, and then use your selective lighting to highlight certain areas within your composition. Twilight is especially difficult, as you have only a limited amount of time to work—30 minutes at most—to balance selective lights with the ambient light. Moonlight, especially a full moon, can be remarkable; a 30-second exposure can make a scene look almost like twilight. However, the photo will have quite different characteristics that give it an eerie quality. You can then draw with light or use selective lighting to add to the moonlit scene.

> "Art does not reproduce the visible, it makes visible."
>
> PAUL KLEE, PAINTER

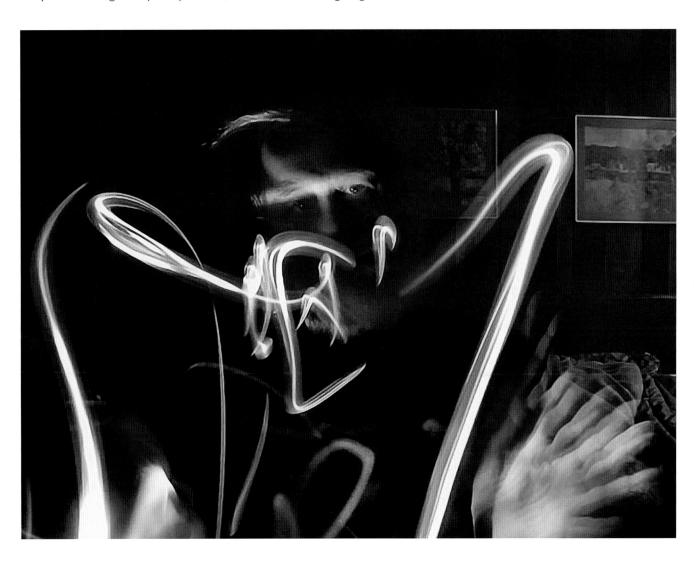

ABOVE
This 8-second exposure combined three kinds of lighting: ambient light from the room, light painting from my LED flashlight on my face and hands, and light drawing from pointing the light directly toward the camera.

To make this series of self portraits I set the camera on a tripod, marked out where I needed to stand for correct framing, turned off all the lights in my living room at night and then stood in front of the camera with an LED flashlight. Then I quickly moved the flashlight across my face and hands (switching from one hand to the other). Notice that you do not see my hand or the flashlight—only the light from the flashlight. I found that the LED flashlight had a natural color, and that the beam of light was about the right width and intensity for my portraits. The thickness of the beam and the intensity, of course, were also determined by the distance of the flashlight from my face, shirt, and hands. In some cases I decided to light my turtleneck shirt while with others, I just lit my face.

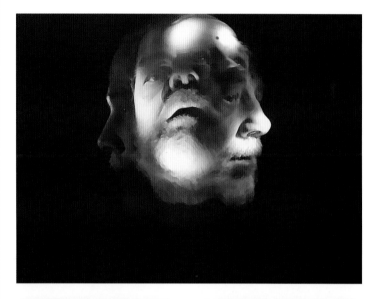

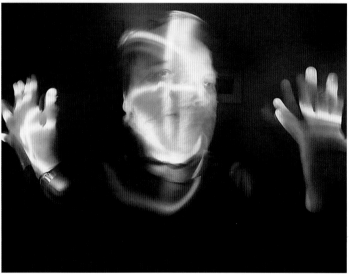

HANDS-ON EXERCISE:

Add Selective Light

Nothing could be simpler than selectively adding light to a photo.

Find a room that you can darken completely at night. Position your camera on a tripod (or shelf or table) and set the zoom lens to wide angle. If possible use manual focus and lock in an appropriate distance. Then take a few test shots with the lights on. Reposition the camera until you have a pleasing composition.

Next, turn off all the lights and set the camera to its slowest shutter speed such as 30 seconds or more. Set the camera on self-timer mode, hit the shutter button, and when you hear the shutter open or you see a tell tale light on the camera, walk around the room, and illuminate sections of it with a flash light.

Of course, the first few photos will probably not be what you want. You will need to adjust the exposure, move more quickly around the room, move the flashlight more slowly and so on. But after a while you will have a photo of a room where you have lit only those places that you want lit and the rest will remain dark.

ABOVE
I took these two self portraits with an LED flashlight. In the second photo I held out one hand as I painted it with the light; then I switched hands so that I could paint the other hand with light. And, as you can see, because of the fast movement of the flashlight, you cannot see the flashlight itself.

RIGHT

This is perhaps my most successful painting-with-light self portrait. I used long straight strokes of my LED flashlight to produce a look similar to a painting done with the wide sharp edge of a palette knife in this 8-second exposure.

BELOW

Using a Mini Maglite flashlight I thoroughly lit my face before turning the point of the naked Mini Maglite bulb to outline the contours of my face in this 8-second exposure. Notice the occasional blooming in the drawn lines.

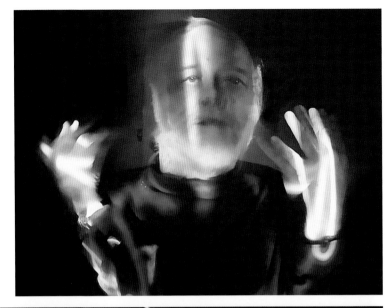

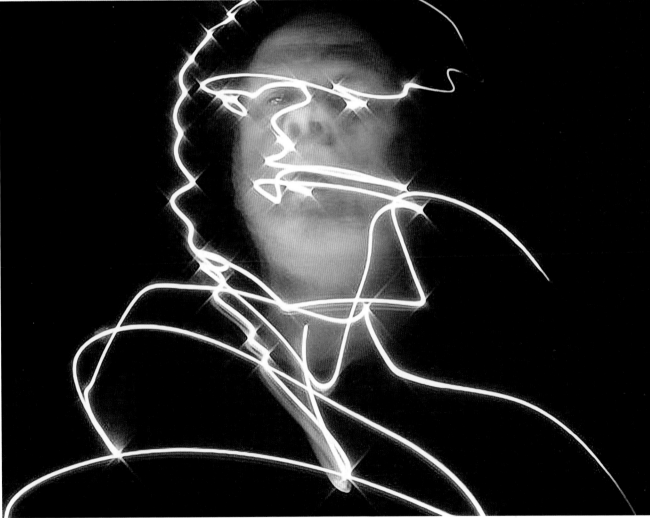

Timeline Experiments with Light

MAN RAY A.K.A. EMMANUEL RADNITZKY (1890 – 1976)
In 1937, he created a "space drawing" photograph in which he drew lines with a flashlight in front of a camera with an open shutter. Known for his photographic experiments, Man Ray may have been the first to do this.

JOHN ALTON A.S.C. (1901 – 1996)
In the 1940s, American cinematographer Alton perfected lighting scenes in black and white movies with light that created its own sense of space and depth. His most famous film noirs—**Border Incident, The Big Combo,** and **He Walked by Night**—exemplify his techniques and mastery. In 1949, he coined the term and wrote a book on the subject, "Painting With Light". It was one of the few books ever written by a practicing master of the cinematic craft.

OGLE WINSTON LINK A.K.A. O WINSTON LINK (1914 – 2001)
In 1955, this American photographer dedicated himself to photographing the disappearing steam locomotives almost entirely at night with huge lighting setups.

GJON MILI (1904 – 1984)
In 1949, Albanian-American photographer Mili took a photo of Picasso in his studio, drawing in the air with a flashlight. Picasso had come up with the idea but was inspired by a photograph of Mili's that used small moving lights. Yet Picasso took this idea in a new direction: He drew one of his famous figures—a Centaur—in the air. Mili, fortunately, was open to experimentation. Mili was also a close friend of experimental photographer Doc Edgerton.

LIGHT PAINTING WITH DIGITAL PHOTOGRAPHY
In 2009, over 35,000 "light painting" photographs were listed in Google Image and over 18,000 photos listed with the search "painting with light". Like all experimental forms, it continues to evolve with variations such as "light graffiti" with over 7,000 photos listed, and "light drawing" with about 5,000 photos listed.

CONTEMPORARY LIGHT PAINTING
"Like night photography, it has grown in popularity since the advent of digital cameras because they allow photographers to see the results of their work immediately."—from Wikipedia

CAMERA PAINTING

Camera painting describes something similar to light painting and drawing, but in this scenario, the camera itself moves across lights and lighted areas to create the patterns and abstract effects with light sources. Camera painting in particular turns photography into an individual and expressive medium, because the way each person holds and moves a camera is quite different.

There are an unlimited number of ways to move the camera (refer to the section on camera movement on page 69), making this kind of photography quite creative. A camera painter could use a circular movement, a long sweeping motion with undulations, camera shake, or vibration. Large motions can be combined with camera vibration to produce a kind of visual vibrato. Movement can also involve stops and starts which can create a multiple exposure effect, as though different images have been overlaid.

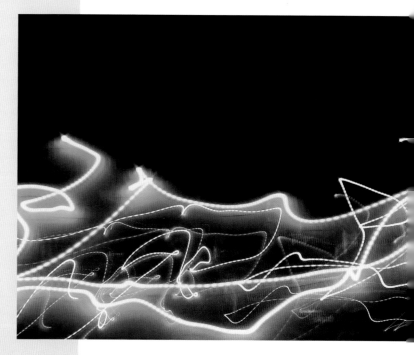

ABOVE
Camera painting allows the photographer complete creativity in an art form that essentially did not exist before digital photography.

THIS PAGE
The eight photographs in this series show what is possible with camera painting.

I found an area—the Duke Marine Lab in Beaufort, NC—where there were a number of different colored lights, also reflected in the water.

The first photo (top, left) shows a normal, stable shot of the scene. The other seven photos were taken of that same scene but with camera movement added each time.

I initially framed the scene so that the lights and the reflections were a small area in the middle. Then I swept the camera across these lights, taking well over 100 photos during a session. It took me a while to determine how fast to move the camera as the speed of my movement affected how the camera recorded the colors, as well as the amount of shading. Over several years, I went back to this spot and produced some very different images. The photos you see on this page are the result of these experiments.

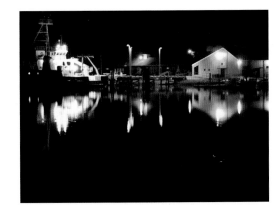
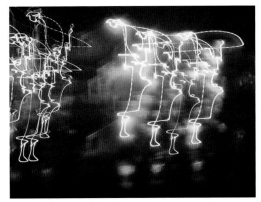
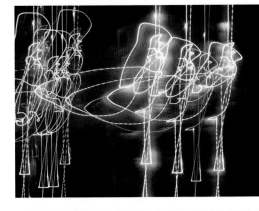
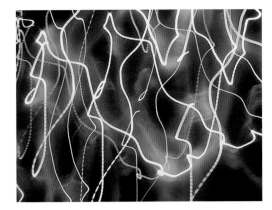
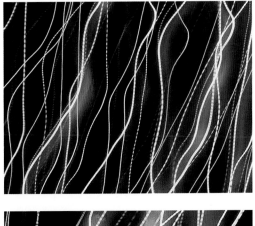
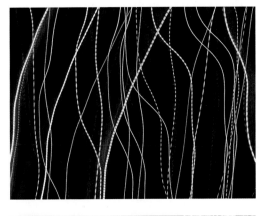
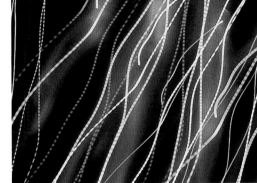
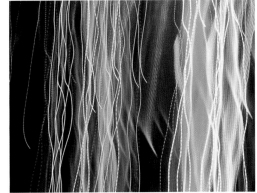

Camera Vibrations

LESS WELL KNOWN than controlled camera movement is controlled camera shake. This can be a vibrating or a tambourine type of movement, and the speed can vary greatly—just about anything is possible. The Ferris wheel pictures on page 10 were created with a considerable amount of camera shake.

"I believe in perception as being the highest order of recognition. When I work, there is no consciousness of ideals—but intuition and impulse."

DAVID SMITH, SCULPTOR

THIS SPREAD
This series of shots shows the variety of effects a photographer can achieve using lights commonly found in most towns and cities.

Camera Painting Elements

Light Intensity: The principles of light painting also apply to camera painting; the slower you move the camera across the light, the brighter, thicker, and fuzzier the light will appear. Conversely, the faster you move the camera, the dimmer, thinner, and crisper the light appears. The points where lights cross will go white from overexposure.

Remember that most digital cameras produce blooming when the camera's lens is aimed directly at a light source. Play with the camera angle to reduce or enhance this effect.

Framing: For most camera painting, you will want to allow for extra room around the central area used in the painting, because initially it can be hard to predict how far the drawing will expand. If you use the highest possible resolution on your camera—while avoiding a resolution that produces noise—you can crop later with virtually no image quality loss.

Viewing: When the picture is being taken, the LCD monitor or the LCD viewfinder goes blank, meaning that the photographer cannot see what the camera is seeing or see the image appearing on the LCD monitor. Cameras with optical viewfinders do not blackout, but no system can show the image as it builds up over time.

There is a solution of sorts to this problem. To start, position the camera as best as possible and take a few test pictures to determine the basic exposure. Next, if you have an electronic viewfinder, use your right eye (if you are right handed) to look through the viewfinder when making the initial framing and then open your left eye to view the scene itself while the viewfinder is blank and the picture is being taken. With your naked eye and a blank monitor, you will learn to visualize what the sweep of lights will look like.

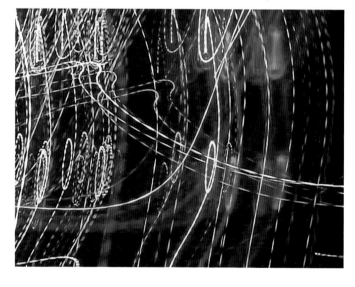
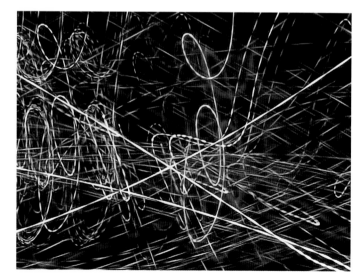

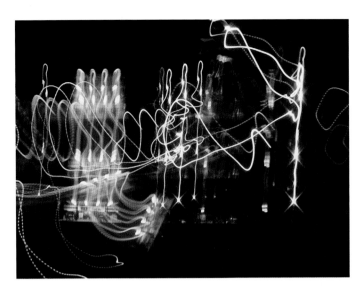

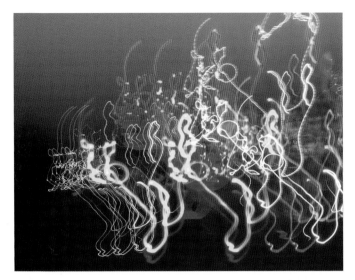

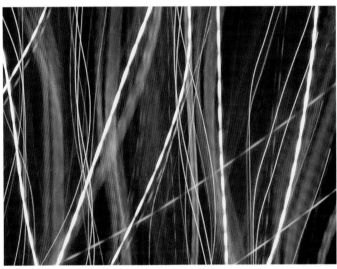

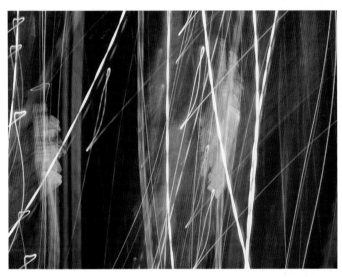

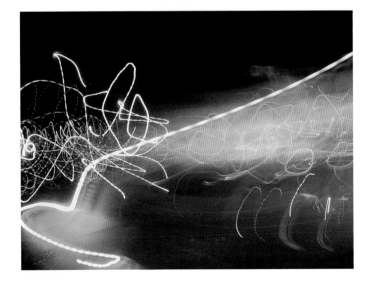

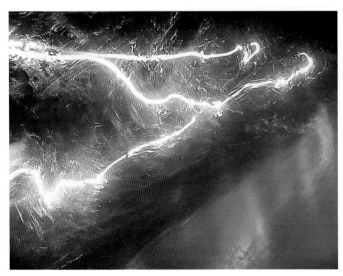

Camera Painting

Ideally, you should find a very dark place with a number of different colored lights to experiment with camera painting. Lights reflected in water are particularly good since the reflection adds another dimension.

If the lights are at different distances, focus the camera on a middle light source or at one of the light sources if they are at the same distance. Manual focus usually works better in darkness; the autofocus has a hard time reading exact focus in low light scenes and may take some time searching for correct focus.

Set the camera's shutter speed to its maximum—at least 4 seconds, but longer shutter speeds are better if possible. Frame the lights so that they are a small part of the picture.

Finally click the shutter and move the camera. Just as with panning, you will probably get a smoother line if you start your movement before you click the shutter and continue to move the camera for a moment after the shutter has closed (like following through on a golf swing).

The first couple of shots may be too dark or too light, so adjust the ISO or the aperture; however, don't change the shutter speed. Also, try moving the camera more quickly to make the lights sharper and darker, or slower to make the lights brighter and wider.

Going Further with Camera Painting

• Find some neon lights and take a variety of shots while you move the camera in a number of ways. Try moving the camera smoothly, then in distinct stages, then while arching it at the same time.

• You can also camera paint as you go down the highway. Have a friend drive as you move you camera across lights that speed by you on the road. As always, safety is first. The photographer should never distract the driver or make any sudden changes.

BELOW
Neon lights are the basis for these two photos; neon lights are a good light source to start with if you are just learning how to camera paint.

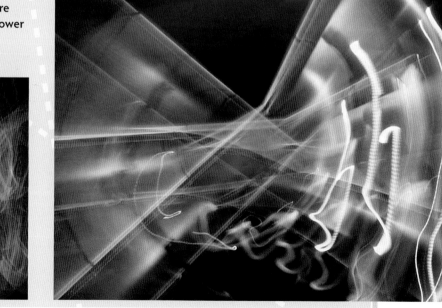

Camera Tossing

THE FLICKR CAMERA TOSS GROUP defines the technique this way: "Camera Toss is a particular form of kinetic photography, the camera must be airborne and unobstructed by the photographer or other means." With camera tossing there are no rules other than to let the camera go free from your hands and up into the air.

While you can use your expensive camera, I would not recommend it unless you are in a very protected environment. You may want to confine your wilder experiments to a low cost camera. Inexpensive cameras now sell from about $10 to $30; you might be able to find one with the right specifications. Keep in mind that older, moderately priced cameras are often sold at fire sale prices, so good deals are for the asking. Perform an online search for "low cost digital cameras" to get started. Look for a camera with two seconds or more as its slowest shutter speed setting, and remember that snapshot cameras can often be forced to go to their lowest shutter speed by using the landscape mode or adjusting the exposure compensation setting.

Low light camera tossing often involves using a slow shutter speed and then throwing the camera up with a spinning motion to create kaleidoscopic patterns from the lights in the environment. Try to click the shutter just before you let the camera go to get the longest exposure.

Daylight camera tossing involves using the self-timer because the exposure will usually be much shorter. In this case, spinning the camera is not as important as the position of the camera when the shutter snaps. For example, for a daytime self portrait you want to throw the camera up so that it points down at you when the self-timer causes the exposure to be taken. This type of tossing can also be applied to shots taken at night with the flash turned on.

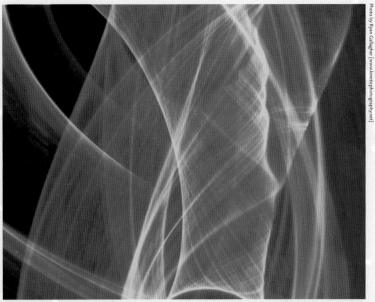

Photo by Ryan Gallagher [www.kineticphotography.net]

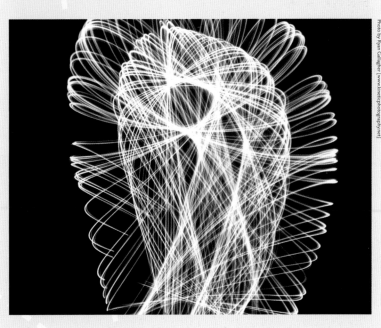

Photo by Ryan Gallagher [www.kineticphotography.net]

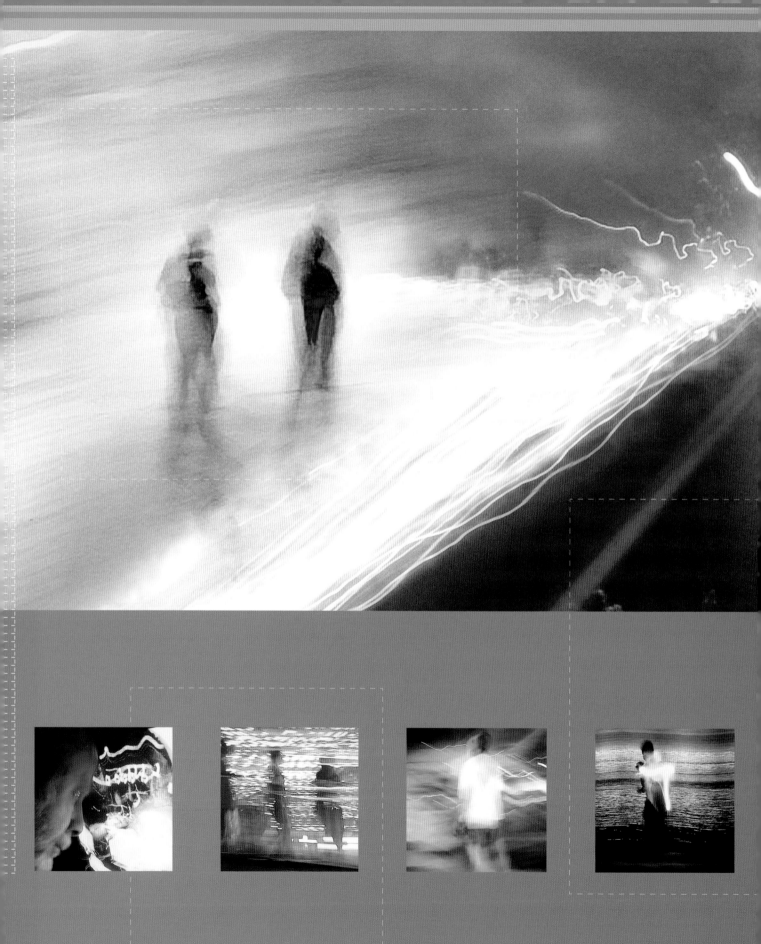

Building

YOUR IMAGERY

When you find a situation you enjoy shooting or a specific type of imagery that inspires you, you will soon become quite skilled at taking photos of those subjects. This skill will naturally begin to grow and branch out into other related areas that are more sophisticated and challenging.

"New needs need new techniques. And the modern artists have found new ways and new means of making their statements... the modern painter cannot express this age, the airplane, the atom bomb, the radio, in the old forms of the Renaissance or of any other past culture."

JACKSON POLLOCK,
PAINTER

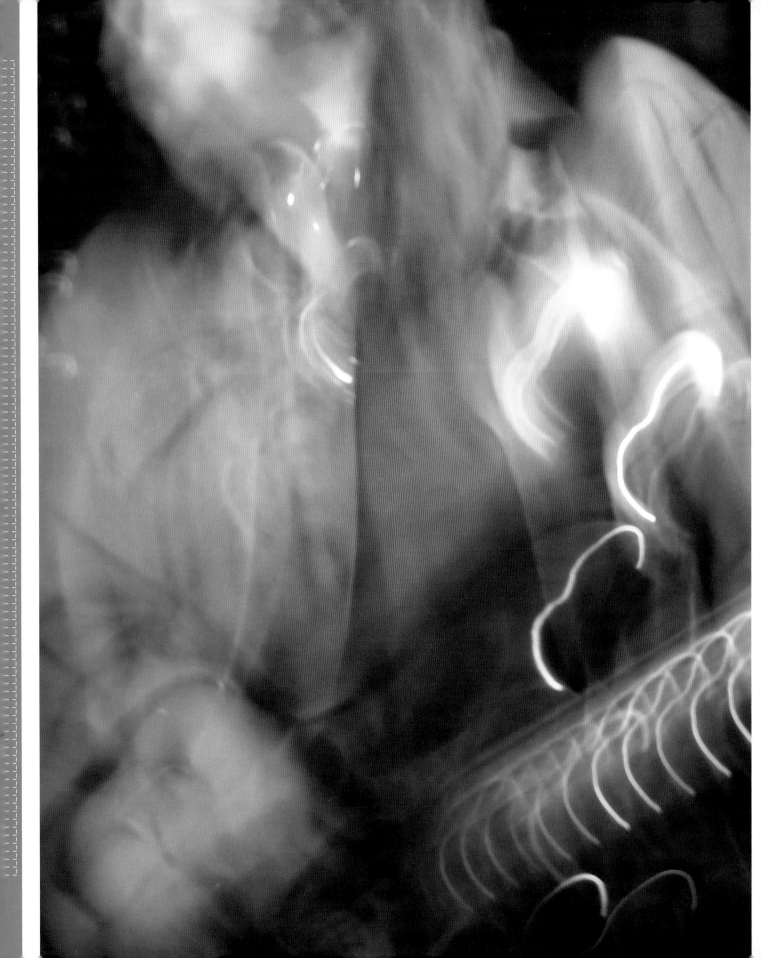

DEVELOP YOUR IMAGERY

Photographers often find themselves exploring the same themes for long periods of time. If you take photos at the same event every year, or at the same stop light every time you drive to the mall, you will learn to see more subtleties with each new set of shots. With experimental photography, this approach is particularly fruitful, as you will find that you are revealing different aspects of the same idea with each group of photographs.

Combine Themes

Combining skills and picture themes to develop new imagery happens so naturally that you may not realize it at first. In fact, you may not need to be aware of this process as long as your work keeps growing and developing. However, when you get stuck, this idea can yield a new set of images, photos that come directly from your experience and which build on your themes as an artist.

Suppose you like to take portraits and also like to photograph still life studies. You could combine these two interests so that a subject stands next to a still life composition set on a table, for example. Early on in my digital shooting experiments, I made a series involving my television and also a separate series of self portraits. Later, I combined these to make a series of self portraits with my television in the background.

Build on a Repertoire

Most photographers develop a repertoire of the subjects, situations, and lighting that they master. For example, as an experimental photographer you might be good at candid slow shutter speed portraits of your friends under natural lighting, as well as good careful compositions in mixed lighting at night. In this case you could combine these two skills to create unusual portraits of your friends under odd lighting; this could involve coloring the faces and clothing of your friends as they are engaged in their normal activities.

Provide Context

A series of photos or a thematic group of shots can provide context for the viewer. For example, a set of photos depicting automobiles in motion could progress from simple panning shots where the image of the car is clear, to quite abstract shots where the viewer must look carefully to see the distorted vehicle in the photo. In another example, a series of recognizable photos of people walking down a sidewalk might gradually change to quite abstract images of figures that almost merge with their background.

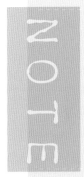

LEFT
This photo of a musician turned out to be very abstract and yet works as a composition.

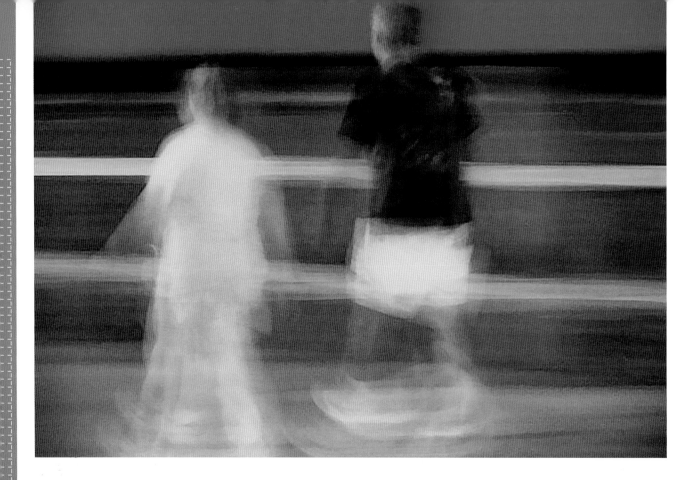

ABOVE
Before I attempted
candid photos like this
one, I took a number of
self portraits with body
movement.

Develop Your Own Personal Photographic Switch

Many years ago when I was working with film photography, I shot regularly in black and white and in color. After years of doing this, I realized I had developed a "switch" in my brain that I could turn on and off: a switch for color and a switch for black and white. When I shot with color film, I saw the world full of blues, oranges, yellows, and greens; when I shot in black and white I visualized the same world in shades of gray.

This kind of switch also works with the hi-tech world of digital photography. For example, you can learn to pre-visualize how a photo will look before you take it.

Pre-Visualize

Although the photographer Ansel Adams used this term with film photography, it applies just as well to experimental photography. Pre-visualizing means that you have an accurate sense of how pictures will look when shot in a certain environment or with a particular technique, and this ability comes with experience. Knowing this can save you a lot of time and allow you to focus on angles, lighting, settings, and situations that will work. For example, when you see a musician moving quickly under a bright light against a black background you can learn to pre-visualize how that performer will photograph at a certain shutter speed. Or when you come into an environment that is filled with different light sources, you can learn to judge how the camera will record those colors.

Caption Your Photos

Since your imagery can get quite complex and the subject matter hard to distinguish at times, you should add captions to your work when you display it in public, whether on the Internet or in a gallery. Just a few words can tell a viewer what to look for. For example, "Car in motion at night" can make a blurred image of a vehicle easy to grasp, but without such a caption, the photo might be hard to understand.

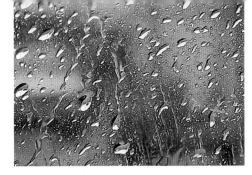

COMBINING EFFECTS

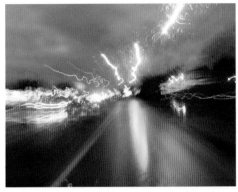

Combining imagery is quite personal and unique to the growth of an artist. There are no specific rules or formulas. When you become skilled in taking several types of imagery, consider putting two or more of them together in one photo. The following are some personal examples from my work.

1. Rain, Car Windshield, and Movement

Before I took motion photographs of streetlights through the windshield of my van when it was raining, I had taken a number of shots just of rain on my windshield and also a number shots of streetlights on clear nights as my van was moving. When I had mastered both of these types of imagery, I combined the two to create another series of shots—rain on the windshield as the car was moving.

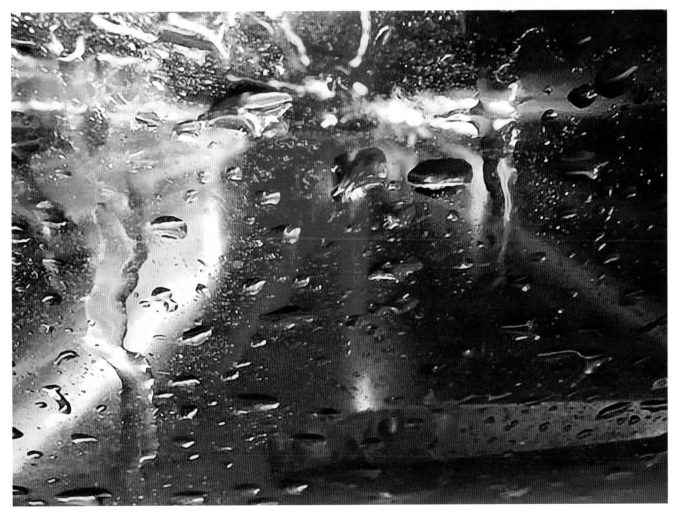

Combine Techniques

While every photographer has an idea of how to combine the various techniques mentioned in this book, here is an easy exercise that can yield some surprising results. The effects can be quite varied depending on the traffic, the weather, and where you decide to travel.

This exercise is similar to the camera movement exercise and requires two people, and the results you get may be similar to the photos I took of my wife driving that were described earlier in the book. One person drives the car, while you take photos of both the person driving and the sweep of lights as they pass behind the driver. This exercise should be done at night. Position yourself by the passenger door—make sure the door is locked—and face the driver.

Safety Comes First

Make your photographic settings and find a comfortable position for your camera before the car starts rolling. Always wear a seat belt. If you want to make a major change, stop the car and reposition the camera before continuing. Remember: the photographer should be careful not to distract the driver. Caution and patience are essential.

NOTE

These settings (above, right) will vary with the darkness of the night and the amount of ambient light. If the first images are too dark or too light adjust the ISO accordingly, but leave the shutter speed constant for each series of shots.

Possible Settings for Your Camera

Use Shutter Priority and choose a shutter speed somewhere between 2 - 8 seconds. Set the zoom to wide angle, focus on the driver, and set the white balance to Auto.

The photos of my wife driving (at right) were shot with the following settings:

Zoom setting:	widest angle—about 40mm (35mm equivalent)
ISO:	80
Aperture:	between f/2.8 and f/11, but mostly around f/2.8 - f/4
Focus:	The driver
Exposure Mode:	Shutter Priority
Shutter Speed:	4 - 8 seconds
White Balance:	Tungsten preset

Reviewing Your Photos

Take photos in this manner for half an hour and then review them before shooting another series. You will soon discover there are many variables, and you can capture accidental images that you had not planned on. For example, you will not be able to predict the amount of approaching traffic and how the lights of those cars will both illuminate the driver's face and also sweep behind the driver as the cars go by. The color of the lights also can be unpredictable; a green traffic light will throw a green cast on the driver's face, which may mix with the white light of another car's headlights. Additionally, subject movement often cannot be predicted. The driver may turn his or her head, or the car may hit a pothole that jerks both the camera and the driver.

2. Slow Shutter Speed Portraits and Camera Movement

I took a number of photographs of my wife using slow shutter speeds. Around this time I was also taking a number of light painting shots from the side window of my van as I drove down the street. After a while I realized that I could combine these two ideas. Using a wide-angle lens, I pushed myself against the passenger side door and took photos of my wife as she was driving. She was relatively stationary in relation to the camera but we were moving very quickly in relation to the lights outside her windows. Chance played a large role since I could not predict the color or intensity of the lights, which both created a light painting pattern behind her and also lit her face.

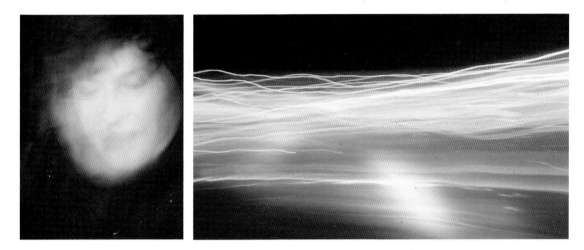

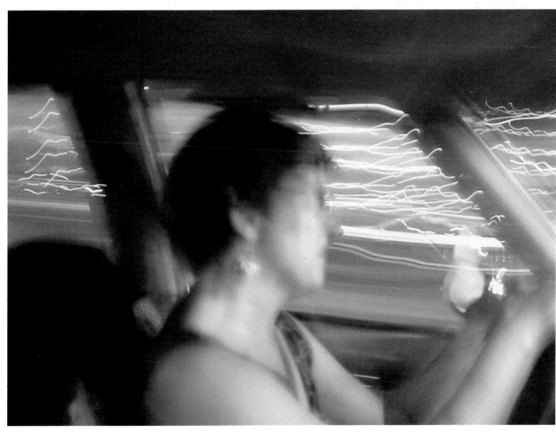

3. Silhouettes and Light Painting

I had done considerable work with candid silhouettes, even my own. This first candid shot (right) was taken at a fall festival; then a situation occurred that allowed me to take a shot of silhouettes combined with a light painting background (below). This was a spur of the moment shot that was extremely experimental, as I did not know how these photos would turn out.

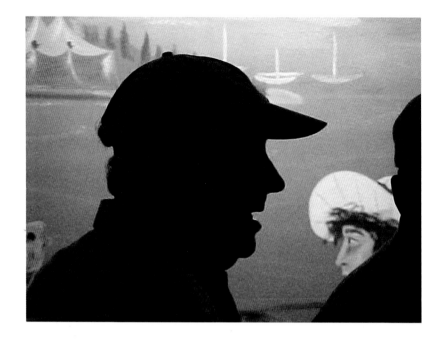

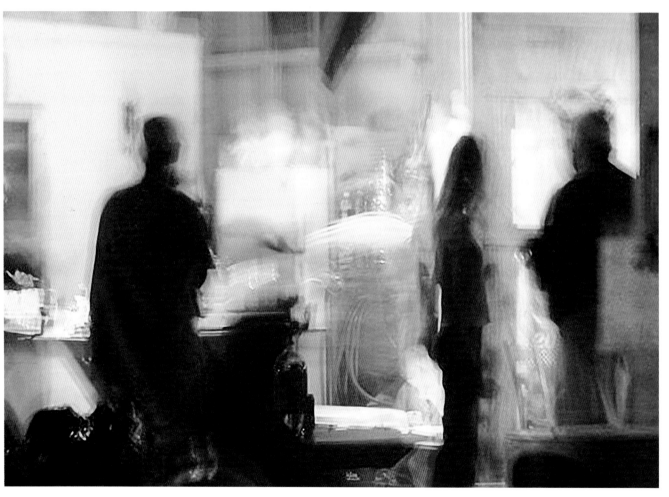

My Personal Journey

ART AND IMAGERY ARE VERY PERSONAL, and each photographer combines his or her skills in unpredictable ways—this is part of the fun of creation. However, it is useful to see how other photographers progressed along with the steps and stages he or she went through.

To draw from a personal example, I was not aware that I had taken all of these steps until I started to write this book. Yet, when I went back over my 10 years of digital photographs, it became clear that when I had mastered one subject matter or one type of situation, I added it to my repertoire and built on it. During these 10 years, my imagery evolved from standard, carefully focused compositions to dynamic photos of moving people and situations.

Personal Examples of Evolving Imagery

- I made a number of carefully composed pictures of neon before I began to play with neon lighting by moving the camera or using the light to illuminate my face in a self portrait.

- I took a number of well-focused self portraits before I branched out to photos of myself in motion.

- Before I took candid photos of people walking on the waterfront near where I live, I took a number of self portraits where I had added a considerable amount of body movement.

4. Night, Portraits, and Light Painting

When I saw a person carrying a lantern in the evening near a night fishing spot, I grabbed my camera and hoped for the best as I had only seconds to work with. I had taken pictures at this fishing area many times before, so I was familiar with the area. In this case, I guessed that the lantern light would adequately illuminate the person and that the light reflected in the water would make a light painting background when I panned my camera. While I was quite sure that the lamp itself would overexpose, I guessed that this brightness in the middle of the shot would work for the overall composition (below).

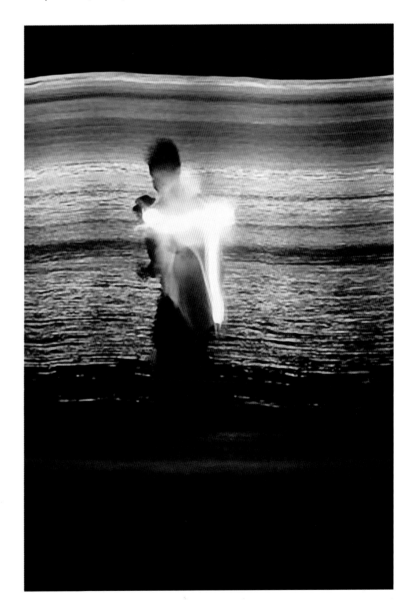

5. Lightning and Light Painting

I had taken a number of photos of lightning, which is not as difficult as it might seem. I simply steadied my camera, selected the longest shutter speed and then aimed it in the direction where the lightning was hitting. Sooner or later the shutter would be open when the lightning struck and the lightning—being so bright and yet so fast—would be registered as a fairly sharp photographic image. For this particular shot, I positioned my van where I had taken many photographs with the added light of my headlights. I also knew that lightning was striking over the water across from this spot. I turned on my van lights and hoped that I would get lucky, guessing that a bolt of lightning would be the right brightness to mix with light of my headlights.

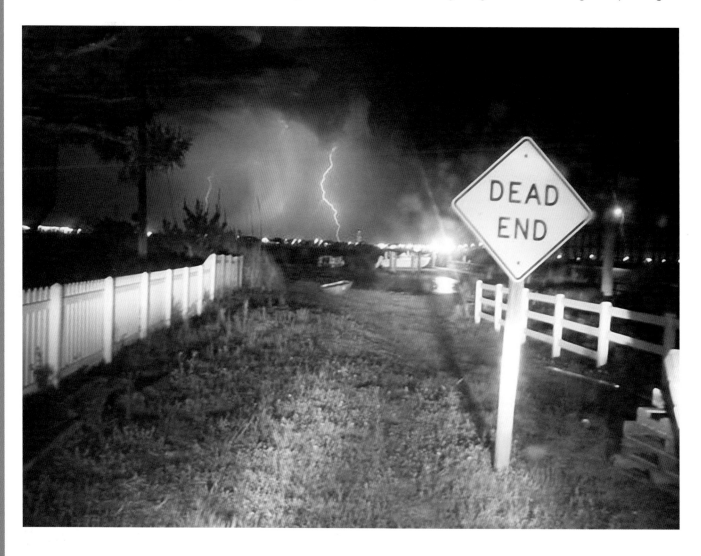

6. Self Portraits and Alternate Light Sources

I had taken a number of self portraits that used the light from a TV on my face (left, top), and I had taken a number of slow shutter speed photographs of people walking. Then it occurred to me to take a self portrait with the TV combined with a slow shutter speed—to blur the image on the TV and to make that screen image abstract (right, top).

For this next series, I combined a self portrait with my previous imagery of a Ferris wheel to come up with this unusual self portrait that included negative ghosting (bottom).

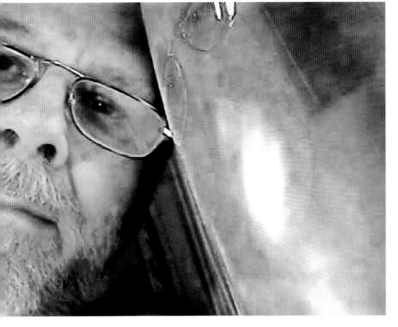

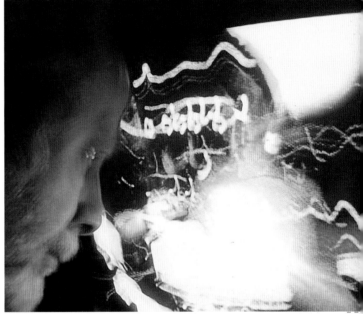

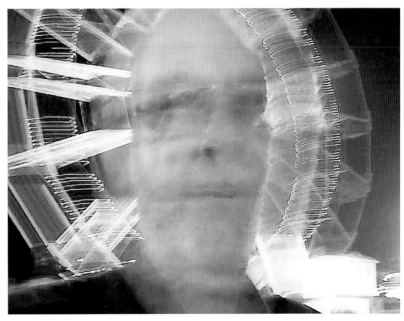

Sometimes your experimental photos might be too blurred or contain too much movement to be very recognizable. If the image still works and you like the composition, consider it to be an abstract image—one in which the actual subject matter disappears within your experimental techniques but which still functions as a colorful composition.

Here are some examples of compositions that went past the point of depicting a realistic subject and crossed the line into abstract imagery, although buried in each photo is the actual subject.

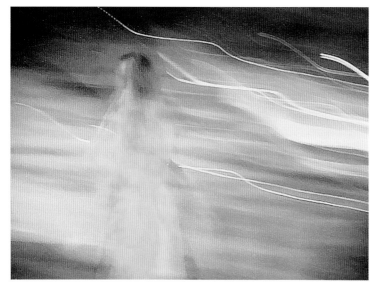

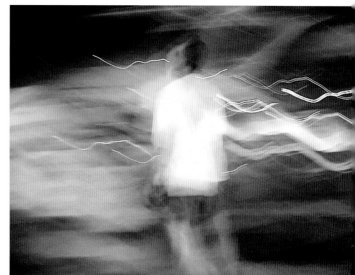

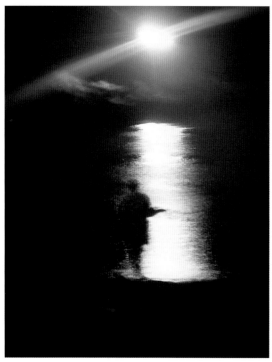

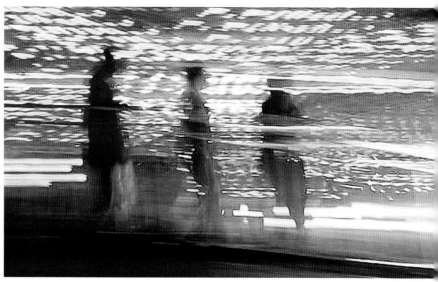

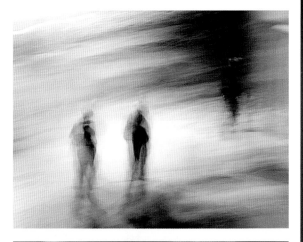

THIS SPREAD
When the experimental pictures go past the point of clearly recognizable imagery, abstract images can happen. Don't be in a hurry to discard your work before looking at it from an abstract point of view.

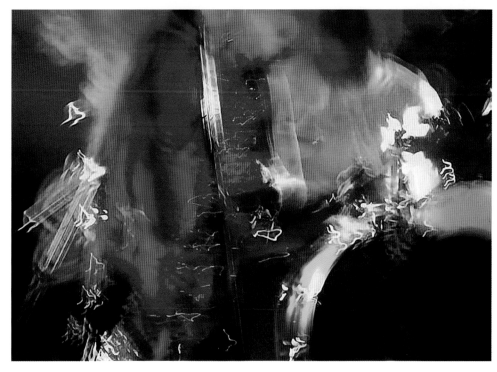

Saving and Editing

YOUR IMAGES

After you are finished shooting, your work has only just begun. Many if not most artistic photographers spend more time carefully reviewing their shots than they do actually taking the photos. The reason is simple: The act of taking pictures may involve many people or a fast changing event—to do good work on a shoot, you should be in high gear and on top of your game—yet this kind of intensity can normally be sustained for only a few hours.

The job of reviewing your shots, however, can be done in a leisurely and more reflective fashion. This review time is in addition to any time spent tweaking photos in the digital darkroom. Like all disciplines, there are a lot of chores that should be done by the serious photographer after every session.

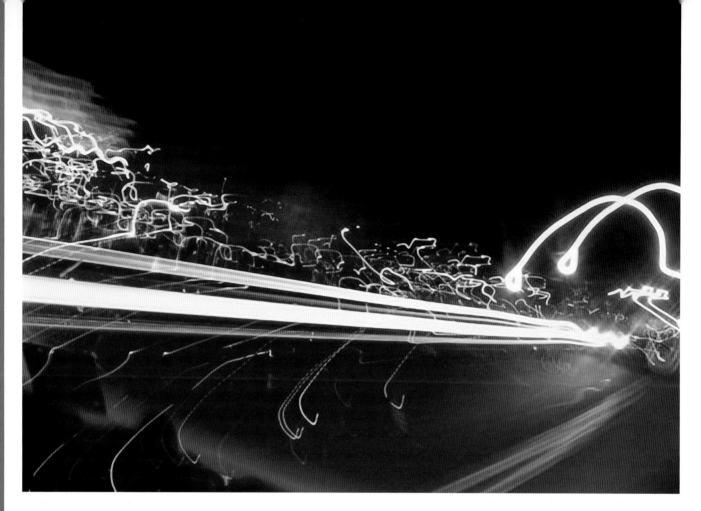

I had completely missed this photo until I went through my old shots for this book. This is an example of how easy it is to overlook something and why it pays to go back and revisit your work from time to time.

STORING AND ARCHIVING YOUR IMAGES

Archiving your images has always been an important aspect of photography. Storing negatives came with it's own issues, but the digital age has presented photographers with a whole new set of storage complications. Since digital photography costs very little to shoot, photographers tend to take a slew of pictures. For this book, for example, I went back through ten years of digital photos and in the process discovered I had shot over 50,000 pictures. The large number of digital photos means that you will need to carefully manage and organize your files.

External Hard Drives

AS YOU UNDOUBTEDLY KNOW BY NOW, digital photography uses a lot of hard drive space since each photo can take up megabytes. The solution for both additional space and also for backup is a USB drive. They are compact, fast, cheap, portable, and come in a variety of storage sizes. USB drives have another advantage. If you computer crashes, you simply plug the USB drive into another computer and you are back in business.

Used in conjunction with simple backup software, such as SecondCopy (www.secondcopy.com), this becomes a strong archival system. You can back up your altered and additional files every night in minutes.

Basic Storage Goals

The sheer number of digital images you can accumulate demand that you develop a precise editing, storage, backup, and retrieval system—a system that you can use year after year. This system must be flexible so that you can add tens of thousands of photos, and it must be consistent so that you will be able to find photos from years earlier.

Rules for a Safe Filing System:

- Save the originals in separate, clearly named folders so they can never be accidentally overwritten

- Organize the originals so that you can find them by date

- Do not organize images by the camera-assigned number; automatic camera numbering systems repeat eventually

- Create a renaming system that is clear, consistent, and different for processed photos than for the originals

- The system should be easy to navigate so you can find your best shots; it should be easy to go back years later and find other photos shot during the same time period

- The system should save EXIF data when you modify the image

- A note-taking system should be included as part of your archiving method; use it to take notes to remind yourself how you constructed your archive and also the meaning of any shorthand system you devised to name files along with notes about specific shooting sessions

- Backup your image library every time you add new images or process photos

Specifics for Managing, Storing and Editing your Photos:

- Always save a copy of your original photo. Never ever overwrite it with a modified version. Keep your originals in a separate folder from the images you are modifying in your digital darkroom.

- Backup your originals onto an external hard drive. When you are done backing up, double check to make sure that your copy was successful.

- Once you have made certain that you backed up your photos properly, it is a good idea to format the memory card in the camera. Formatting should always be an in-camera practice; you can usually find this function in a setup menu. Unlike simple deleting of images, formatting erases the existing images as well as completely resets the card. Formatting can also act as a check to the integrity of the card.

"The joy of geometry—when you realize everything is right."

HENRI CARTIER-BRESSON, PHOTOGRAPHER

BELOW
This is a typical thumbnail screen in an editing program. Editing programs allow easy organizing, storing, and retrieving of images. This screen shot is from the free IrfanView program.

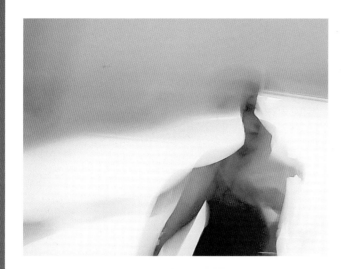

Now that you have backed up your work and put your originals safely in their own folder, it's time to get to work. I recommend that you go through your images more than once before you start to make decisions about which to select. It takes practice to understand which photos are worth spending time on.

Working with experimental photographs in the initial editing stage is particularly difficult for a number of reasons. First, you may shoot dozens of photos that don't work before you come across one that does. Second, because your images are experimental you can often miss potentially good photos, especially if they need further adjustments with an image editing application. Take the time to really look over your shots; look for the unexpected, accidents, or effects that you had not planned on.

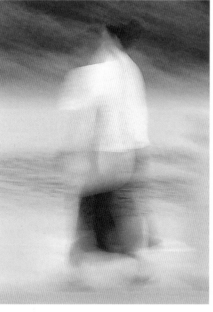

THIS PAGE
These three photographs did not turn out the way I expected, but rather than dismiss them as mistakes, I see them as fruitful imagery that I would like to explore.

Watch for Accidents

BE PARTICULARLY ATTUNED to accidental and unusual imagery. The unexpected can be a powerful source of inspiration and spark new ways to approach your work. Yet many people have trouble both identifying accident and also accepting it. They often don't see it because they had a certain effect in mind and an accident falls outside of that perception. Or, they don't accept it because they feel that they were not responsible for the effect—that it was blind luck. However, accident has played a major role in art and science, and often the most important accidents have happened to people who were deeply involved with looking for the kind of effects that the accident created. Consider the following anecdote:

"I was returning, immersed in thought, from my sketching, and on opening the studio door, I was confronted by a picture of indescribable and incandescent loveliness. Bewildered, I stopped, staring at it. The painting lacked all subject, depicted no identifiable object and was entirely composed of bright colour patches. Finally, I approached closer and only then saw it for what it was—my own painting, lying on its side on the easel! One thing became clear to me—that objectiveness, the depiction of objects, needed no place in my paintings, and was indeed harmful to them." —WASSILY KANDINSKY, 1908, painter, considered the founder of abstract art.

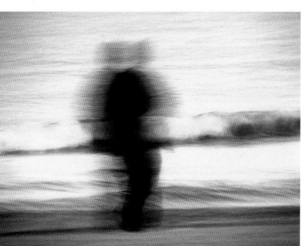

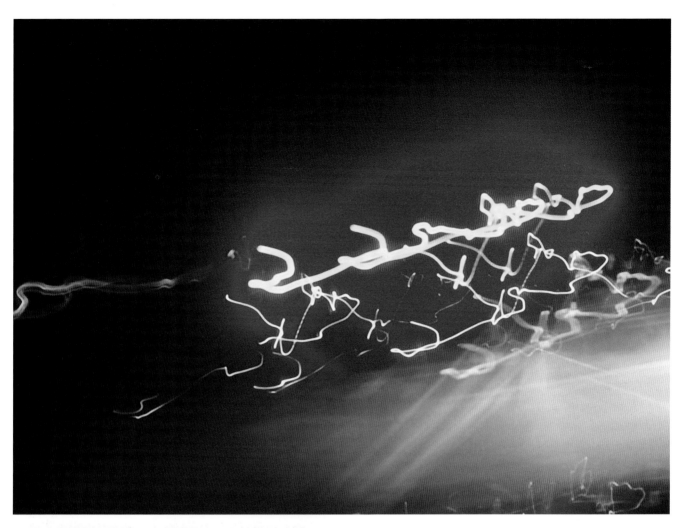

LEFT
This glitch photo happened with an early digital camera. To be honest I have no idea why this image came out this way. I know that it was extremely underexposed, but I had taken underexposed shots before with this camera and I did not get this kind of glitch effect.

ABOVE
This is another happy accident. The atmospheric conditions diffused the light to create this effect which I was not expecting.

"The way I work now is accidental, and becomes more and more accidental."

FRANCIS BACON, PAINTER

 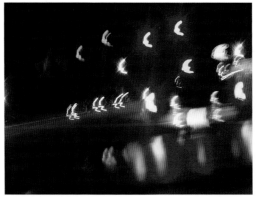 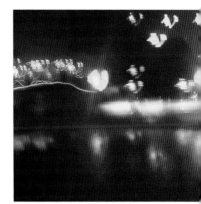

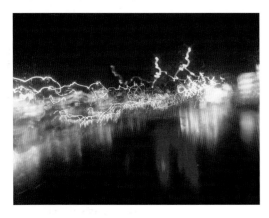 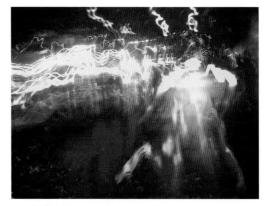 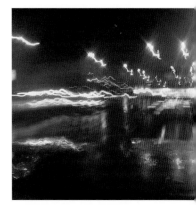

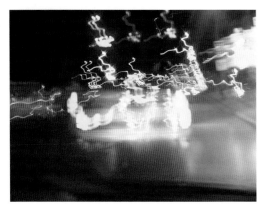 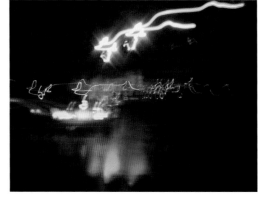 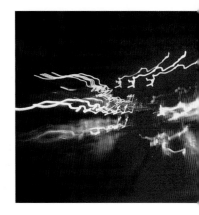

THE EDITING SYSTEM

As I pointed out earlier, you may find that you shoot from 50 to 100 photos to get a really good one that you like. To find your way through this forest of images, I recommend a two stage process: The first step is to save any promising photos to a "working" folder, and the second step is to save only the best of the best of these to another folder which you might label "best".

In the first stage of editing, don't be too picky. Select and resave any pictures that you think have potential. This simple process will drastically reduce the number of photos you will need to evaluate; instead of looking at hundreds of images, you'll only be looking at dozens.

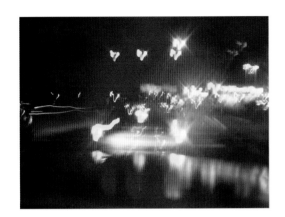

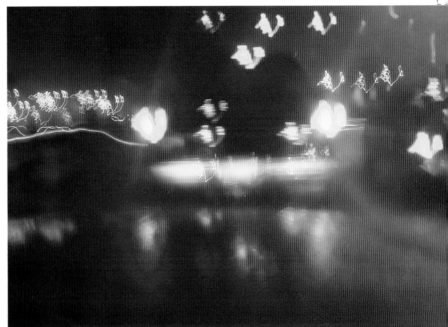

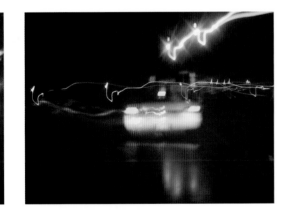

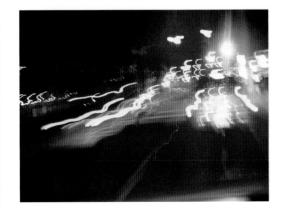

LEFT
This series shows the classic task of editing. My goal is to determine which of the brake light series is the best. I have deliberately grouped them together to show the difficult task of choosing from among a number of similar pictures.

ABOVE
Out of this series, I chose this one as my best; it is a study in red with reflections and depth across the entire composition.

The Working Folder

Adopt a simple system for marking promising photos for darkroom modifications and accessing them later. The first stage of editing is saving your originals; you might call this second stage of folders "working," followed by the date or the name of the event that you photographed (such as "working_birthday"), and then save copies of your photos to that folder. Once you have put these selected images into a working folder, rename them so that they cannot accidentally overwrite the originals. You might rename them "birthday_001," "birthday_002," and so on.

Renaming groups of images is quite easy; there are several free programs that enable batch renaming—programs that rename all the files in a folder with the same name plus sequential numbers.

The Best Of The Best

Once you have selected any promising pictures from your shoot, your editing job becomes much easier. When you view a strong photo next to another strong photo—rather than being mixed in with dozens of so-so photos—it becomes obvious which are the best of the best. This is your third stage of editing: save the best of the best to a folder marked "best".

Now you are ready to get to work. Go through each of these photos as needed with your digital darkroom and make corrections.

Weeks or even months after your first edit, you might go back to your working folder and see if there are any images you missed at the time that you now want to reconsider.

Why the Extra Zeros?

WHEN YOU RENAME FILES, you'll usually want them sorted in the order you shot them. If you shoot over 100 images, you should end the file name with the three digit numbering option (_000) since only using two digits (_00) will not sort correctly once files are numbered past file number _99. If you don't choose the correct number of integers, then "picture_99.jpg" will be placed after "picture_144.jpg" and therefore end up in the wrong order.

FREE EDITING AND PROCESSING SOFTWARE

IrfanView is a fantastic program and it is free (www.IrfanView.com). You could not get better software for quickly viewing your files, and it is also a superb basic image processor. In fact, this program does so many wonderful things I will not try to describe them all. Instead you should go to the IrfanView website, read the features page, and get your own free copy.

RIGHT
A shot of the main screen of the IrfanView software. Even if you own other software, this free program is a must-have for any digital photographer.

Batch Renaming Software

The small, simple freeware program, Rename-It, is a digital photographer's dream. This program can perform the most sophisticated renaming tasks on hundreds or thousands of picture files, making archiving and storing quite easy. Go to download.cnet.com to find a free copy. The highly recommended free image program IrfanView also has a batch-renaming feature.

ABOVE
The Rename-It batch renaming software.

ABOVE
The IrfanView batch renaming feature.

Renaming Your Working Files

WHEN YOU TWEAK AND PROCESS YOUR PHOTOS in the digital darkroom, you should always use the "Save As" control and rename the file each time you make a major change. Never save over the original file; leave it just as you imported it from the camera. Rename the files you plan to process with a name that makes sense such as "birthday.jpg," as recommended in this chapter. (You might even consider saving a new version of the file each time you make a change—such as "birthday_001a," "birthday_001b," "birthday_001c," etc.—especially if you are not sure how you want to use the file or what changes are your favorite. You can always delete the versions you don't want later.)

After years of working with file names, I recommend adding an underscore symbol (the _ symbol) and then a number, such as "birthday_001.jpg". These changed files names will really jump out at you when you look at them on your hard drive.

Notation Software

The very best program I have seen for note taking is completely free. It is called Treepad, and it allows you to make a sophisticated folder and sub folder system for a wealth of information. This software is perfect for keeping notes about your photos and anything else related to your photographic work. You can easily search and retrieve your notes months or even years later. To download a free copy go to: www.treepad.com and download the program, Treepad Lite.

ABOVE
The free note taking software, Treepad.

Basic Corrections with IrfanView

More than 90% of your photos should not require more than the following corrections, which can be easily accomplished by the free IrfanView program. These controls are pretty ubiquitous and are available with most editing software. The names of the correction tools can vary from program to program, but the functions are similar, if not exactly the same.

Lighten/Darken: An image that is too dark or light can be easily tweaked with this simple control. Just remember when you are brightening, you are in essence adding white to all the colors (i.e. more pastel) and when you darken you are adding black. Lightening an image—especially an image taken in low light environments—might create noise issues. You can minimize noise by using a low ISO setting, or you can enhance noise by increasing the ISO. We discuss this later on in this chapter. (This tool is called Levels in Adobe Lightroom, Photoshop, and Photoshop Elements.)

Gamma: Gamma is very similar to the lighten/darken control, but it lightens the shadows more quickly that it lightens the highlights. This means that you can bring often bring up shadow detail without blowing out the highlights. The gamma control is perhaps the one control you should use the most. (The Gamma tool is called the Curve tool in Adobe Lightroom, Photoshop, and Photoshop Elements.)

The IrfanView brightness control tool.

The IrfanView gamma control tool.

The IrfanView contrast control tool.

> **NOTE**
>
> **The gamma, contrast, lighten/darken, rotate, and cropping features are probably the most commonly used controls in the digital darkroom.**

Contrast: Adding contrast will give your photo more snap—to a certain point. Contrast has certain side effects, such as increasing the graininess of the image, or making an overall color cast more pronounced.

Crop: Experimental photos may require some cropping since it is often necessary to give these images more room than other photos. Tight cropping almost always improves an experimental photo.

Rotate: Your horizontal photos may need to be rotated to a vertical position, or you might need to adjust a skewed horizon line. The latest version of the free IrfanView program has lossless JPEG rotation available as a plug-in.

Color Correction and Saturation: There are different versions of basic color corrections. Several variations involve changing the overall hue and increasing or decreasing the color saturation. Saturation allows you to vary the intensity of the colors. At one extreme the colors will often be bright and bold and at the other extreme they will render as shades of gray. To my mind, the most useful control is the one in the free IrfanView program that lets you adjust the red, green, and blue values. While this takes some getting used to, it allows fine-tuned control over the color tones in your photograph. (This tool is referred to as Hue/Saturation in Adobe Lightroom, Photoshop, and Photoshop Elements.)

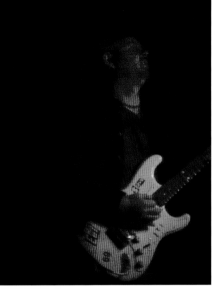
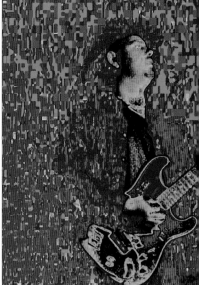

ABOVE LEFT
This photo of a musician was underexposed.

ABOVE RIGHT
After increasing the brightness, I tweaked the image to create a more graphic image. However, I did not add computer graphics; I only brought out patterns and colors that were in the original photograph.

Use the Multiple Undo Feature

MANY DIGITAL DARKROOM SOFTWARE PROGRAMS have a sophisticated undo feature which allows you to undo many changes, step by step, and also redo changes step by step. This can save you a lot of time and aggravation if you go too far in your processing and want to go back to an earlier stage. Some software programs allow you to set the number of undo steps; I suggest selecting a high number.

The IrfanView saturation tool.

The IrfanView color balance tool.

Playing with Digital Darkroom Controls

Having encouraged you to concentrate on in-camera photographic effects and keep your digital darkroom time to a minimum, I have to admit that on some rainy days I will take a few images and play with them using PaintShop Pro.

While I know it does not look like it, I did not add any computer graphics to these images; instead I tweaked them to bring out what was already present in the image. I primarily used the highlight/midtone/shadow control in PaintShop Pro. This allowed me to manipulate the color of different areas of the picture while leaving other areas untouched.

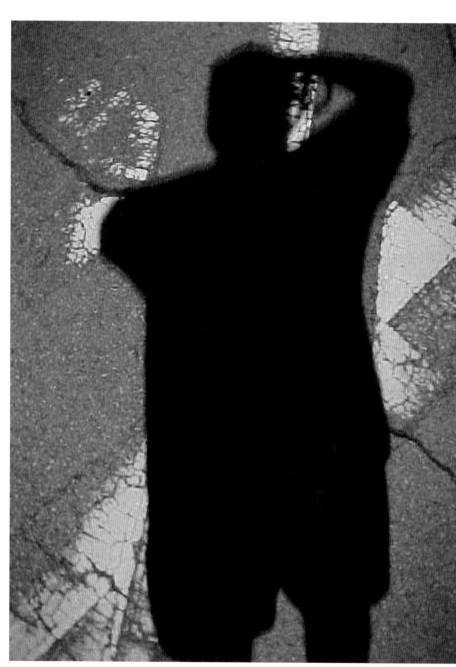

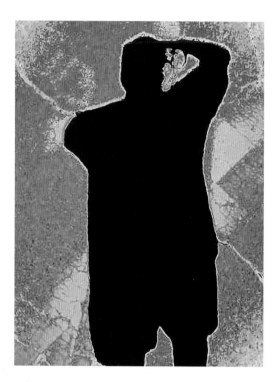

This Page:
I took this self portrait of my shadow against an old railroad-crossing marker painted in the road. The light source was a streetlight above me. The larger image is the original, and the smaller is what I created after tweaking it in the darkroom.

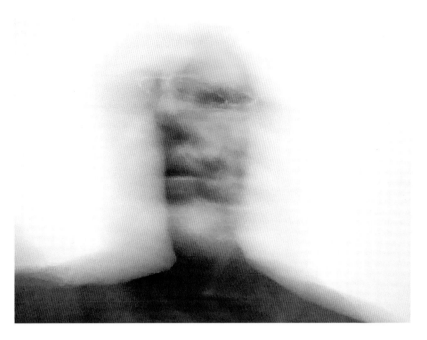

THIS PAGE
These five pictures are all from the same original photo (above, left). I played with this self portrait to see how many variations I could get.

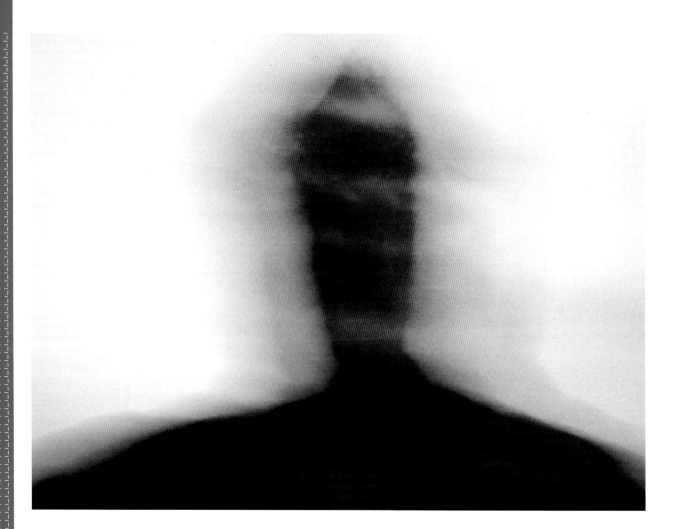

THIS PAGE
Like the series before this, I
played with the original first
photo to get the next three and
to see just how many different
variations I could arrive at.

NEAR AND FAR LEFT
This shadow picture and its companion was derived from a real shadow (see below). After cropping and tweaking the image in my digital darkroom, I came up with these two images with no added computer graphics.

LEFT
This is the original picture that the shadow image was made from.

"He [Henri Cartier-Bresson] always said eye, mind and heart had to be aligned."

FERDINANDO SCIANNA,
PHOTOGRAPHER

Noise is the digital equivalent to grain in film photography and occurs in the same situations, usually photographs taken in low light with a high ISO setting. In digital photography, noise is caused by random sampling errors of the digital image sensors when these sensors are pushed to the limit, as they are in low light environments.

Low light photography often needs higher ISO settings to record an image, and higher ISOs can produce a significant amount of noise, which you may like or you may hate depending on the image. As an experimental photographer, you are bound to encounter situations that require a high ISO setting. If the noise in these photos is objectionable, there may be a software fix that can remove most if not all of it.

Free Noise Software

Experimental photos can require one additional piece of software you might not need with other kinds of photography: noise reduction software. Noise reduction software does exactly what it says; it minimizes the appearance of noise in digital images.

I recommend that you try out the free Noiseware "community edition" software. This freeware program is powerful enough to show you what noise removal and noise tweaking can do for your photographs. If you like the results from the freebie, you may want to buy the standard edition; at the time of this printing the software was selling for around $30. Go to the website at: www.imagenomic.com.

About Your Software Settings: I recommend that when you process a batch of photographs, you keep track of the settings you made when you corrected them. Since program settings can often be set quite precisely, you can make a record of them and return to those settings if needed. The easy way to do this is to take notes or reference the EXIF information.

Saving your files after you've edited or adjusted them is a no-brainer. There are several things to remember when you save your adjusted files: do not to overwrite the original file, make sure you can easily find your changed files, and save your image in the appropriate file format.

JPEG File Format

Although the JPEG file format is perhaps the most commonly used format, it is a lossy format. This means that when your file is saved in the JPEG format, some detail is lost depending on the level of JPEG compression that is used: higher compression results in a smaller file size and more detail is lost, and lower compression means a larger file size and less detail lost. If you are publishing the image on the Internet, you will want to save it as a JPEG—it is a smaller file size, meaning faster downloading, and it requires less storage space.

Select the JPEG Compression: The JPEG compression is often set at a default level in your software, which will not save your image at the best quality setting. The setting itself is often buried. For example, in the IrfanView program, you must first use the "Save As" function for a file, to bring up a dialog box that allows you to choose the "Options" submenu; here you can finally select the JPEG compression setting.

If you want to save your files as JPEGs, I recommend that you select the highest JPEG compression setting. Also, make sure to set this as your default JPEG compression setting; some software will reset back to the factory default unless you specify a new default.

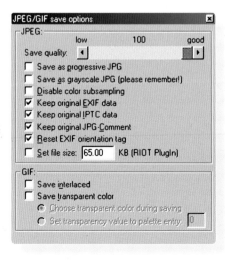

NEAR LEFT
The JPEG compression dialog box in IrfanView.

FAR LEFT
The free Noiseware Community Edition software for reducing noise in your images.

TIFF File Format

To be absolutely certain that no image quality or detail is lost when you save your edited files, you should save them in the lossless TIFF format. One downside is that TIFF files are huge. If you have limited hard drive space, you may not be able to do this for very many files. But I recommend you consider saving all of your edited images as TIFF files; storage is cheaper every day, and you never know how you might want to use that file in the future. You can always size it down for specific needs, but you can't add more information to the file. If you are printing your image, you will probably want to save it as a TIFF—the TIFF format retains the most detail and image quality.

BELOW
This photo needed a bit of cropping to remove part of my van window that appeared in the shot. However, other than that, no other processing was required in this 8-second exposure.

Don't Overuse It

AS WE HAVE DISCUSSED, the first rule of experimental digital photography is that there are no rules. However, having said that, I do have some personal opinions. One of these opinions is that the digital darkroom should not be overused.

To put it simply, I encourage you to put more of your effort into taking the photograph and less into tweaking it on the computer. Seasoned photographers know that the better the photo at the outset, the less work needs to be done later in the darkroom, digital or otherwise. For example, many if not most of my photos in this book were not cropped and required minimal, if any, darkroom corrections.

The bottom line is this: Would you rather be outside taking pictures or inside working on the computer? As a photographer, I know I would much rather be out taking photos.

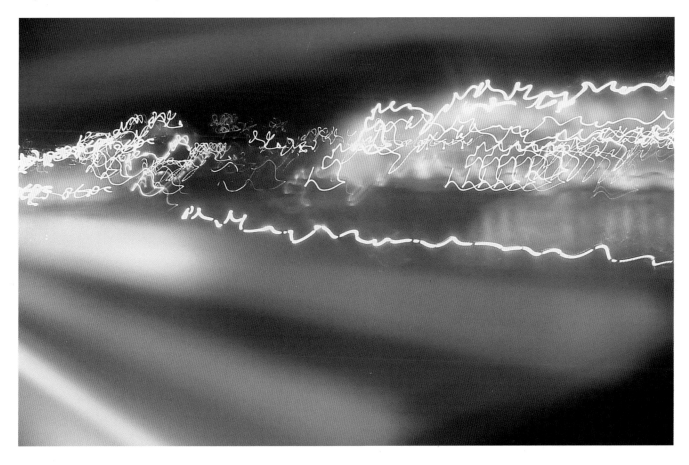

Judging Images

AND FINDING YOUR VOICE

When you throw out the rule book, what are the rules? Because experimental photography often uses blur, distortion, and other non-traditional picture elements, the normal ways of judging and evaluating a photograph do not apply. Many experimental images look raw or rough, as they were intended, so the normal rules of perfect computer and digital control are not appropriate either.

However, this does not mean that all experimental photographs are equally successful. It simply means that the criteria for judging them are different.

> "It is our function as artists to make the spectator see the world **our** way—not his way."
>
> MARK ROTHKO AND
> ADOLPH GOTTLIEB,
> PAINTERS

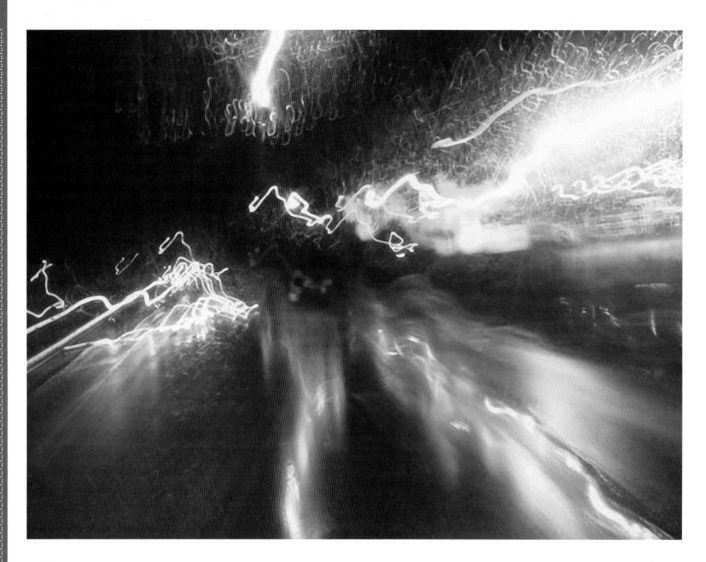

Even a slow shutter speed image should have a full range of tones from black to white.

CRITERIA FOR JUDGING EXPERIMENTAL PHOTOS

Full Tonal Range: While this rule can certainly be broken, most photos have more snap and more power when they contain a full range of tones from black to white. This is an old rule in photography, but it still applies even in the digital era.

Color: A photo should have a clear sense of color. There should be a palette of colors that work together with a range of saturation, along with subtle shading that gives the image both depth and dimension.

Clarity: While this factor seems contradictory to experimental photography, it is not. The various elements of a photo—even if they are blurry or in motion—should be clear.

Composition: An experimental image should have strong composition. When viewed at a distance or abstractly the composition should be balanced and effective.

Complex Subtlety: A good experimental photo should have depth, levels, shading, rhythms, and interior geometry.

Appropriate Technique: The particular experimental technique should fit with the subject matter.

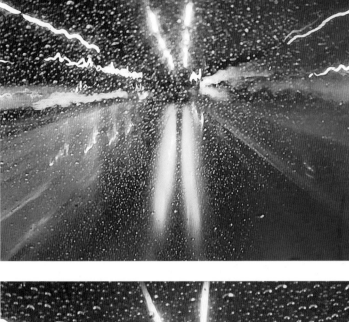

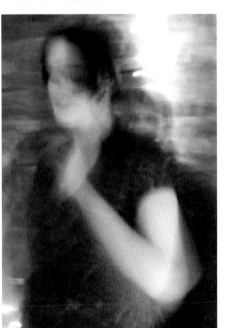

ABOVE
The different elements of a composition should be distinct.

LEFT
Careful and close composition is essential to any good photograph.

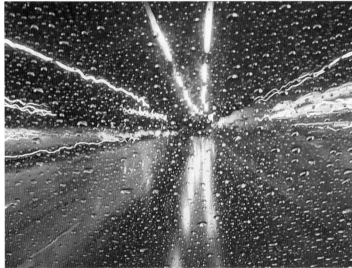

ABOVE
These two pictures, taken seconds apart, have a very different feel. I changed the colors using the white balance control. Because of this, the color palette in the top photo is primarily blue and yellow, while the palette in the bottom photo is primarily only yellow.

Dynamics: Instead of thinking of these pictures as still images, think of them as active compositions. Every active element affects the other elements and can create ripples, reverberations, and interaction. With these compositions, look for energy, flow, rhythm, direction, tension, and opposition.

Flexible Framing: In some compositions, people or objects might give the feeling of wanting to break out of the frame or move beyond the frame. In other compositions elements might appear to be crashing into the frame or intruding.

Make a Print

MY FAVORITE TECHNIQUE FOR JUDGING MY IMAGERY is to make a print. I print my favorites, put them on the walls, and live with them for a while. I see this work at odd hours, such as when I am half asleep or rushing out the door. If I get tired of one after a while, then it didn't have much depth. If, six months later, I see things in an image I did not see before, that is a good photo.

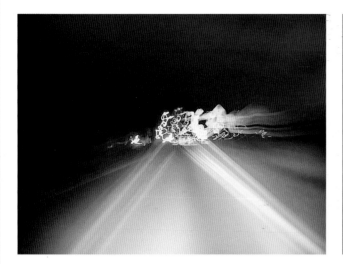
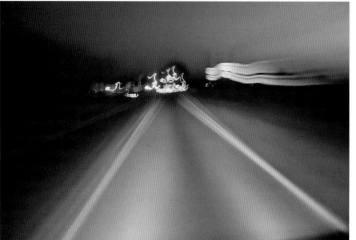

These three minimalist highway photos are constructed in the same way, but have a very different feel. The force and movement of the highway plays a major part in the composition as well as the graphic and static elements of the triangles that make up the road, the land on either side, and the sky. As the painter Paul Klee noted, a composition can be both stable and contain a sense of motion. Klee called this type of composition "calm-dynamic".

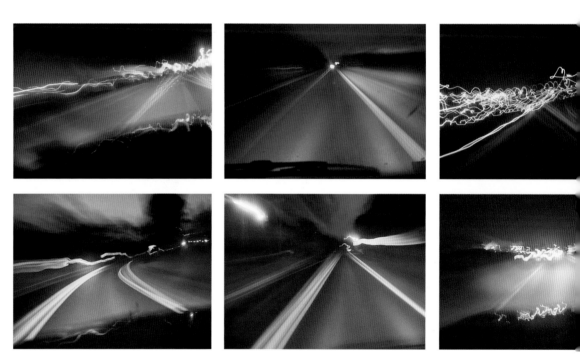

ABOVE
How many ways can you photograph a highway as you drive down the road? This kind of study is good for experimental photography; these photos show the different moods, colors, movements, and lighting that can be achieved with the same subject matter.

"I think of my pictures as dramas; the shapes in the pictures are the performers."

MARK ROTHKO, PAINTER

But is it Art?

WHILE A NUMBER OF CRITICS will dismiss experimental photography out of hand, many of these same people admire Impressionist painters. However, one has to ask why the rather indistinct Impressionist paintings are great art, but slow shutter speed photographs poor photography? In both cases, the overall lack of sharp detail is important because it expresses a larger idea—an impression of reality.

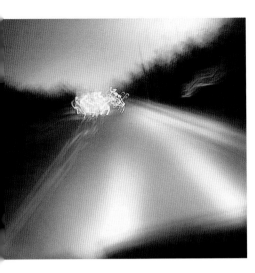

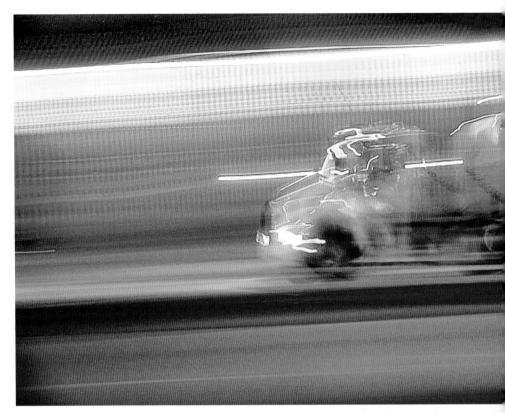

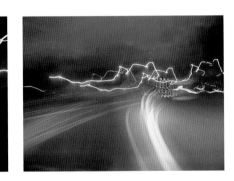

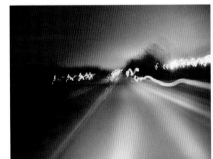

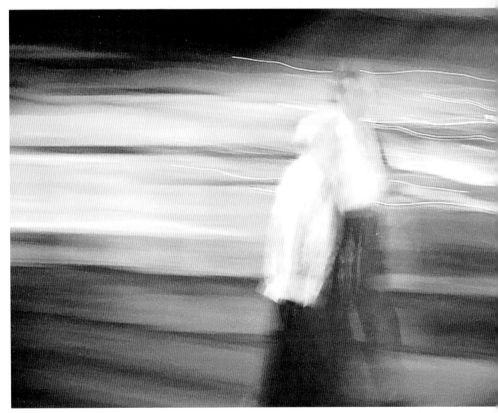

When movement is added to composition, things change. In the first photo the truck seems to be rushing to fill the empty space in the left of the frame. In the second photo there is very little space in front of the walking couple; they seem to be quietly and slowly exiting the frame.

The Digital Dilemma: Creativity in a High Tech Art Form

Many people are concerned that this digital age will rob us of our imagination and creativity, and to be sure, many photographers have become obsessed with pixel perfect creations. As Iman Moradi wrote in his dissertation on media, "we are becoming more silent as technology finds its own voice."

But just because digital cameras and computers can create perfect imagery does not mean that other forms of photography cannot exist. In fact, as this book shows, just the opposite is the case. For those who want to take up the challenge, digital cameras allow unprecedented potential for expression in photography—expression that was not easily accessible for photography in the past but that now can be unleashed due to the power of digital technology. More than one person has responded to the passion of experimental digital photography with emotions that can only be called poetic.

Yet like any art form or discipline, digital photography is both technical and artistic; and as always, in order to be truly artistic, a photographer should learn the nuts and bolts of the craft. Then, like a dancer who has mastered the basic steps, a photographer can branch out and put his or her creative stamp on their work.

> "The voyage of discovery is not in seeking new landscapes but in having new eyes."
>
> MARCEL PROUST, AUTHOR

Build on Your Own Experience

You are your own best teacher. The photos you shoot will point the way to new photos and new avenues for exploration. Just keep shooting.

If you take hundreds or thousands of shots, you will soon have your own experimental library. All the pictures you took, even those that did not work, will help you develop your skills, your themes, and your style of imagery while at the same time helping you become more comfortable in various situations where you take your pictures. As you go over your archive of photos, keep these ideas in mind.

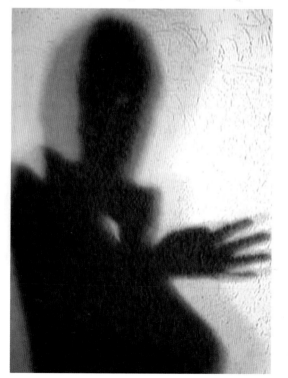

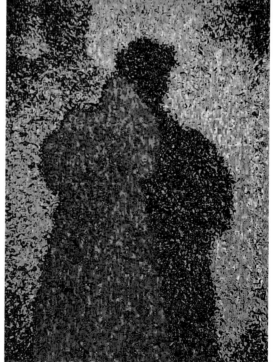

LEFT
I used my shadow for my early figure study efforts.

Periodically Review Your Work

Every couple of months, you should browse your picture files with no particular purpose in mind. Like all creative pursuits, your best ideas may come to you when you are not goal oriented but rather when you are just taking the time to flip through your various photos. Often a photo that did not work or that almost worked will point the way to a new technique or yield new ideas.

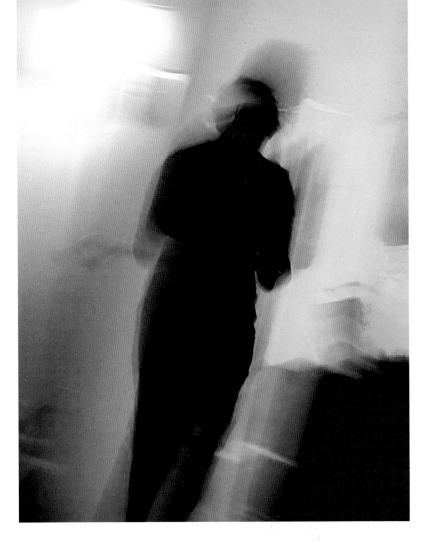

RIGHT
Then later I took pictures of my wife in candid situations. For example, this blue/white shot of her was taken while staying at a motel.

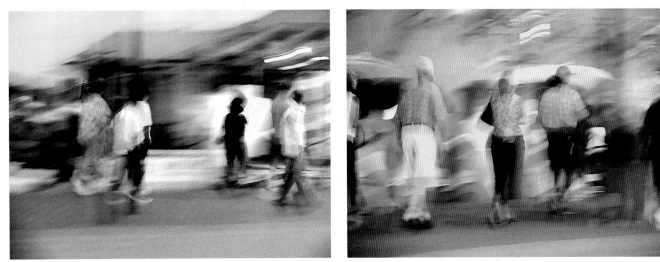

ABOVE
After becoming comfortable with figure studies of my shadows and my wife, I progressed to candid studies of people walking on the Morehead City, NC waterfront near where I lived.

Develop Your Own Style

Most artists and photographers want to develop a unique style that expresses their point of view and identifies their work. You can achieve this but it will take time; it will come naturally out of your interests and your experience as a photographer.

In order to do this, you should create photos that you feel strongly about; images that state something you are trying to say, even though you may not understand exactly why one photo has such an emotional pull on you and another does not. Follow your instincts. Your feelings will come through as you develop, and without it your work might be technically perfect but lacking warmth.

The pictures that express your own unique point of view will come from the subjects, situations, techniques, and artistic considerations that interest you. Some people will become involved in a particular subject—like candid photos at a certain park—while others might approach their work from a more technical side, such as flash with night photography.

While each person's journey will and should be quite different, I believe it is useful to list real world examples of places, situations, and environments that lead to successful imagery. In my case, I wanted to work with my daily world and not go out of my way to find exotic or unusual subjects. I felt that my ordinary world would be remarkable enough if I could render it

the way I envisioned it. I also found that doing the same photo over and over such as taking a series from my car every time I drove into town at twilight was quite useful as I learned something each time. The element of chance meant that on some days I would capture things that had not been available on other days.

I enjoyed taking photos of my shadow, so I found myself looking for different places where I could create compositions with it. I took a series of these at night such as on the beach, against a faded railroad crossing warning painted on a road, on a lawn next to a car dealership where there was a mixture of light, and against a wall of a beach towel store where multiple lights created overlapping shadows.

And these shadow pictures and the idea of including myself, lead almost naturally to self portraits, where again I looked for a situations where I could create interesting work. While I still preferred to work at night, I also included a number at twilight and in the late afternoon. Eventually I added other people in my self portraits, such as my wife and my cat.

BELOW
These images taken with an early, lo-res point-and-shoot digital camera led the way to the themes I would explore over the next ten years.

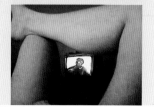

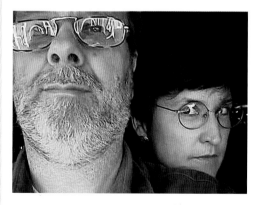

ABOVE
This early and spontaneous self portrait of me and my wife was taken in front of a neon sign while waiting to be seated at a crowded restaurant.

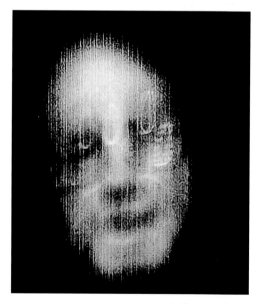

ABOVE
An early self portrait created with camera vibration. These self portraits, in turn, led me to experiment with lighting in a studio situation.

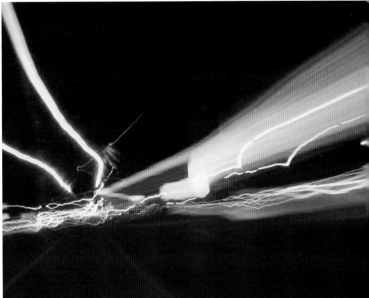

This Page
These photos evolved from my first windshield photos and became more graphic and abstract than my original shots.

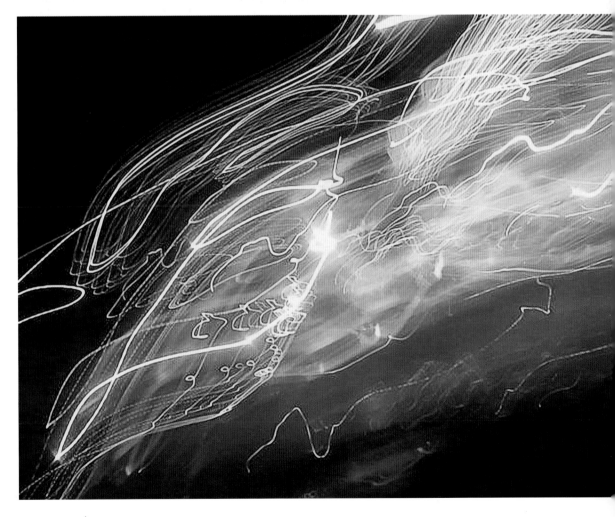

Train Your Eye

As your photography develops, work on developing your own artistic eye. Compositions are everywhere. Learn to look and to see color, detail, shadows, picture elements, and split second timing—all those factors that separate a good photo from a run-of-the-mill photo.

As an experimental photographer, you have the flexibility to think in new terms. But in addition to understanding the requirements of experimental composition, you should also study the work of famous visual artists. The more photographs of others that you look at and the more paintings you view, the better your skills will become. Much of photography has to do with simply seeing—becoming sensitive to the world around you and its every detail—especially at the moment you click the shutter button.

Get Ideas from Other Artists

I have made a personal list of photographers and painters whose work I admire. I included the painters because many of them experimented in ways that are relevant to experimental photography.

If you find work that you especially admire, look at it carefully and return to it year after year. Really good art will reward you for a lifetime. And overtime you will find elements that you did not see initially or a subtle use of color that only makes sense once you are thoroughly familiar with the artist.

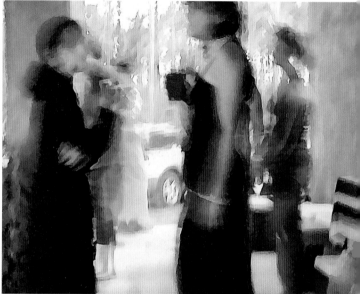

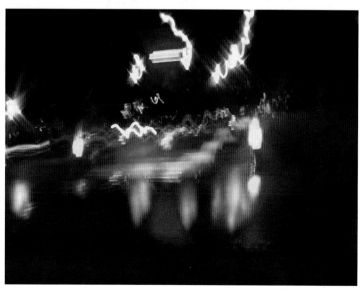

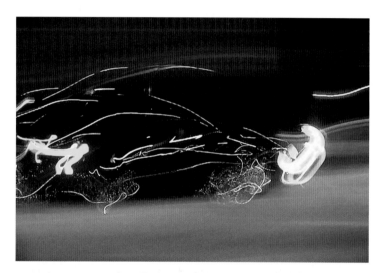

ABOVE
I have always been fascinated by the way that people naturally arrange themselves. The French painter Seurat, who also painted such arrangements, inspired this image.

LEFT, TOP
The Futurist painters, who wanted to capture the sensation of cars and other machines in motion, inspired this photo.

LEFT, BOTTOM
The Abstract Expressionist painter, Arshile Gorky, inspired this photo of car brake lights.

Photographers to Study

- **Eadweard Muybridge (1830 – 1904):** His extensive studies of human and animal locomotion are a gold mine for the study of motion and have never been equaled.

- **Étienne-Jules Marey (1830 – 1904):** His images of overlapping sequential motion are quite poetic.

- **Man Ray (1890 – 1976):** A man who experimented more than any other modern photographer.

- **Brassaï (1899 – 1984):** One of the first photographers to shoot extensively during the night.

- **Harold Eugene "Doc" Edgerton (1903 – 1990):** His high-speed photography revealed hidden worlds, often in the most ordinary things—such as a drop of milk.

- **Aaron Siskind (1903 – 1991):** Calling himself an Abstract Expressionist photographer, Siskind brought photography closer to the world of painting.

- **Henri Cartier-Bresson (1908 – 2004):** Some of his images do use a blurred sense of motion: all of his photos have an acute sense of timing.

Painters and Art Movements to Study

- **Cubism (1907 – 1911):** In Cubist art, the subject could be seen from multiple perspectives at one time.

- **Futurism (1909 – 1914):** Similar to Cubism, Futurist art depicted motion and environments that affected and surrounded a subject.

- **Claude Monet (1840 – 1926):** French painter whose use of color and light defined the Impressionist movement.

- **Georges-Pierre Seurat (1859 – 1891):** Inventor of the pointillist painting technique—his work, in a sense, is similar to that of digital photography.

- **Vincent van Gogh (1853 – 1890):** Both an expressionist and a colorist, van Gogh was one of the first artists to use his craft as a means of personal expression.

- **Wassily Kandinsky (1866 – 1944):** Founder of abstract art, his early abstracts in particular are text book lessons in abstract composition.

- **Arshile Gorky (1904 – 1948):** American Abstract Expressionist, his use of color and composition are inspirational.

- **Jackson Pollock (1912 – 1956):** His paintings are the result of his motions and in themselves convey a sense of motion.

- **Willem de Kooning (1904 – 1997):** His woman series in particular shows how to abstract a figure while still retaining its identity.

NOTE

To write this book, I looked to the few instructional works by practicing artists: Paul Klee's **Pedagogical Sketch Book**, Bela Bartok's **Microcosmos**, and J. S. Bach's **Well-Tempered Clavier.**

Do You Need a Lot of Equipment?

Reading this book might get you believing that you must buy a new camera with more capabilities, but before you buy something new, learn to use all of the capabilities of the camera you already own. Some of the most dramatic pictures in this book were taken with a basic Casio Digital Camera (QV-100)—an almost primitive camera by today's standards. So taking striking photos does not necessarily require owning the latest and greatest technology. Go back and read your manual and experiment with what you already have; it won't cost you anything and it will help you decide just what capabilities you need when you finally do buy a new camera.

And what about accessories? There has always been and will always be an endless amount of photographic equipment you can buy or add. The trick is to find small, cheap, and compact devices that you can work with. Therefore, before you buy something, make sure that you really need it, that you know what you want to do with it, and that you cannot make do with something you already own.

Make a Portfolio

While looking at your work on the computer monitor is good, you should print out your work from time to time. If you do not want to spend a lot of time and money printing your work, go to a copy center such as your local Staples store (or www.adoramapix.com) and have them print your work on the best quality paper for about a dollar or two each. These prints are quite stunning and you will look at your work in a new way when you see it on paper. Over time, you will find that you have dozens of photos that you can arrange and edit into an impressive portfolio.

Put Your Work on The Internet

Since the Internet reaches hundreds of millions of people around the world, putting your work on the Web can help you reach an audience that appreciates your efforts. For example, photo sharing web sites such as flickr.com have groups dedicated to light painting. Other web sites are sure to keep popping up with like-minded interests. You can also start your own blog at blogger.com and add photos.

"Neither a lofty degree of intelligence nor imagination nor both together go to the making of genius. Love, love, love, that is the soul of genius."

WOLFGANG AMADEUS MOZART, COMPOSER

ABOVE
This self portrait shadow was from my shadow on the lawn series.

ABOVE
My shadow picture was accepted at a museum showing. Here you can see it on a large screen as people viewed it while standing on the museum floor.

Attitude is Your Greatest Asset

Your best asset as an experimenter will be an open attitude and your ability to grasp a fast changing situation. Learn to recapture the sense of play, that sense you had when younger that allowed you to try different things just for the pleasure of trying. As adults, we tend to be quite goal oriented; while this is important, there are times when we should put away this point of view and just do things for the hell of it. Each picture does not have to be perfect, and letting yourself try a number of things often leads to unexpected and quite exciting new results.

At the same time, when you discover a promising technique, take the time to really explore all the possibilities. I suggest that in this case you become methodical and investigate every possible variation.

While these two ideas seem to be contradictory, they are not. In order to find new ideas, you will need to be open-minded. Yet to get the most from a new technique you will, in turn, need to proceed in an orderly manner to understand all the variables.

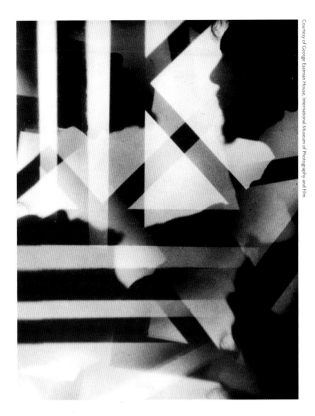

Courtesy of George Eastman House, International Museum of Photography and Film

The Future of Experimental Digital Photography: My Own Personal Wish List

EXPERIMENTAL PHOTOGRAPHY has plenty of room to grow and develop. Here is a short list of subjects and technical developments that I would like to see.

Slow Shutter Speed Studies:
- Human Locomotion: I would love to see a repeat of Muybridge's landmark studies of human locomotion redone for the digital age using slow shutter speeds.

- Nudes In Motion: The subject of the nude body has been a central subject in western art for thousands of years.

- Studies of Sports: Some sports and other activities work well with slow shutter speed imagery such as baseball, circus acts, rodeos, or gymnastics.

Future Digital Cameras: I'd like to see these features in future digital cameras (manufacturers are you listening?)
- An LCD display of a slow shutter speed exposure that "builds" the image as the exposure progresses, instead of the LCD screen blacking out.

- Very low ISO settings—such as an ISO of 1, 2, 4, 8, 15, 25— which would allow taking slow shutter speed photos in normal daylight.

LEFT
Around 1917, Alvin Langdon Coburn created a number of photos he called Vortographs that were made with a kaleidoscopic device he designed. It fit over his camera's lens and fractured objects into a prismatic image. This photo is a Vortograph portrait of Ezra Pound.

"I don't think that we have even begun to explore the possibilities of the camera."

ALVIN LANGDON COBURN, PHOTOGRAPHER

index